Art of the
Modern Potter

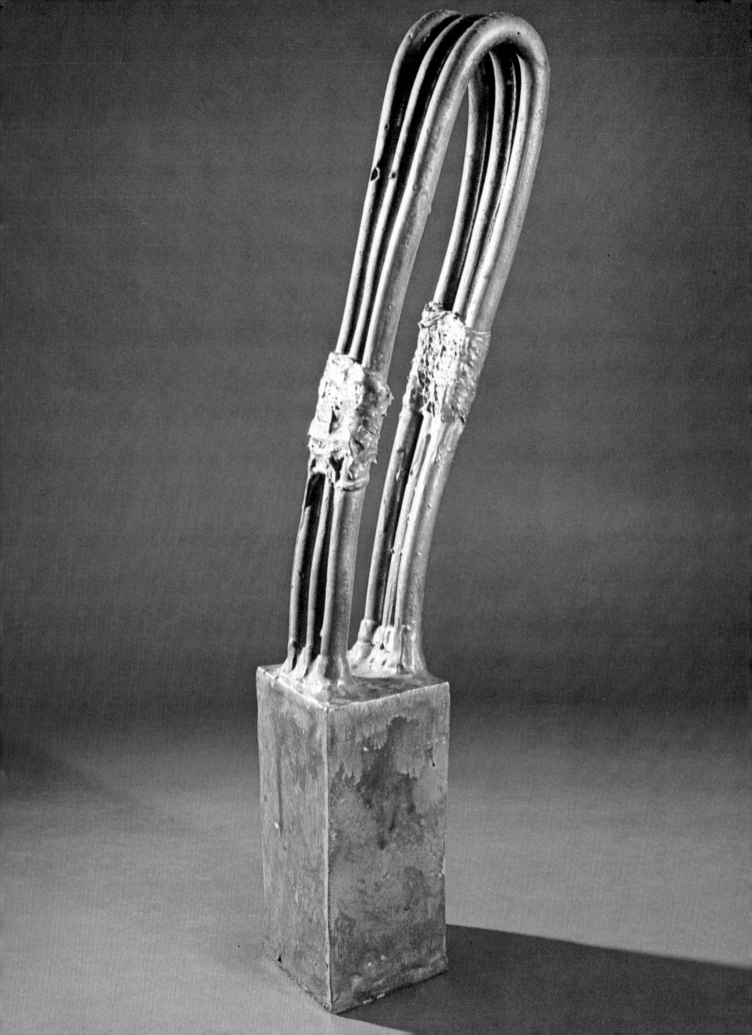

Tony Birks

Art of the
Modern Potter

Country Life Books

This book was designed and produced by
Alphabet and Image, Sherborne, Dorset

Published by Country Life Books
and distributed for them by
The Hamlyn Publishing Group Limited
London · New York · Sydney · Toronto
Astronaut House, Feltham, Middlesex, England

First published 1967
Revised and enlarged edition first published 1976
Reprinted 1977, 1979

ISBN 0 600 37126 3

Frontispiece: Standing form by Anthony Hepburn
A slab-built box with three long extrusions of clay bent in
harmony, fixed to the box and bandaged with scrim soaked in slip.
The pot is glazed in a felspathic stoneware glaze and painted with
gold and silver lustres and refired. 25 in. high, 1,250°C and 720°C.
Collection of the author

Filmset and printed in England by
BAS Printers Limited, Over Wallop, Hampshire

Contents

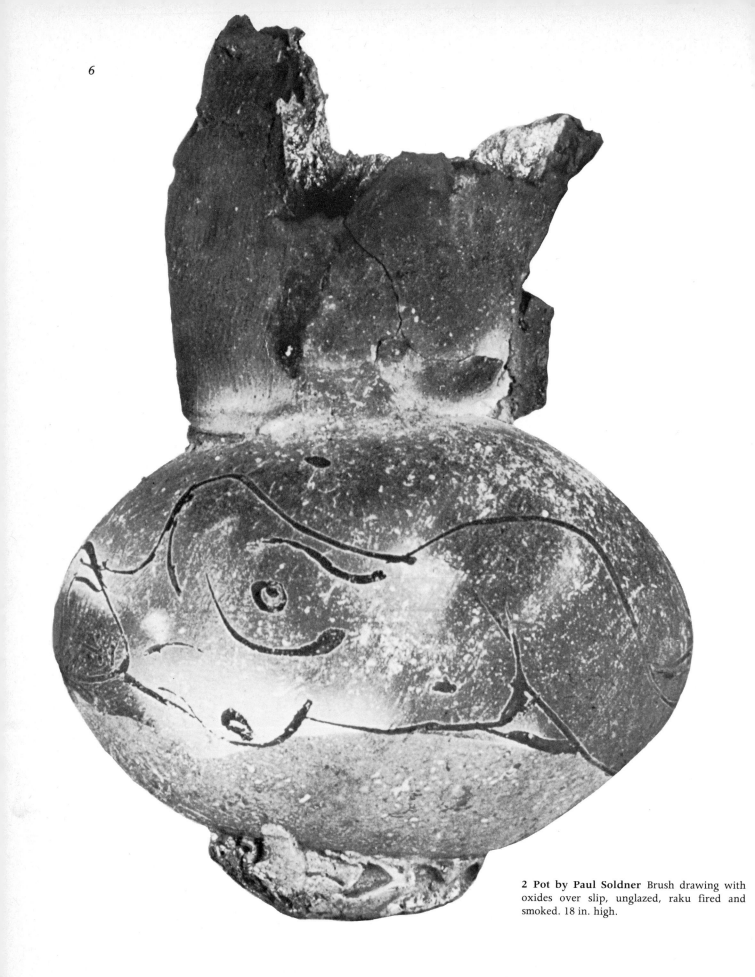

2 Pot by Paul Soldner Brush drawing with oxides over slip, unglazed, raku fired and smoked. 18 in. high.

Introduction

Man, both super-civilized and uncivilized, has been fascinated by pottery for seven thousand years, using it not only as one of the great practical standbys in life, but as a means of direct visual expression, endowing hand-made bowls with ears and feet, refining wheel-made pottery to peaks of aesthetic excellence, allowing clay and the forms it will take to mirror the society in which we live.

Much of the twentieth century has been hampered by a stilted self-consciousness in ceramics, with little of the vigour of other ages, and too much theorizing. In the decade since 1965 a new spirit of adventure has shown itself in ceramics, and in particular in the use of clay for figurative rather than functional ends. Some purists may regard this as a sign of decadence, but it all depends on the pots, which, as always, speak for themselves. It is certainly a return to the broader canvas which allowed a pottery duck into an Egyptian king's tomb, and porcelain cauliflowers to be modelled by Wedgwood. It also allows those potters who aspire to it, and have the necessary talent, to emerge from a respectable craft into the field of fine art.

In so small a selection of potters the choice is bound to be a very personal one, and cannot represent the full spectrum of contemporary work. It excludes potters who make only tableware, and shows very few examples of tableware by those artists who are included, for that is the subject of another book. My only regret is that amongst the wealth of sculptural potters there seems to be a dearth of artists who draw and paint figuratively and freely on the surface of their work, rather than using the automatic techniques of silk screen and transfer. It is this fresh, first-hand drawing which gives life, and can match vitality in the form. In this respect I am pleased to illustrate on the facing page the inspired work of Paul Soldner, who finds in raku a way of using fire to add to the vigour of his already original pots.

Most of the pots in the following selection have been drawn from private collections and the personal collections of the artists themselves. Thus pots which are not normally on view are shown, and in some instances documented in detail. I am most grateful to the owners for their kind co-operation in allowing the pots to be photographed and in particular to the artists for giving so much information about the materials and the methods they have used.

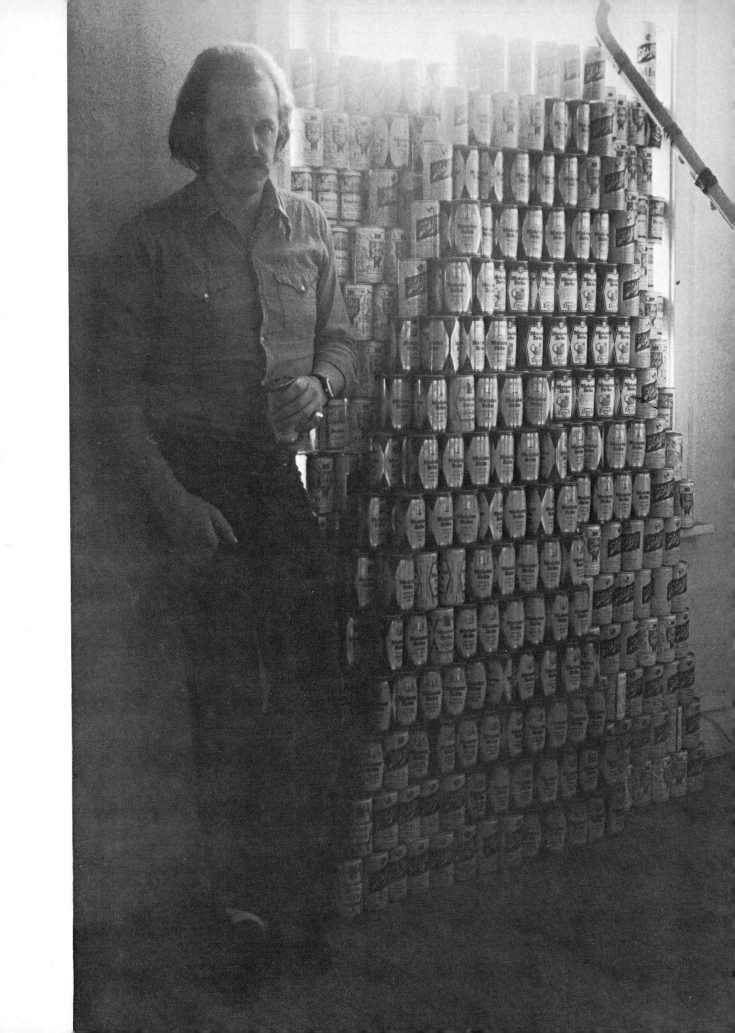

Anthony Hepburn

Anthony Hepburn is a sculptor in clay whose work lies outside all ceramic traditions. He is an artist of great originality and confidence whose total involvement with his material – his tar-baby relationship with clay – has consisted over twenty years not in a repetitious or continuous attempt to resolve timeless aesthetic problems in ceramics, but in a series of forays exploring aspects of clay and including excursions every year or so into other materials such as metal, wood and cloth. The more he tries to work away from clay, however, the more it holds him.

His work has developed from a complicated combination of techniques and figurative images to an ever simpler form. In this book it will be seen to represent an extreme in ceramics. It is his sculptural sense which sustains Anthony Hepburn in his progress as an artist, although it is right to consider an element of showmanship as significant in this progress, firstly because of the importance to him of his role as a teacher and secondly because he views the making process as of equal importance to the finished result. He is not particularly interested in permanence – even in a durable material like clay. Taking off one's shoes and jumping into a bath of clay, leaving prints which can be preserved, but need not be (something he may never have done) is no doubt a liberating experience, unlocking the doors which cupboard up our pottery and our sculpture, and he justifies such actions because it is part of his professional educating function – to make people see and feel. He recently staged a sculpture-making performance – himself and stepladder – designed to show how the artist's own body can be used to generate ideas about sculpture. The value of the end product is something that he himself often questions. In regard to his ceramics – *'several tons of it deposited around the world'* – its very permanence is sometimes tiresome. However, it is fortunate that clay is durable, for his work includes some remarkable pieces that perpetuate dynamic moments with a real sculptor's authority. Exceptionally aware of the passing of time, Anthony Hepburn often freezes actions, moments of collapse or disintegration or, like the frontispiece of this book, imprisons energy, as does the clip of a safety pin.

As Professor of Pottery and the head of the Division of Art and Design at Alfred University, New York, succeeding Daniel Rhodes in the post, he is in a key position in the teaching and practising of ceramics. Taking up the post in 1976 follows a long period of close association with American ceramics, although Anthony Hepburn is an Englishman.

Born in Stockport near Manchester in 1942, he took part as a child in a remarkable educational experiment. The Manchester High School of Art, founded in the 1950s

and located in an ex-mental hospital by Strangeways Prison, had the express aim of teaching all subjects through art to specially selected children whose abilities seemed to lean in that direction. As one of the first pupils he was taught to work with raw materials like glass and steel in a constructive and creative way and to regard drawing as a natural part of the learning process. Familiarity with structural and engineering principles, techniques like welding and processes like kiln firing, has been of great use to him, and he has no fears or inhibitions in tackling and combining materials and techniques from which other artists shrink for reasons both aesthetic and practical.

He moved to London when he was seventeen, and as a student at Camberwell School of Art was taught by Dick Kendall, Lucie Rie, Hans Coper, Ian Auld and Bryan Newman and later by Bill Newland. It was a fertile period of British ceramics, and several of his fellow students have since become distinguished potters. He shared a studio in London with Ian Godfrey and Mo Jupp, and lived for a time at the cultural community centre at Digswell, Hertfordshire, occupying a studio once used there by Hans Coper.

He taught pottery first at Oxford School of Art and then at Coventry. By 1967 he was exhibiting his now well-known series of slab pots at Primavera in London, putting to good use his experience in ceramic techniques and his eye for humble utilitarian forms as basic sculptural shapes. His ceramics consisted mainly of a combination of hollow slipcast forms and slab-built boxes, a curious mixture of readily recognizable objects in tight situations: cast skittles clumped together or toppling, but held in one piece by their glaze, often confined in boxes and decorated with bright underglaze colours or ready-prepared metallic lustres. The boxes themselves were often frozen in the moment of collapse or of crushing other forms with their own weight. Sometimes slab-built hollow cubes stacked together would show a springiness like marshmallows, and Anthony Hepburn would exploit the rubberiness of semi-soft casting slip in some of the other forms he chose – milk bottles, telephones, toasters and slipcast bricks. He transformed the bland plastic or glass of the original into an equally bland ceramic, often glazed all over with a creamy dolomite glaze or embalmed in a filigree of slip made by soaking and wrapping the pot in sculptor's scrim before firing.

At a time when Funk art was burgeoning in America and odd slipcast objects were appearing in British art schools, these ceramics gave a lead. Unlike many of their American counterparts, these pots do not carry a message of horror or despair. A cast telephone set may be surrounded by several receivers for sculptural reasons, not symbolic ones. The repulsive mutations so temptingly available to the slipcaster do not interest him, and after two exhibitions at the British Crafts Centre in London in 1967 and 1969 he turned smartly away from representational ceramics to more abstract forms.

Anthony Hepburn first visited America in 1968 and returned to New York and Los Angeles in 1969, combining this with a short sponsored visit to Japan in the company of Bernard and Janet Leach. He was there able to meet Hamada, whom he most admires as a potter and with whom he stayed for a few days. Japan, however, was clearly not to have for him the attraction and magic it has for some potters and he is more interested in the work of American sculptors Richard Serra, Terry Fox and Dennis Oppenheim, and American potters Ken Price, Ron Nagle and Paul Soldner. He shares with the latter a sympathy with fire, and although not using Paul Soldner's direct raku methods he has developed the ability to work with the kiln, knowing just

how far his material will bend and flex under the influence of heat and gravity. Several of the pots illustrated on the following pages show these kiln distortions, arrested as if by magic at the optimum moment. In this context glaze is used partly for decoration and partly as a glue which allows parts of the composite pots to slide about as the temperature rises.

Anthony Hepburn was invited to teach in America for three periods in 1969 and 1970, and in 1971 spent eight weeks teaching in Pittsburgh. By this time he had become interested in the use of extruded clay, and in November 1971 staged an exhibition of clay pieces including some unfired and wet clay in combination with metal and wood at the Camden Arts Centre in London. Many of the pieces in the exhibition were massive – many feet high – and mobile, though some were small and more compact, as shown in Plate 15, this object being made from fired pools of stoneware slips. Ropes of extruded clay were used in curves and loops, and later more rigidly in stacks – impressive towering blocks which it is interesting to contrast with Bryan Newman's more frankly figurative slab architecture.

In 1973 he went to teach at the Chicago Art Institute for two months and held a one-man exhibition at the Ulman Gallery in Cleveland. In 1974 he was asked by the Chunichi Shimbun ceramic collection at Nagoya, Japan, to prepare a series of ceramics based on the cup. He made sixty variations. Using a porcelain or agate clay, the bowls were thrown and completed with extruded or pinched handles by means of a variety of fixings, as illustrated in Plates 8 to 13. In the same year he contributed to the Idea and Image exhibition at the Evanston Art Centre in Chicago and returned to the Art Institute of Chicago for a full teaching year. He used extruded rods of earthenware clay fired to an Indian red colour at stoneware temperatures and bound together like scaffolding to make space-enclosing structures, partly as sculpture and partly as maquettes for larger work. Having worked with soft and liquid clay and slip, he next turned his attention to the working of dry clay, using the tools of the carpenter or stone carver – the plane and saw, chisel and rasp and drill – to create unusual textures for ceramics, combining white porcelain and black clay, grogged stoneware, white slip and coloured glazes, sometimes assembling the pieces after firing with resin and string. In his more recent work he has been firing solid blocks of carved clay and combining these with perching or sliding porcelain shapes as shown in Plates 17 and 19.

Many people who warmed to his earlier representational slipcast sculpture find the detrital clay assemblages hard to take, but for Anthony Hepburn they are never regarded as ends in themselves, but experiments in a broad clay spectrum in which the area of view frequently changes. As an irritant in the current of world ceramics he has been effective both as an artist and a teacher. Over the next few decades a tidy and predictable development from him cannot be expected. His confident handling of his material and the technical facilities of Alfred University at his disposal should produce outstanding examples of modern ceramics.

His work can be seen in collections in Italy (International Museum of Ceramics, Faenza; gold medal 1970), Japan (Takashimya Gallery, Tokyo; Seibu Gallery, Tokyo), United Kingdom (Victoria and Albert Museum, London, Stoke-on-Trent Museum, British Council Collection) and the United States (Lee Nordness Gallery, New York). It was included in the Smithsonian Institution travelling exhibition in the United States in 1970, and the Chunichi Shimbun in Nagoya, Japan, in 1974.

1 Standing form (Frontispiece) See page 4.

4 Bottles on a slab box Thin slipcast milk bottles contrast with the sturdy construction of the slab-built box on which they stand. The bottles are glazed in creamy-coloured dolomite glaze and the box has a darker charcoal-grey and pink stoneware glaze with black decoration from an underglaze pencil. The bottles were stacked in such a way that they would be encouraged to slip in the kiln, with a refractory support in front to stop them sliding off altogether. 15 in. high, 1,280°C reduced.
Collection of Ernie Blyth

5 Standing forms Slab-built boxes with solid extruded rods attached to clay plates at the top. The rods sway as a result of bending in the kiln. With a plain stoneware glaze, painted with gold and silver lustre and refired, they are ceramic but metallic. 17 in. high, 1,280°C and 720°C.
Collection of K. Winnitt

6 Brick Anthony Hepburn has made moulds of both regular and misshapen bricks, and cast light-weight hollow versions, sometimes using them as units in large sculptures, sometimes, as here, contrasting a rubbery brick with a spiky filigree of slip left after the sculptor's scrim has burnt away. The pot is glazed in a creamy-coloured dolomite glaze. 8 in. high, 1,280°C.
Private collection

7 Tower Extruded rods stacked on a slab box make a tower. Glazed in stoneware glaze, lustred in silver and refired, it is 24 in. high. 1,280°C.
Private collection

8–13 Cups, 1974 These variations on the theme of a cup – six out of sixty designs – all have thrown bowls. No. 9 is made from a mixture of porcelain and black clay with slices of the same clay applied as a handle. The bowl of the pot only is covered with copper lustre. The agate-ware bowls of Nos 8 and 12 are thrown from an unmixed blend of white porcelain clay and cobalt oxide. The bowls of the other pots are thrown from white porcelain clay. No. 10 has a handle made from a slice of clay slotted into the pot, and darkened with copper oxide. The bowl has a transparent glaze. The artist is most pleased with No. 8, where the stability of the pot is upset by the doubled-up handle, an extrusion of porcelain clay coated in silver lustre.
The other pots all have handles extruded from porcelain clay. In No. 11 the extrusion is draped over the form and attached only by the clear stoneware glaze. In the other two cups, Nos 12 and 13, the handles are attached to the pot through holes drilled in the porcelain cylinders when dry. The handles are silver lustred, the bowls glazed with a clear stoneware glaze.

Each cup is perfect. All gain by contrast with one another. 4 in. to 5 in. high, 1,280°C oxidized.
Chunichi Shimbun collection, Nagoya

14 Porcelain form The standing form was thumbed into shape from porcelain clay. Drawing attention to contrasts of texture, the finger-marks were carefully left, and when the clay was dry it was sawn with a band saw and a triangle of chromed and polished steel was inserted after firing, and glued in. This also gives stability. Clear glaze. 12 in. high, 1,280°C oxidized.
Private collection

15 Clay and steel construction Two thrown stoneware cylinders, squeezed at the tops and slotted to take a steel bar, were covered with silver lustre fired to 720°C. The twelve suspended disks swing freely on the steel bar. They were made by pouring pools of casting slip of different colours (pink, grey and beige) on to a flat surface, and drilling holes in them before firing. They are unglazed. 20 in. long by 18 in. high, 1,280°C and 720°C.
Private collection

16 Construction 1975 Made from bone dry clay, planed and scraped, the individual pieces were fired separately and assembled later with resin-coated string. The clay ingredients are grogged stoneware clay, black basalt clay, porcelain clay, white slip, transparent and blue glaze. 18 in. wide, 1,280°C.
Collection of the artist

17 Form 1976 The base is made of buff stoneware, planed, rasped and sawn to shape when bone dry before firing. There is an addition of planed Crank Mixture at the right hand edge and a carrot of Crank Mixture stuffed in a hole. The cup with extruded handle is in thrown porcelain covered with a clear glaze which also acts as a glue. 12 in. long by 8 in. high, 1,280°C oxidized.
Collection of the artist

18 Assembled form 1975 An assemblage of black clay, blistered in the kiln, white stoneware, grogged clay and white slip. Apart from the scratch marks on the black clay, all surfaces are made by sawing or sanding dry clay. The cross piece is fixed with glaze, the two long pieces strapped on with resin-coated string after firing, 12 in. by 8 in. by 7 in., 1,280°C oxidized.
Private collection

19 Perching cup 1976 A thrown porcelain cup with extruded handle jointed with brown slip perches on top of two slim lumps of Crank Mixture, carved and sawn. The cup and its handle are glazed with a shiny clear glaze. 16 in. long by 4 in. deep, 1,280°C oxidized.
Collection of the artist

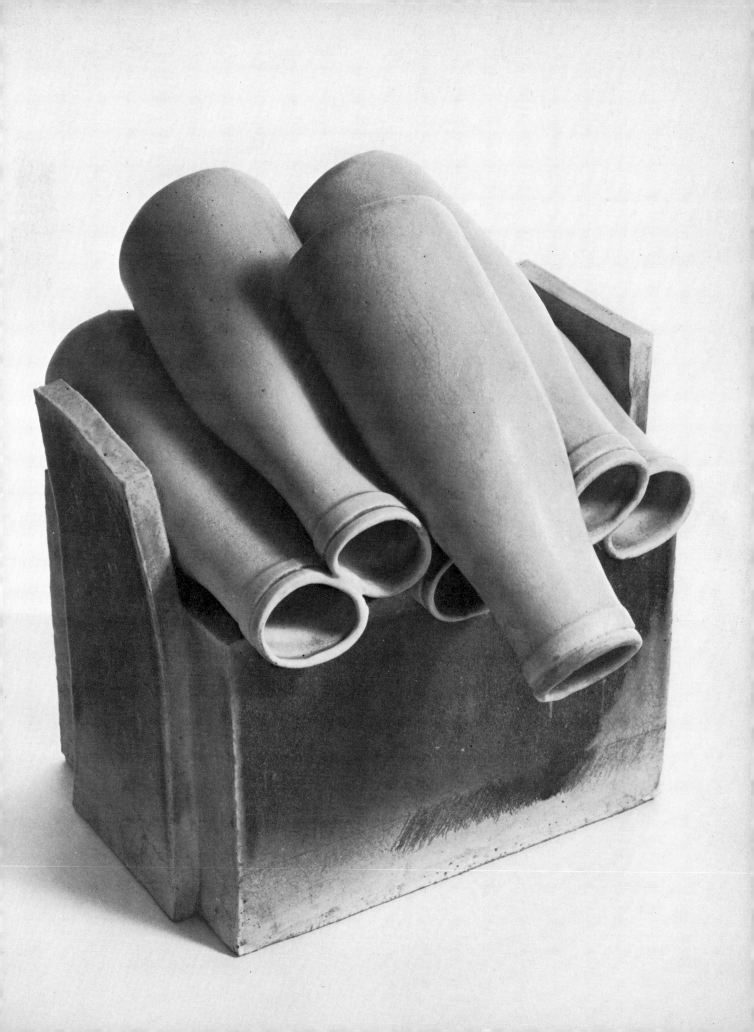

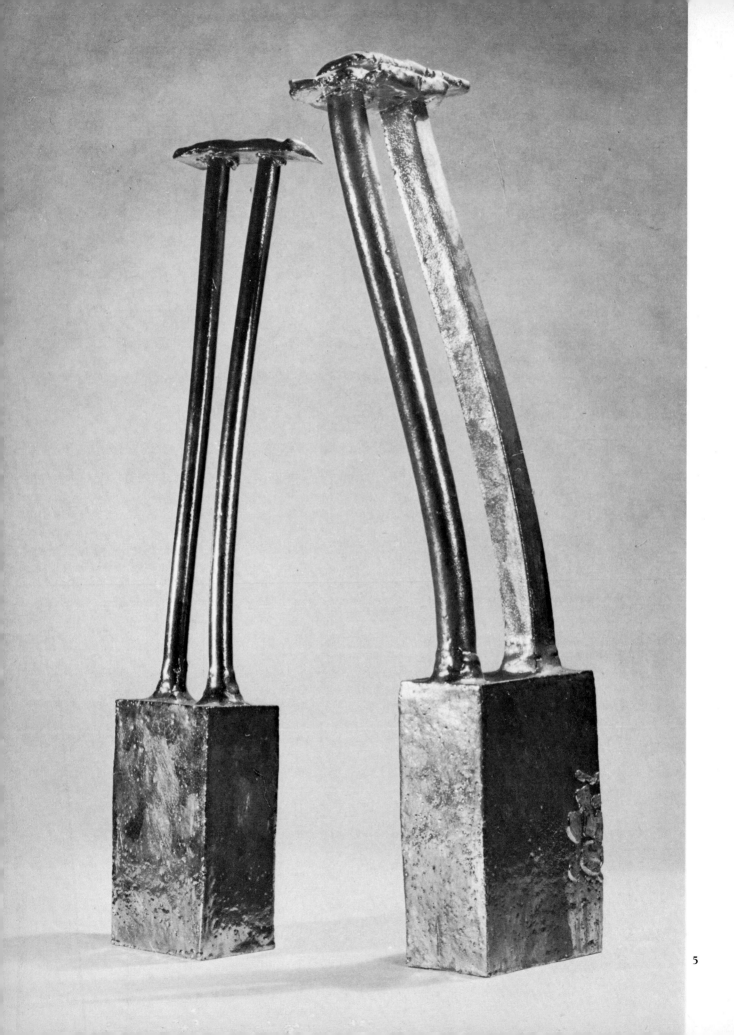

Anthony Hepburn

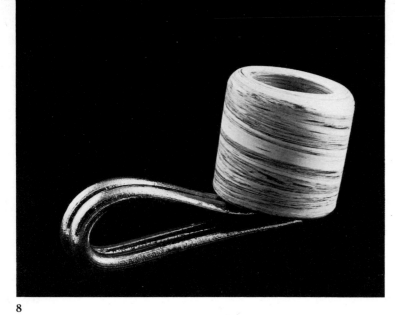

8

Anthony Hepburn

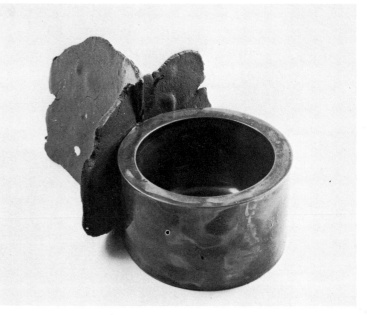

9

10

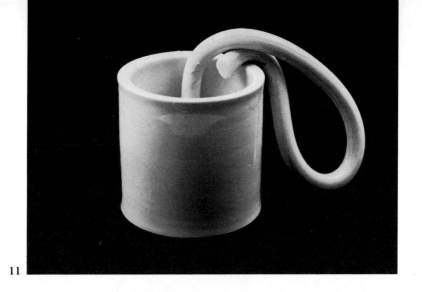

11

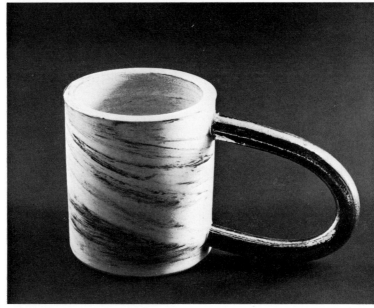

12

13

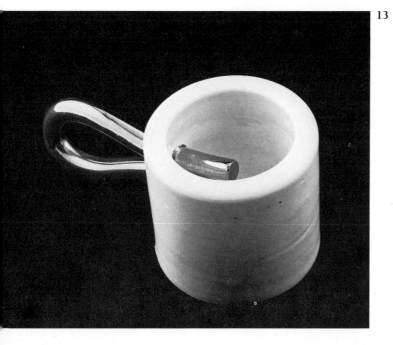

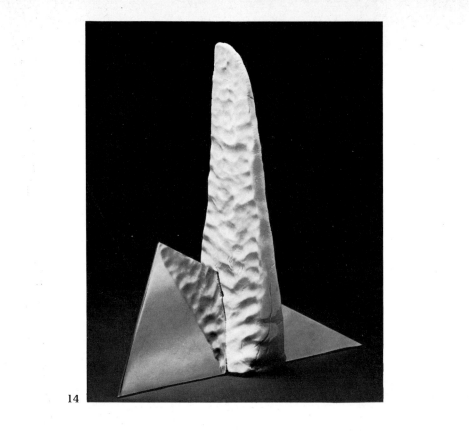

14

15

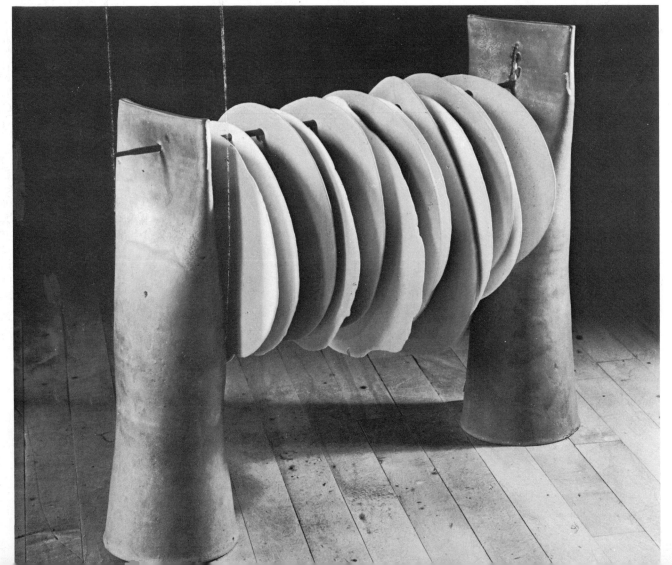

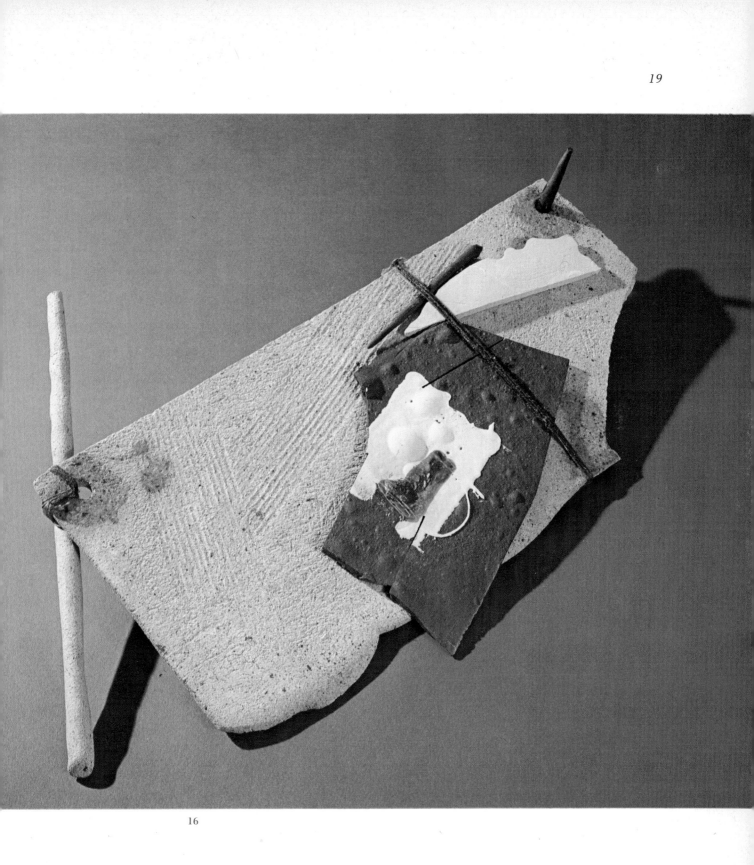

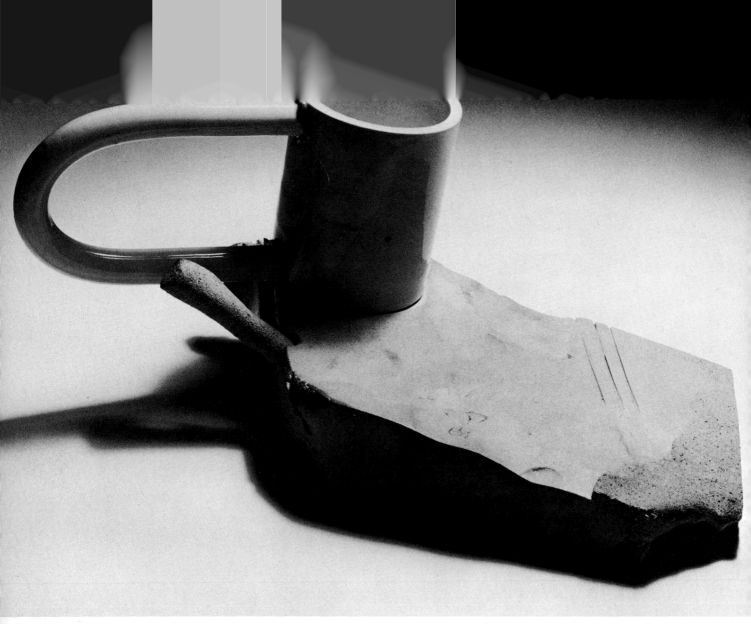

17

18

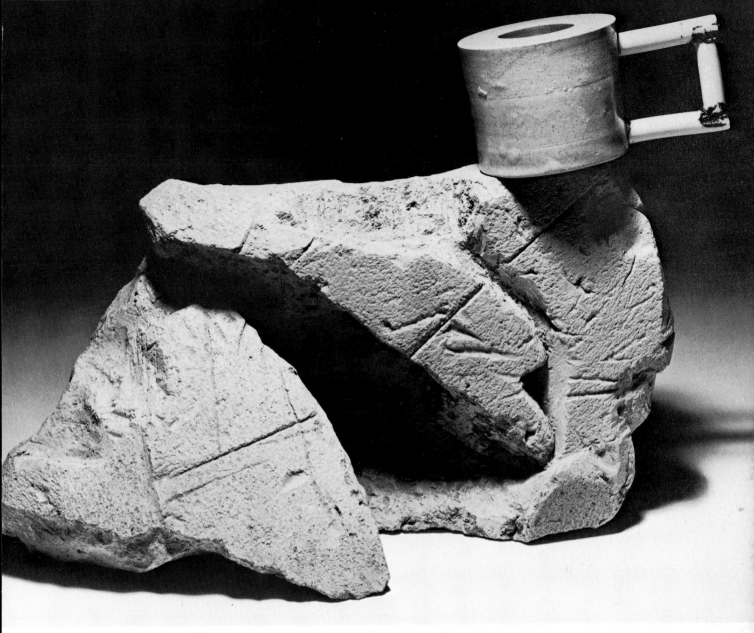

19

Ruth Duckworth

Amongst sculptural potters in stoneware and porcelain, Ruth Duckworth of Chicago must be regarded as one of the world's most influential. Although her inventiveness and skill have matured and her reputation consolidated, the period of her greatest influence was during the 1960s, when massive swelling coiled pots in stoneware and delicate pinch-made porcelain forms were not current, and her work was revolutionary. It has for long been regarded as a touchstone in modern pottery, and exhibitions in Europe and America gain in status if her work is included, as if Callas had come to sing. This rather awesome aura is not confined to her work: it surrounds her too as a teacher, and advance notices or even rumours of her lectures arouse excitement. Yet Ruth Duckworth has none of the outward appearance of a doctrinaire teacher. She is firm in her views about her own work, and ready in her response to the work of others, but she is unpretentious and unshowy. She is a potter who has gone her own way, and happens to have swept many along with her.

She has a wide range of work, from coarse and massive pots and wall panels to delicate porcelain abstractions which have the natural harmony of growing things. If pots could make themselves, one feels they would grow up out of the earth like Ruth Duckworth's.

She was born of a Jewish family in Hamburg in 1919. Before the war she left Germany for England, where she lived with her sister in Liverpool and studied painting and sculpture for four years. She was interested in all creative art forms at that time and did not specialize. In 1940 she joined forces with an Austrian girl to form a travelling puppet theatre and spent two years playing to schools in the north of England. At this time she was officially described on her identity card as an 'entertainer', but her real aim was to become a productive artist. Settling in London in 1944, she concentrated on sculpture, working in stone and wood, and executed a large commission – fourteen stations of the Cross – in St Joseph's Church, New Malden, Surrey, England with her husband Aidron Duckworth, whom she married in 1949.

Her first contact with pottery came in 1953. A plan to make some glazed sculptural panels and a chance acquaintance with Lucie Rie (*I had the nerve to ask her for some glaze recipes!*) led her first to Hammersmith School of Art and then to the Central School in London. In this stimulating environment her love for working in clay and her experience as a sculptor immediately produced sparkling results.

Much of her early pottery was original tableware: she was finding solutions to practical design problems. The conventions which at the time equated domestic

stoneware with heavy forms did not interest her, and she threw light shapes on the wheel. The name Ruth Duckworth became associated with fine coffee sets, a delight to handle and use. A remarkably simple cylindrical cup, partially unglazed outside and with a characteristic shiny dark inside, was thrown and matched with a thrown saucer. As she has moved away from functional pottery, these sets have become rare collectors' pieces, as has the celebrated salt, pepper and mustard set shown in Plate 34 and made from cast porcelain. All this work was made in the brief period between 1958 and 1964 in her studio near Kew Gardens, London. Ruth Duckworth was turning more and more away from wheel-made to sculptural pottery up to the time of her arrival in America as Visiting Professor of Ceramics in Chicago in 1964. From this point onwards she felt complete freedom to return to the making of sculpture rather than pottery, though now in the ceramic medium she handles so fluently.

One of the most notable qualities of Ruth Duckworth is her intuitive sense of equilibrium in a form. It enables her to build stable pots on small bases. She returns again and again to the theme of swelling, breast-like forms springing from this tiny base, and yet somehow her shapes stand up. 'She risks the threat of imbalance,' says Alice Westphal of the Gallery of American Ceramics, Evanston, 'thus endowing her works with poise . . . and tensions . . . which subliminally engage the viewer.' Her large stoneware forms often result from a very simple basic conception, the hollow sac – inflated, deflated, elongated or flattened. Sometimes enormously heavy, these pots are massive and timeless. A wide gulf separates them from her other work: delicate tiny porcelains, sometimes thrown and sometimes pinched, often branching forms growing wings and fins. She only began to use porcelain material in 1962, and her direct approach to it was a significant breakthrough in the development of sculptural ceramics. Currently it is this small-scale sculpture which takes up most of her time, and by pressing against the limitations of the porcelain medium she is apt to lose some pieces in the drying or firing stage.

For her large-scale work, consisting of free-standing pieces several feet high and wall panels up to four hundred square feet in size, she frequently makes small maquettes first, to clarify her ideas. An early mural commission in America was for the Chicago University Department of Geophysics, an apt location in view of her fascination with physical geology and all processes of rock formation and erosion. The influence of earth sciences is clearly visible in her larger work, but the patterns and forms thrown up by other science disciplines such as astronomy, biology and microbiology are also a source of interest to her. She is no fossil copyist, but an original designer, yet her work always consists of organic shapes and is regarded by some people as very sensual.

Almost all of her ceramics are now made by hand, and are usually asymmetrical. This is not studied asymmetry applied to a circular form before it dries – the calculated ellipse with its origin in the thrown bowl – her work has the asymmetry of an apple or pear which grows in response to sunlight or physical circumstances.

As the illustrations show, white predominates as the basic glaze colour for her porcelain. It results from two glazes, a medium matt felspar glaze and a semi-transparent 'fish scale' glaze. The golden colour which is characteristic of her English ash glazes (see Plates 26 and 34) depends on the particular ash content and is rather unpredictable. It occurs in oxidized firing. Before settling in America, Ruth Duckworth worked exclusively and happily with electric kilns, but now prefers the greater flexibility of gas firing, and uses reduction at low temperatures – from 870°C

to 1,150°C, returning to oxidizing conditions to complete the firing to maturing point.

Naturally enough for a sculptor she has a great interest in the relationships between buildings and ceramics and has undertaken several architectural commissions in America, including a mural for the Dresdner Bank in Chicago. Her architectural work has led her to the use of non-ceramic materials for the bolting and fixing of sculpture made in pieces, and she is increasingly experimenting with the use of Plexiglass and epoxy resins as materials in their own right.

Working in a studio close by her Chicago apartment, she enjoys making commissions to precise specifications, and finds working for an exhibition stimulating and exciting. She also has a large capacity for work, having staged fifteen one-man shows in as many years since 1960, and contributed towards more than twice that number during the same period. She regularly exhibits outside America, with a major one-man show in autumn 1976 at the Hamburg Museum fur Kunst und Gewerbe.

Ruth Duckworth has tramped across continents as a teacher, leaving Chicago to teach at the Bath Academy of Art, England, and later to go to Florida, to Alberta, Canada, to Italy and to Jerusalem. It seems that talking, lecturing and judging ceramic shows are often tiring and worrying for her, and yet her teaching style is distinctive, effective and fresh. She stresses the importance of personal affinities with clay, believing that clay can mean different things to different people. She likes to encourage students to make the kind of pots they want to make rather than to impose formal exercises on them. In Chicago she has taught for some years in the Ceramics department at Chicago University. She is critical of her own work, but retains affection for certain pots, especially those which, though old, marked a particular stage of development. She is uninfluenced by other potters, but admires the work of Hans Coper and Peter Voulkos, and, amongst sculptors, Noguchi and Henry Moore.

Her work is in public collections in Britain (Victoria and Albert Museum, London, and Royal Collection, Windsor Castle), Germany (Dudelsheim Museum, Stuttgart Museum), Holland (Stedelijk Museum, Amsterdam and Boymans Museum, Rotterdam), Italy (Bassano del Grappa), Japan (National Museum of Modern Art, Kyoto) and the United States of America (Mills College, California, Art Institute of Chicago, University of Chicago, Philadelphia Museum of Art and Utah Museum of Fine Arts).

21 Round pot A ripe-looking shape built from thin slabs of coarse clay, on a small base. The clay is dark and is stained with several glazes applied and then sponged away. 12 in. diameter, 1,280°C reduced.
Private collection (ex Paul Koster Kunstkammer)

22 Two stoneware pots Both of these large coiled pots are partially glazed, so that the buff, grogged body is visible and the glaze, poured on to the pots from above, breaks across the forms in vertical lines. The pots are glazed inside and the glaze spills out of the tiny holes at the top. The taller pot has iron and copper oxide rubbed into the side and top, and then sanded off the surface so that the dark charred colour appears only out of the crevices. The glaze is an ash glaze, orange where it is very thin and light green where it is thicker. The same glaze, used in two layers, partially covers the pot in the foreground. 14 in. and 21 in. high, 1,280°C oxidized.
Private collections

23 Standing form The fleshy crease shown in the photograph is smoothed out to leave a straight, firm profile at the back. Reminiscent of both body and bone forms, this coiled pot is given an earthy quality by its surface texture, made by applying small patches of clay to the finished form while still damp. Particularly notable is the handling of the rough-edged skewed top, and the pot's elegant balance. Two clear glazes – both containing ash – are applied with copper and iron to give dark green to black. 22 in. high, 1,280°C oxidized.
Collection of the artist

24 Oval vase This porcelain pot is a tall oval cylinder, shaped by hand, standing on a thrown base. The diagonal stripes are colourful, dark green and dark purple, bleeding to yellow and brown in the white glaze. 8 in. high, 1,280°C reduced.
Private collection (ex Paul Koster Kunstkammer)

25 Standing form Made in porcelain clay, this folded form stands on a thrown base. The greenish-white glaze is crackled, and spots of oxide burn through from the porcelain clay. $9\frac{1}{2}$ in. high, 1,280°C reduced.
Private collection (ex Paul Koster Kunstkammer)

26 Porcelain forms Six of a series of crisp thrown and cast forms based on cylinders, with hand-made additions – knobs, buttons and spikes. The tallest pot is a cylinder glazed with a medium stoneware glaze containing iron and manganese. The two pots on the right have a similar iron-rich glaze on the inside, occasionally bleeding over the top into the white matt ash glaze on the outside. The remaining pots are

glazed inside and out with the honey-coloured ash glaze which has a fibrous near-matt texture where thick, and turns the porcelain clay orange where it meets the base. 6 in., 8 in. and 13 in. high, 1,280°C oxidized.
Private collections

27 Porcelain form This shape, made by hand and scored with a wooden tool, is bone-like, but more like a whole living creature than part of one. Ruth Duckworth makes use of the marks made by her fingers to give freshness to her pots. The two pairs of holes, facing different ways, could have been made only by the fingers. After drying, the pot was sanded to soften the scored lines. Glaze decoration is cobalt under a matt ash glaze. 5 in. high, 1,280°C oxidized.
Private collection

28 Abstract form This colourful porcelain sculpture is made in two pieces, cemented together. The top was made simply by thumbing a piece of clay into globular and jagged forms. The physical qualities of porcelain, used for so long only in imitative naturalistic sculpture cast from a mould, seems well suited to abstract work, as this form shows. The matt ash glaze is slightly crystalline, especially where it is in contact with painted copper oxide. This glaze has a low ash content. 5 in. high, 1,280°C oxidized.
ILEA Circulating Collection

29 Vase A small porcelain vessel made from several slabs or pads of clay engraved with diagonal hatching. The pattern is emphasized by dark green and brown from copper oxide under a crackled white glaze. $5\frac{1}{2}$ in. high, 1,280°C reduced.
Private collection (ex Paul Koster Kunstkammer)

30 Porcelain form Standing on a hollow oval stem, this sculptural form recalls in every concave turn the bone forms which have long fascinated the artist. The central pimple on the front wing is decorated with copper oxide. On its other face, a small panel of clay is added, and the copper decoration spreads across the face. The form is made entirely by hand. The matt waxy glaze is greenish white. 6 in. high, 1,280°C, oxidized.
Collection of the author

31 Porcelain panel Made from slabs, with thin fins added by hand, the panel is made as two concave cusps. Fired on its back, the semi-transparent fish-scale glaze is thin like honey in the grooves, but purplish from volatile copper oxide in slight reduction. 9 in. high by 11 in. wide, 1,280°C reduced.
Private collection

32 Porcelain form This rocking form has a plain back, and several thin slab divisions like a complicated purse. The central cavity has a transparent glaze and the outside has a semi-matt felspar glaze, thick and pinkish-grey towards the base, deeper pink in the navel. 9 in. wide, 1,280°C reduced.
Private collection

33 Coiled pot Coiled symmetrically about its tiny base, this pot, which weighs about 12 lb, is perfectly stable. The pot is painted all over with a cobalt and manganese mixture, and glazed by pouring from above with two different ash glazes. 9 in. high, 1,280°C reduced.
Collection of W. Ismay

34 Salt, pepper and mustard set in cast porcelain Ruth Duckworth's original and much copied cruet set was designed in 1958, and is cast from plaster moulds. The salt pot is based on a Greek oil lamp, and has obvious practical advantages with its wide salt mouth. The set has been glazed in many ways with a range of colours from dark brown to white. In the photograph, her golden ash glaze is seen at its best, thin near the top edges, rich in colour and texture. Pepper pot 4 in. high, 1,280°C oxidized.
Collection of Mrs Eileen Hunt

35 Porcelain form Hand-built porcelain on a thrown bowl base, the interior of this pot is packed with fine curved porcelain divisions, and spliced with a wafer of clay. The paired sheaths protect the inside and hide most of it. This delicate form has a thin matt felspar glaze, rather yellowish. 4 in. high, 1,280°C reduced.
Collection of H. R. Hyne (from Oxford Gallery)

36 Clay relief The rhythm of this relief depends partly on the shapes of the folded slabs of clay which make the units, and partly on the grooves which run across them. Mounted on black Plexiglass, the stoneware clay is coloured brown, black and green with oxides, and has a thin grey glaze. 3 ft by 4 ft, 1,280°C reduced.
Private collection (ex Paul Koster Kunstkammer)

37 Porcelain form Perhaps the oddest yet most subtly appealing ceramic illustrated in this book. Ruth Duckworth made this slab-built form and fired it in three pieces, each side resting in a stoneware cradle to prevent sagging. The thrown porcelain foot and the two sides were joined with epoxy resin after glazing. The form is white, with a semi-matt felspar glaze, with a small addition of semi-transparent fish-scale glaze. 26 in. long, 1,280°C reduced.
Collection of A. Kessel

38 Stoneware sculpture This sculpture was hand made in five pieces and assembled after firing, secured with epoxy resin and metal pins. The surface is coated with sparce copper oxide, a white porcelain slip and two different matt glazes, rubbed down to give a partly bare surface. 5 ft 2 in. high, 1,280°C reduced.
Collection of Alice Westphal

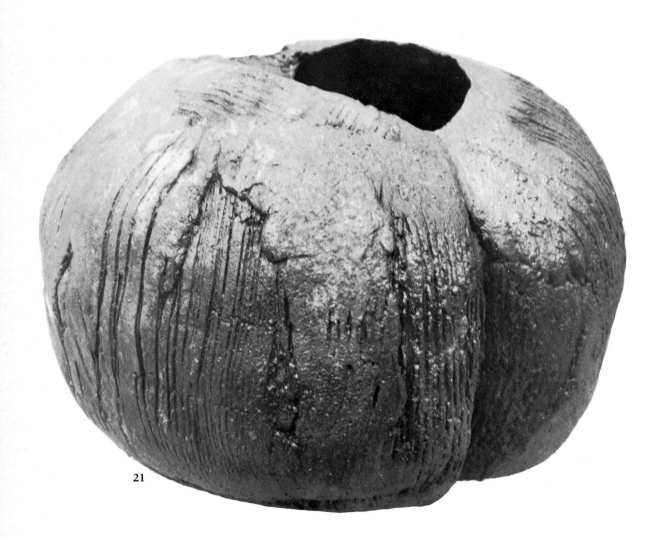

21

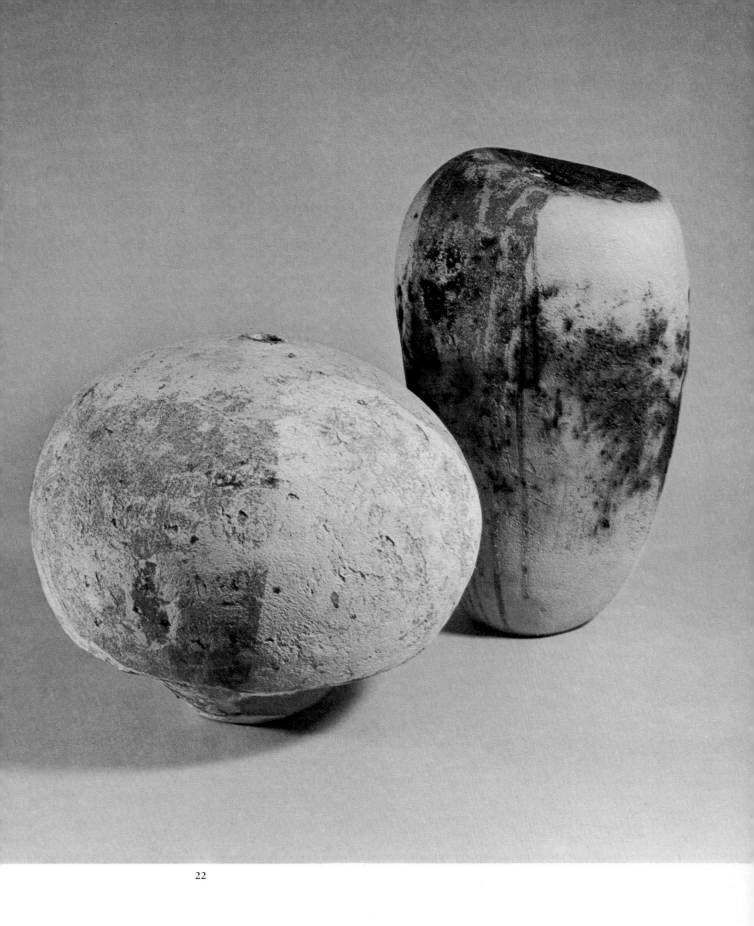

22

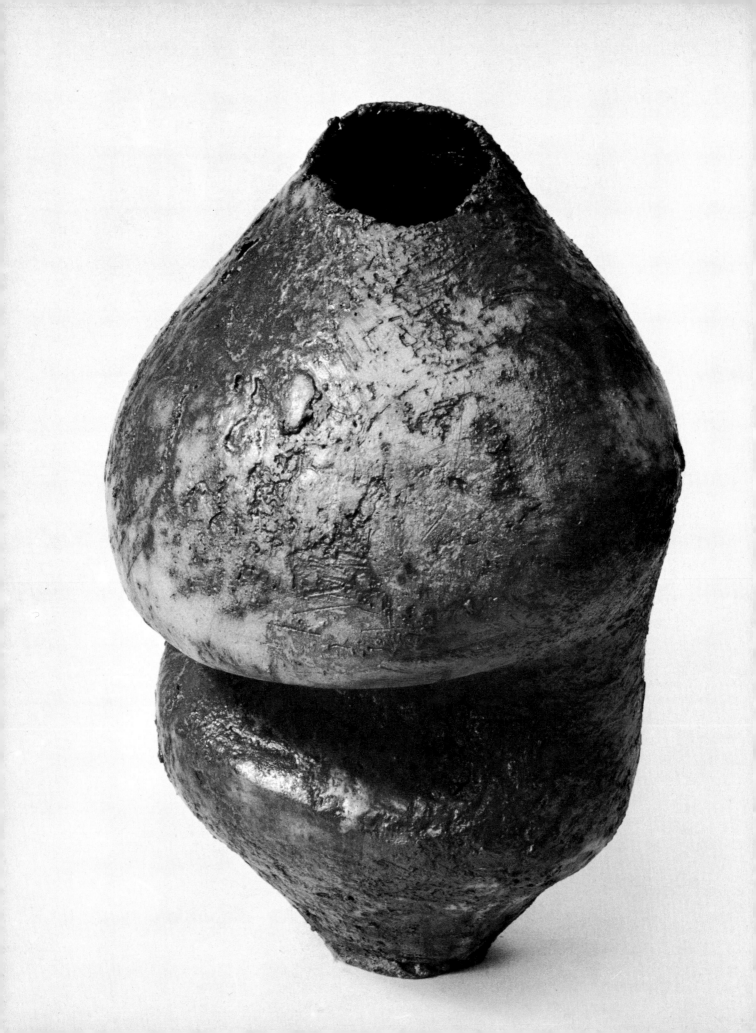

Ruth Duckworth

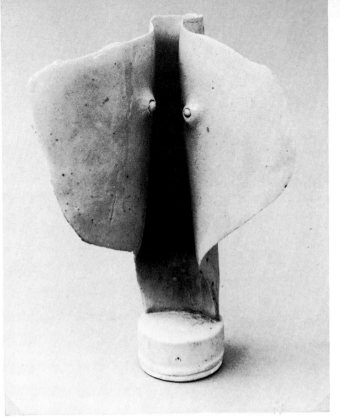

25

24

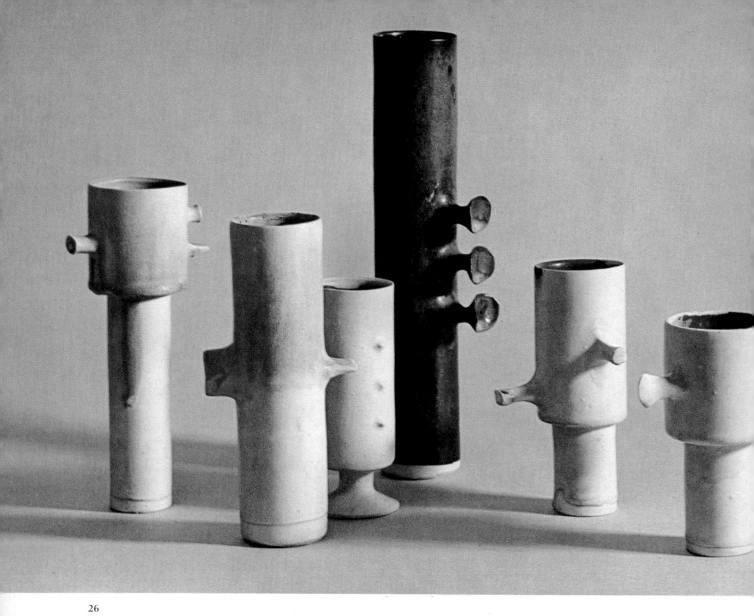

26

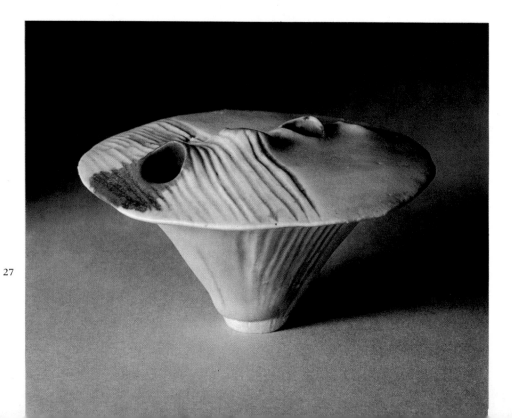

27

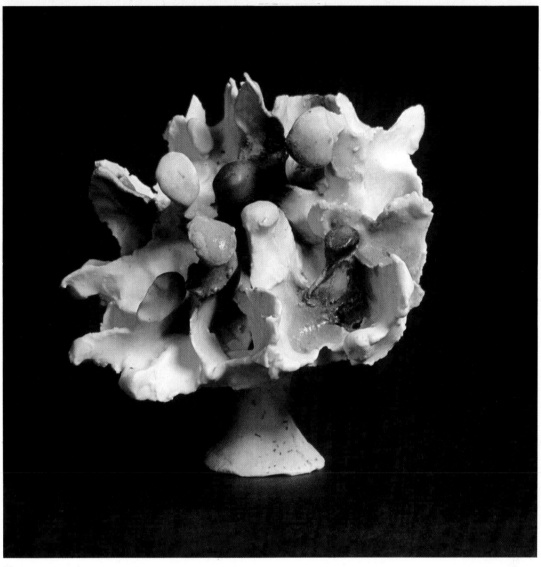

28

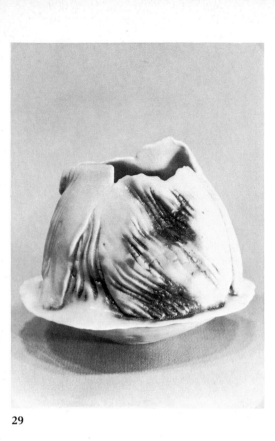

29

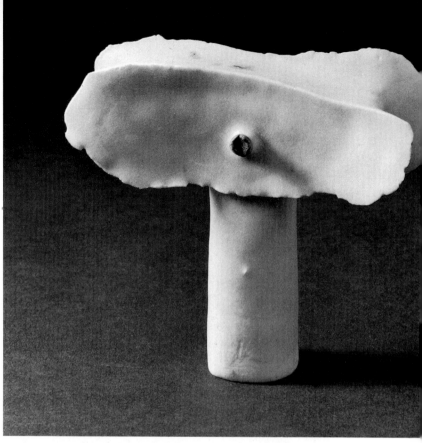

30

31

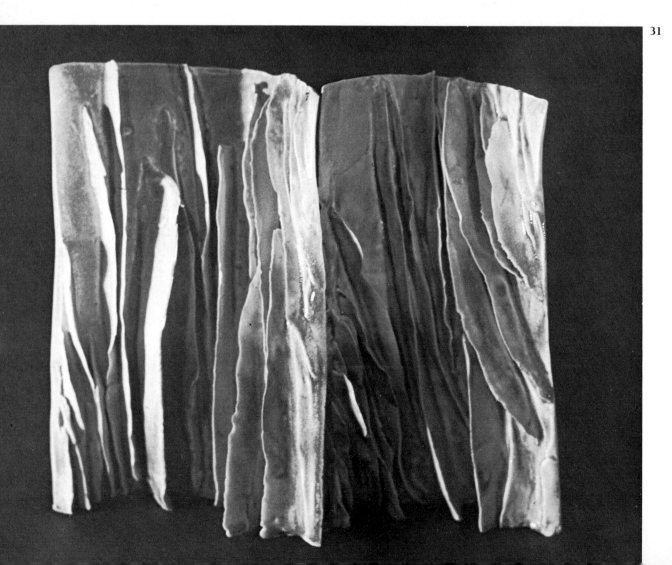

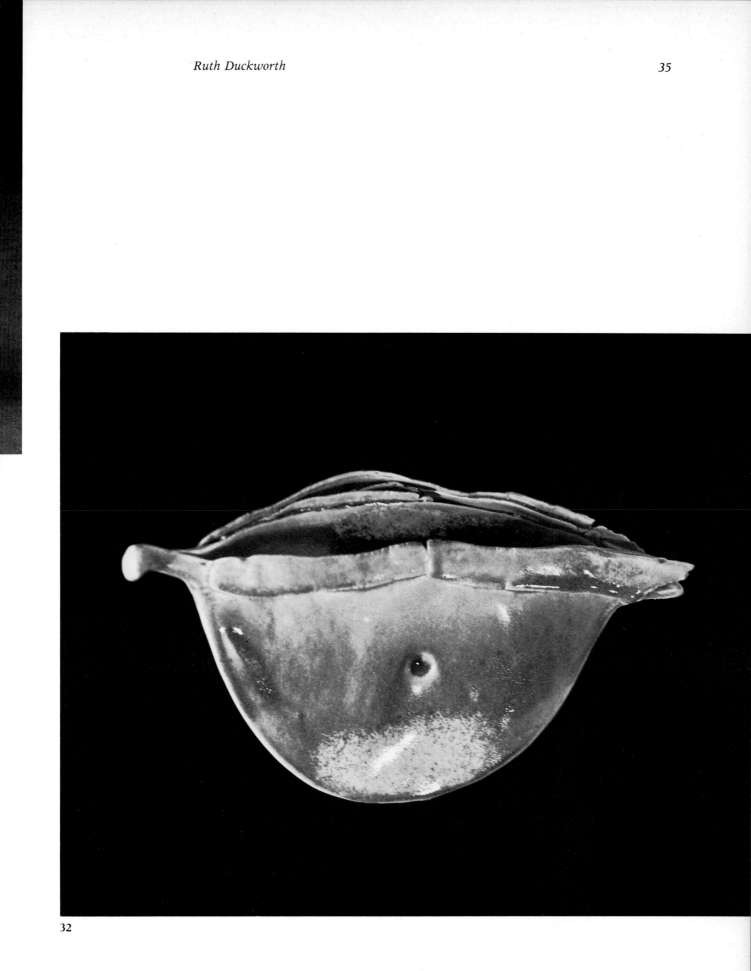

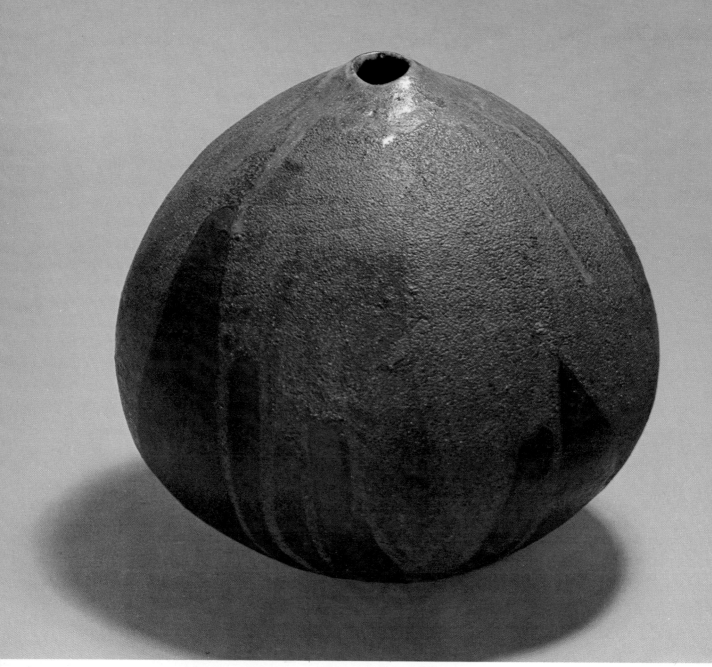

33

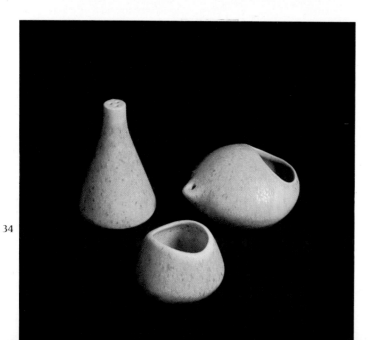

34

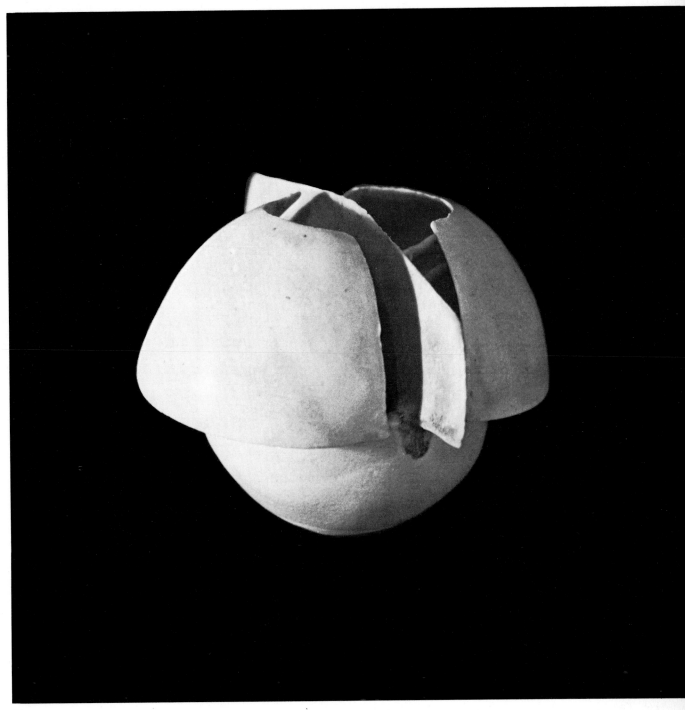

35

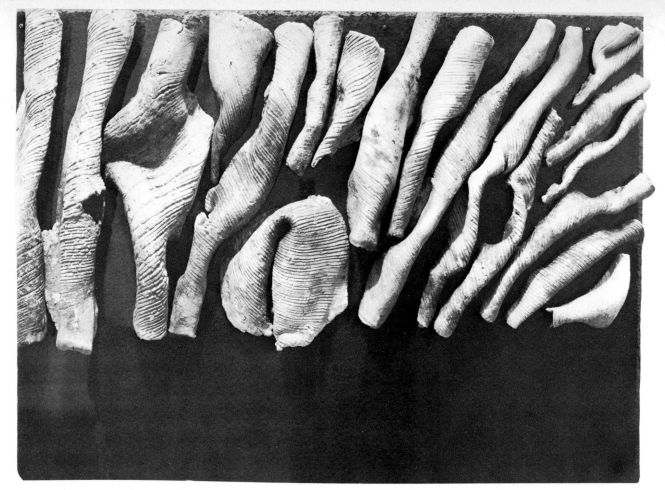

36

37

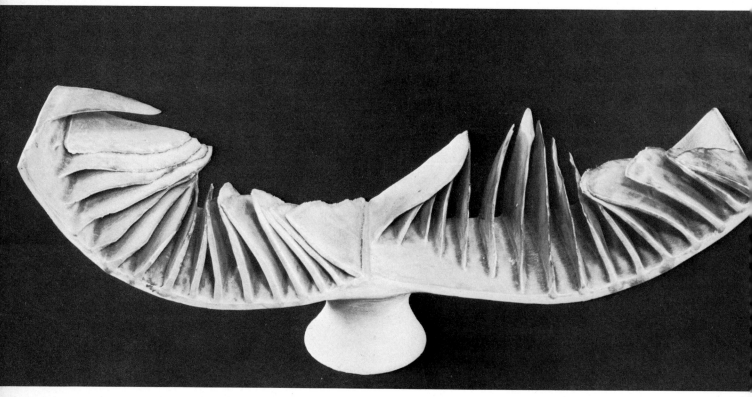

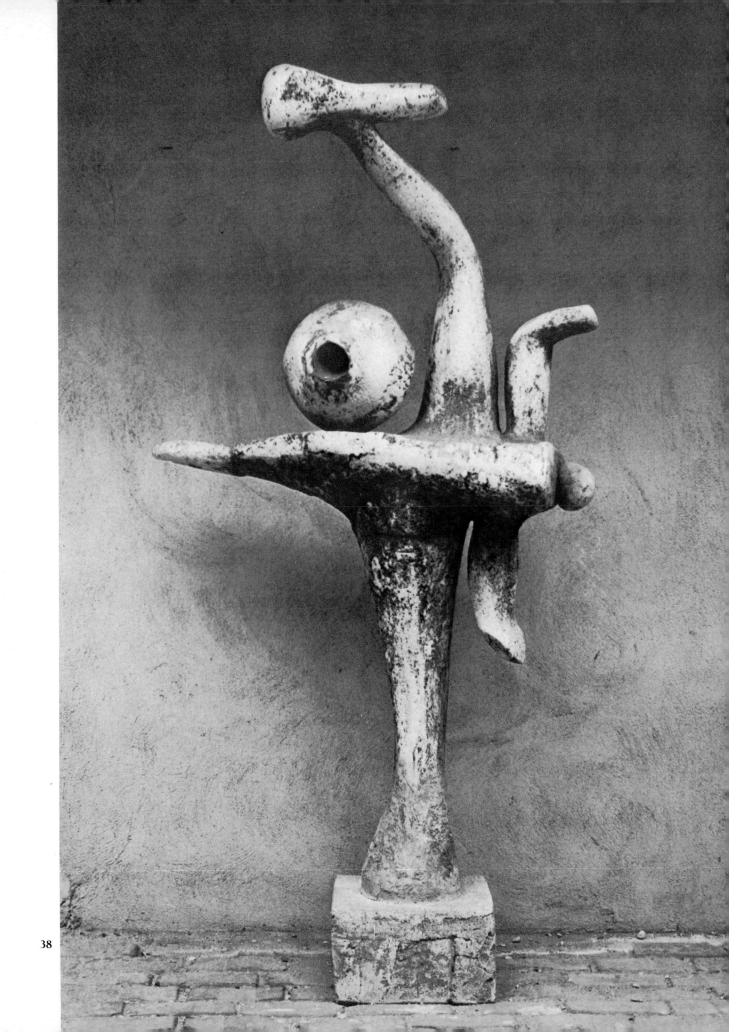

Andrew Lord

Born in 1950, Andrew Lord is the youngest potter in this selection. Within the world of ceramics, he gained early recognition with sculptural work made soon after his student days. These exuberant ceramics – women reclining on boxes, fat female limbs making fleshy gestures and squashing their podia like Turkish delight – belie the artist, for Andrew Lord is not an exuberant man. He is a contemplative and rather isolated figure, who works in a monastic way without much contact with other potters, travelling around the world to study the arts of the past, seeking and finding relevance and associations with pots from other cultures and other centuries, not expecting to find sympathy or inspiration in the work of the present or that of his fellows. When potting, he is essentially creating pots not for a market but for himself.

A casual glance at his work might seem to contradict such a view, for his alliterative pottery, with overtones of the 1920s and 1930s, and the pastel colour schemes of Art Deco, sits comfortably alongside the cynical 'comment' pots of the 1970s. It is this young potter's attitude to his work which is different: it is based on love and affection for the object. He resignedly accepts the difficulty he has in justifying his kind of work to people who are not potters or collectors, whilst keeping outside the coterie of ceramic object-makers, where appreciation of his work is more abundant. It is ironic that his carefully and deliberately made pieces are in distinguished public and private collections around the world, by way of fine art galleries, but are regarded as crude, childish or clumsy by some of the regular outlets for hand-made ceramics.

His not very surprising failure to convey what he is doing to non-ceramists was a source of regret during his stay in Mexico throughout 1974. Here he spent a great deal of time watching and talking to peasant potters and Indian potters, whose aims for their ware were efficiency and cheapness. To spend a week carefully constructing a clay object which, in its final form, could only be called a cup, was in their eyes a form of folly, and difficulties of communication in an alien language made the experience a testing one. For a pioneer, to be misunderstood and reviled is a commonplace experience, but it takes tenacity to survive this, and there is fortunately no doubt that Andrew Lord is sure of what he is doing and single-minded enough to continue, although the going is not easy.

Born in Rochdale, Lancashire, his first art training was at Rochdale School of Art where he took a pre-diploma course leading on to a full-time course in ceramics at the Central School of Art in London. He learnt here from several influential teachers, in particular Bonnie van de Wetering, whose historical perspective in ceramics he

especially admires, and Gilbert Harding-Green. He absorbed the technical skills of throwing, casting and glazing at the Central School, but most important, he gained a confidence in his artistic sense and a feeling of responsibility towards the object he was making. From this period comes the voluptuous jug shown in Plate 40. He spent a year in secondary-school teaching before leaving for Holland in 1972, in search of Delft. He worked for a time in a factory which specialized in ceramic wall coverings. He learnt the detailed skills of the mould-maker, but it is again ironic that, having graduated from the various technical departments to the experimental group, he was sacked by the management, who thought he was 'fooling with clay', when he was making the objects which were the results of this distilled experience and study.

Finding it hard to establish a workshop or a selling relationship with Dutch galleries, he left Holland for Mexico on a British Council travelling scholarship in 1974, and spent almost a year studying Mexican architecture and, as mentioned above, the traditional ware of the Mexican peasant potters. The work he made in Mexico was taken to New York, where he stayed for a few weeks before returning to Britain, and then to Holland in 1975. Awarded a Stipendium by the Rotterdam Art Foundation, he moved his workshop to Rotterdam from The Hague in 1976. He comes to England as a visiting lecturer at the Bath Academy of Art.

His work reflects his travels, both in scale and in subject matter. The shiny tin glaze figures were replaced when he first went to Holland by subjects of popular folk art, animal vases, hollow functional forms decorated with popular symbols of the past such as dairy cows, or the present, such as aeroplanes. When he makes a jug or vase, it may well be chopped in half, spliced with the image of a fish or an aeroplane, carefully reassembled and hollowed out so that it can hold both water and flowers. By the time he went to Mexico he was using 1930s forms and colours, and painted slips left unglazed. He found in the Mexican climate the ideal setting for such biscuit pots, which would weather out of doors more attractively in hot countries than in high latitudes. The work he produced in Mexico (see Plates 50 and 51) shows both an anthropological and an architectural influence, and characteristically the artist spent much of his Mexican time in museums, drawing and storing visual information for future use. By 1974 he was aware of an increasing interest in painted surfaces and in painting itself, which may lead him to a medium other than clay, and he notes a lessening interest in the three-dimensional qualities of his work. The bulging vegetable forms of the predominantly slab-built pots are being replaced by flat surfaces, incised and coloured, or with sprigged decoration in contrasting colours and symbolic shapes. When the designs on his work are representational, they often show sparse 'interiors' like Bacon paintings, with bed, chair or couch, and when abstract they are reminiscent of Matisse.

There are no contemporary potters who influence Andrew Lord, though he is influenced by the painters of De Stijl and Matisse, the turn-of-the-century Dutch potter Theodorus Colenbrander, and by a great deal of popular functional and decorative pottery, running the whole gamut from pot electric fires to advertizing ashtrays.

He has an ambivalent attitude towards functionalism in his own work. He prefers to handle and use complex cups and saucers of his own making than the mass-produced items which are easier to dry with a tea towel. He is prepared to tolerate poor function in a vessel that has other qualities. He makes teapots which are excruciatingly heavy and impossibly untidy pourers, but feels that they would be

devalued if they had holes in the bottom or if their spouts were blocked with glaze.

He distils traditional forms, materials and values from a variety of sources and cultures, and produces essential works of originality. He is not concerned with satire or pastiche. His work is not rugged like that of Janet Leach or Dan Arbeid, for although the exterior is often coarse and rough, the pot is very deliberate, with no room for the happy kiln 'accident'. The surface of his pots is carefully and precisely controlled to maximize the cumulative image. Certain themes recur in his work, just as certain subjects like teapots and waterjugs are worked over again and again. Slow to make, and consequently rather rare, Andrew Lord's pots are precise and painstaking but always original and full of vitality. They can be seen at Garage Gallery, Covent Garden, London and in the following public collections: the Rotterdam Art Foundation, the Victoria and Albert Museum, London, and Boymans Museum, Rotterdam.

40 Jug This large jug was made from five thrown pieces, assembled while very wet and complimented by a pulled handle, fine and taut. The jug is glazed with Dora Billington's lead, lime and potash glaze, using bisilicate of lead and 10 per cent tin oxide, fired to 1,060°C. This large jug has a marvellous noble presence. 13 in. high, 1,060°C.
Collection of Gilbert Harding-Green

41 Three teapots Made in Holland in 1973–4, these teapots are all based on characteristic Staffordshire shapes. The 'camouflaged' pot at the top of the picture was coiled in Dutch buff clay, with a slabbed spout and strip handle. Podmore body stains, china clay and ball clay were painted on to a very wet surface with a brush. The light-coloured pot in the centre is made from slabs of agate clay, made by briefly wedging together clays into which yellow and buff body stains have already been thoroughly mixed. The handle is made from a coil, the spout slabbed and bent.

The green pot on the right is also slab-built from agate clay formed by wedging black clay containing iron and cobalt with a pale green body containing Podmore's green and blue body stains. The pots are glazed with a transparent earthenware glaze. 6 in. to 9 in. high, 1,060°C.
top: Collection of Tim Craig
centre: Collection of Tony Stokes
right: Collection of S. Grimshaw

42 Book money box Made in Mexico in 1974, this was one of a series of money box objects which also included a map of Mexico and a 'couch'. Built from slabs, the dry surface of the sides was spattered with coloured slips reminiscent of the speckled edges of ledgers and record books. The money slot is in the top. 5 in. high, 1,060°C unglazed.
Collection of Betsy Smith

43 Dish and lidded jar These two graceful pots, based on Staffordshire pottery, were made by slab building, each concave facet comprising one slab. As the slabs were joined when the clay was quite wet, the pots needed supporting and propping as they dried.

They are glazed with a lead, lime and potash glaze containing bisilicate of lead and 10 per cent tin. 7 in. to 10 in. high, 1,060°C.
dish: Collection of Peter Schlesinger
lidded jar: Collection of Barry Flanagan

44 Fish pot This big asymmetric storage jar was coiled from clay on to which oxides were brushed and sponged before firing. Its colour is dark green-blue, and the surface is lightly glazed with a transparent earthenware glaze, used more thickly on the inside.

The tall dome-shaped lid recalls the classic Chinese/Meissen shape on which the pot is based. The fish on top is a recurrent motif in his early work. 15 in. high, 1,060°C.
Collection of David Gower

45 Two agate cats Agate clay made by mixing white clay and the same body coloured with Podmore's blue body stain has made the cats smoky blue-grey. They were each press-moulded, in two pieces, and glazed with a clear earthenware glaze. The pair, which seem to contemplate each other's mirror image in the picture, are now in separate collections. There are other cats from the same series – made with even strips of blue and white clay running from top to bottom. 5 in. high, 1,060°C.
left: Collection of S. Grimshaw
right: Collection of Bonnie van de Wetering

46 Goldfish cups These three pots are used daily and with much affection by the artist. Made in 1971, the bowls are thrown, and the goldfish handles modelled on. Podmore's body stain was painted on to the pots to make the bowls bright and dark blue, and the goldfish orange. The white eyes are scratched through the colour to the body below, and the blue pupils are painted in. The glaze is clear earthenware. 3 in. to 4 in. high, 1,060°C.
Collection of the artist

47 Fish vase Two standing fishes make this a double vase for flowers. The pot has affinities with Romanesque carving, but the author's source was the Chinese shape used in Meissen pottery. The pot is partly glazed, and the roughness of the surface accentuated with oxide sponged on. 8 in. high, 1,060°C.
Collection of the author

48 Beaker vase This splendid vessel, which uses the traditional 'beaker' shape familiar in majestic oriental and European china, was slipcast, the mould being first splashed with coloured casting slips, then a cast taken in white slip. Mainly brown and yellow in colour. 10½ in. high, 1,060°C.
Destroyed

49 Black cubist set A five-piece coffee set, hand-made in 1978 from slabs and coils, arranged and rearrangeable on a slab platter. The surfaces are matt bluish-black, from copper and cobalt oxide, and very light-absorbent. It is as if Andrew Lord has taken a cubist painting and reversed the painter's process by creating three-dimensional shapes in the cubist image. 12 in. high, 1,060°C.
Private collection New York

50 Pre-Columbian pots These are coiled in red clay, slightly burnished but left unglazed. The incised pattern on the shoulder of the pot on the left is a traditional one. The source of the shape was an Olmec pot of the second millenium BC seen in the Museum of Anthropology, Mexico City. The source of the pot on the right was a pot from the State of Guanajuato dating from about 800 BC, also seen in the National Museum of Anthropology, Mexico City. 9 in. high, 1,060°C unglazed.
Collection of the artist

51 Vase The outside of this waisted vase is deeply incised and painted within the boundaries of the incised lines, using slips coloured yellow, blue, green and orange. Design motifs cutting across but enhancing the shape of the pot are typical of work from 1975, as are the unglazed surfaces and the flat colours. 8 in. high, 1,060°C unglazed.
Collection of the artist

52 Round shadow set Made in 1978, this five-piece coffee set on a slabbed tray shows the artist's work at its most perfect. The painterly treatment of the white clay forms, using grey pigment, creates strong shadows, making the pots light and luminous, but confounding the photographer. Transparent glaze, 20 in. wide, 1,060°C.
Collection of Anthony Stokes Gallery, London

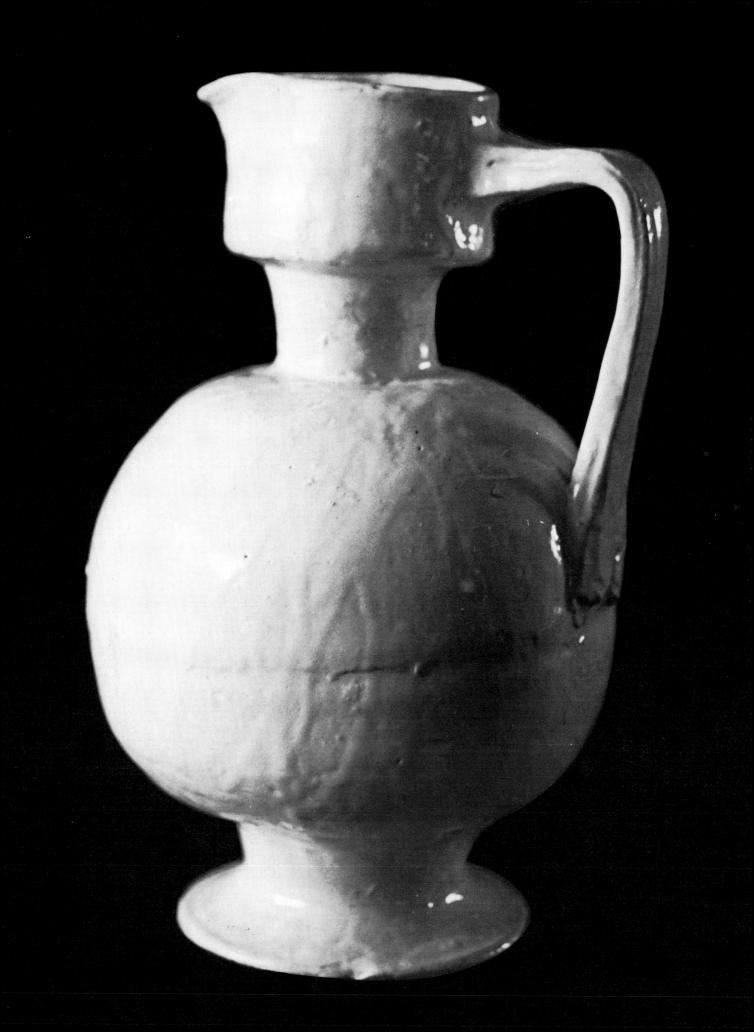

46

42

41

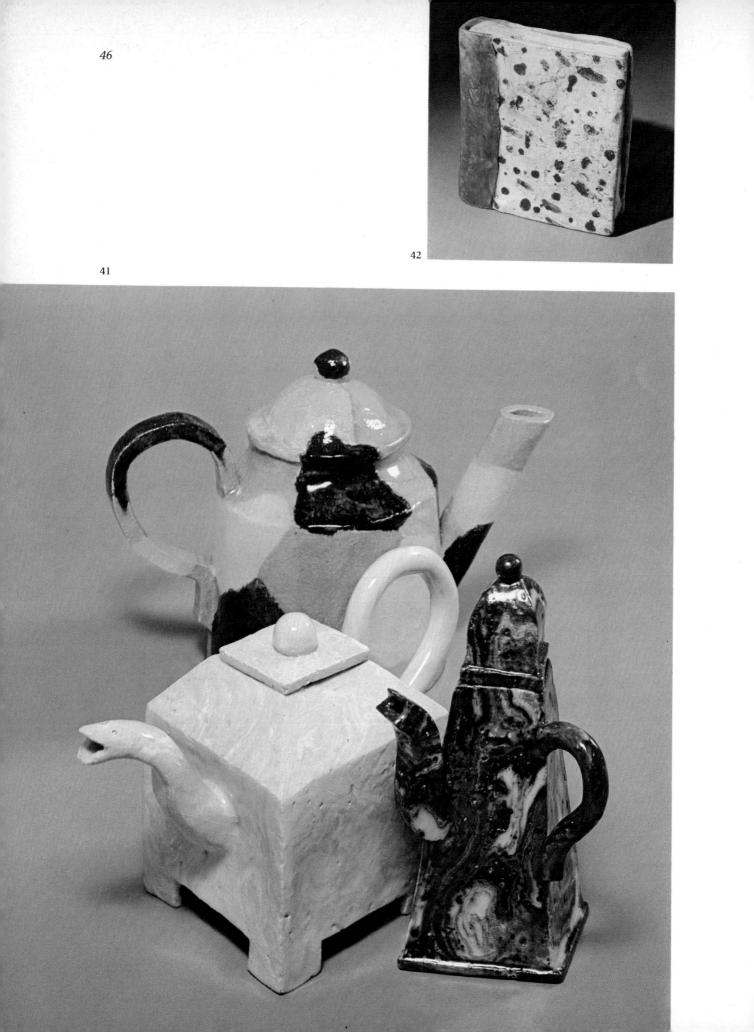

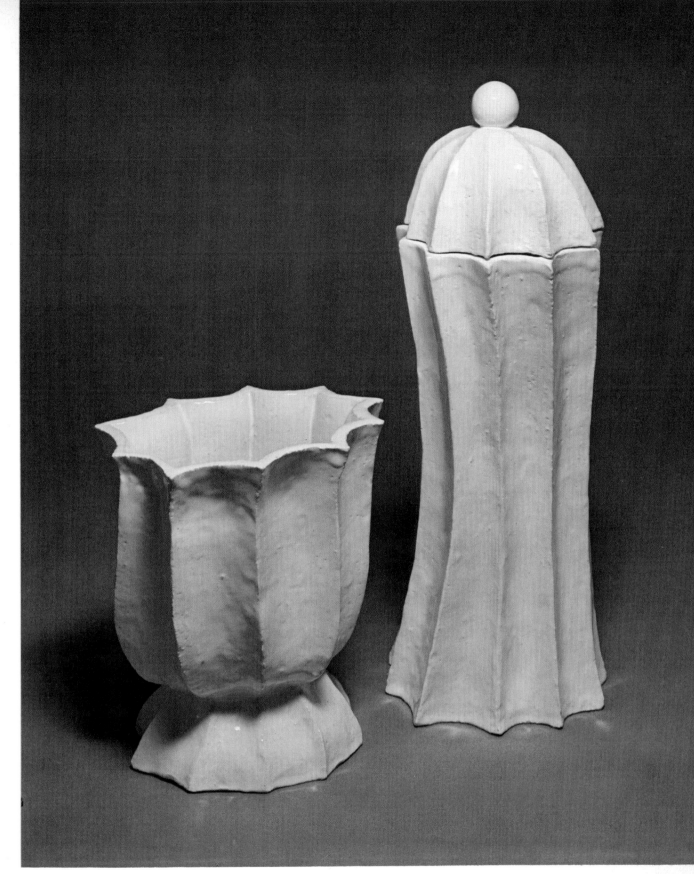

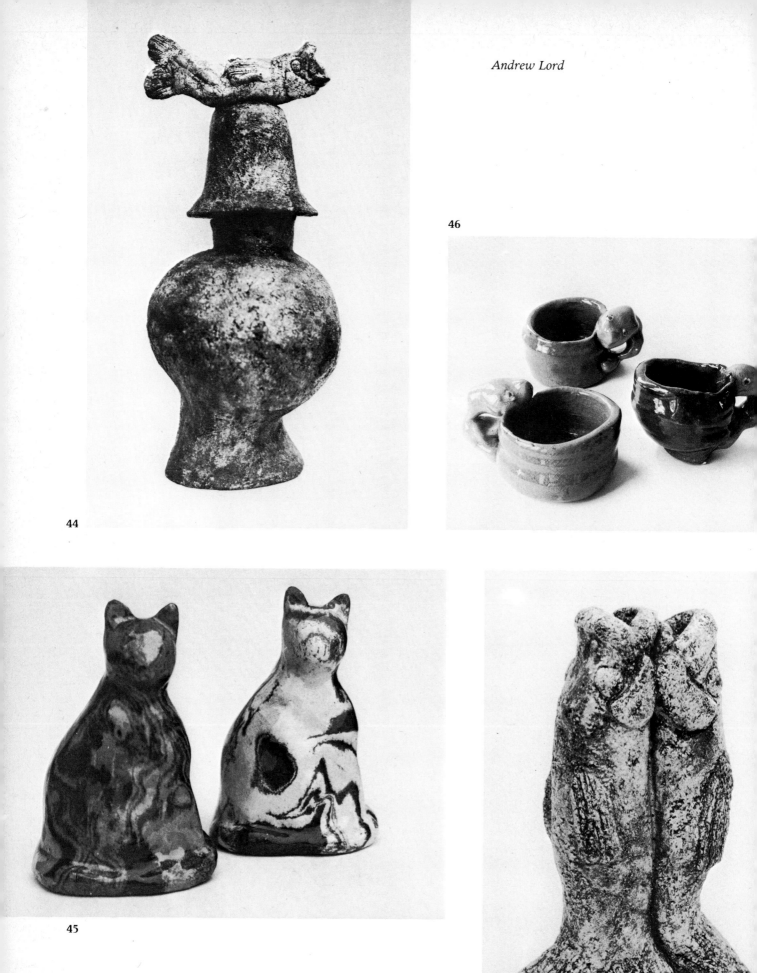

Andrew Lord

44

45

46

47

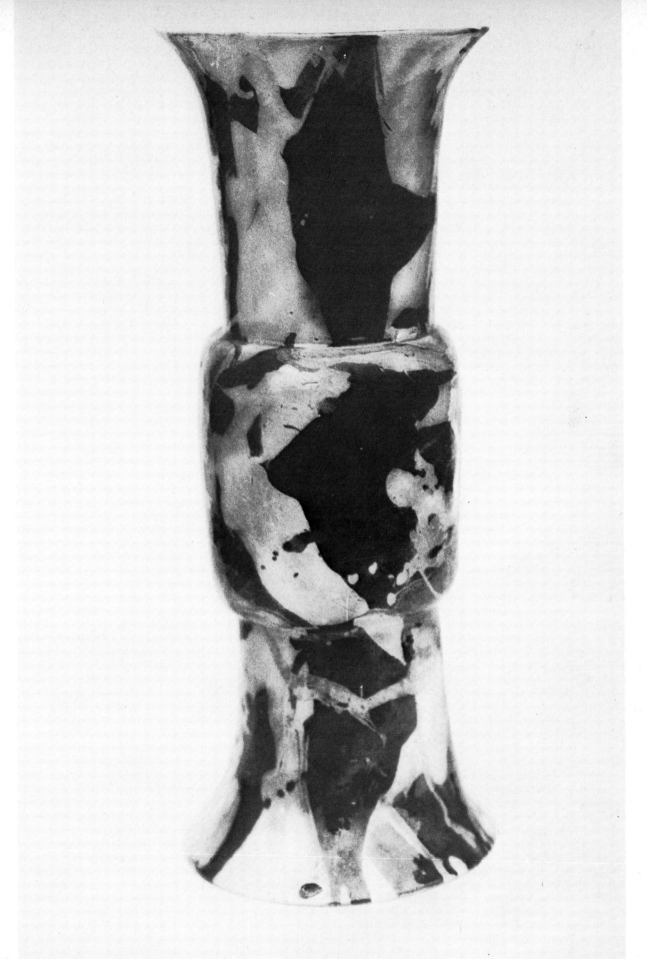

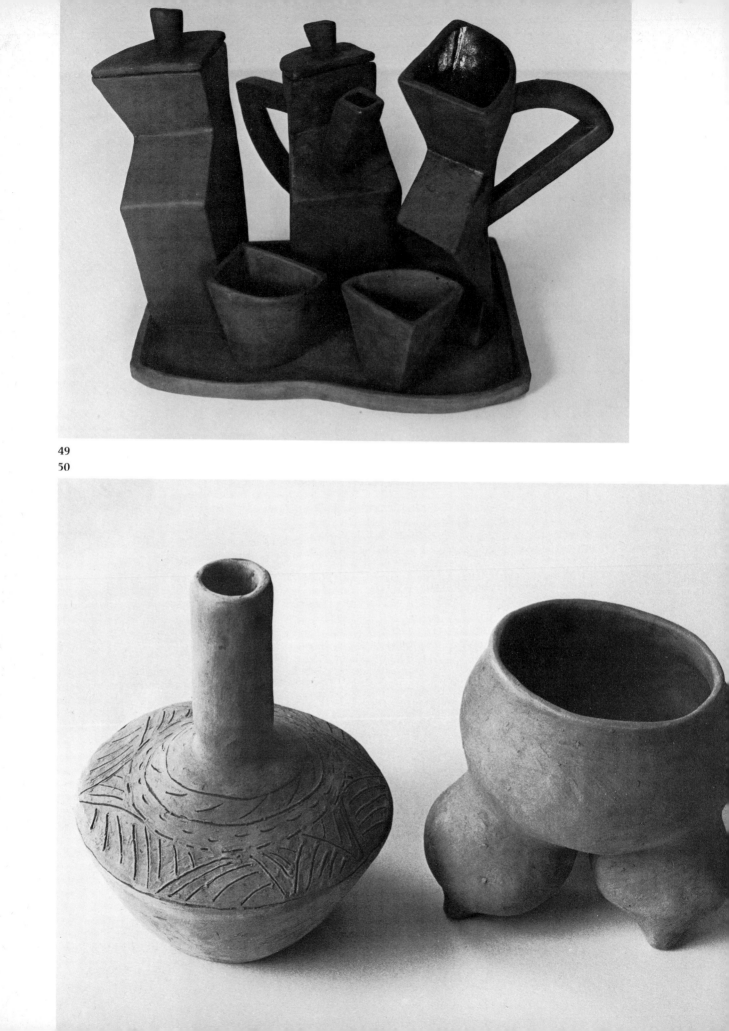

49
50

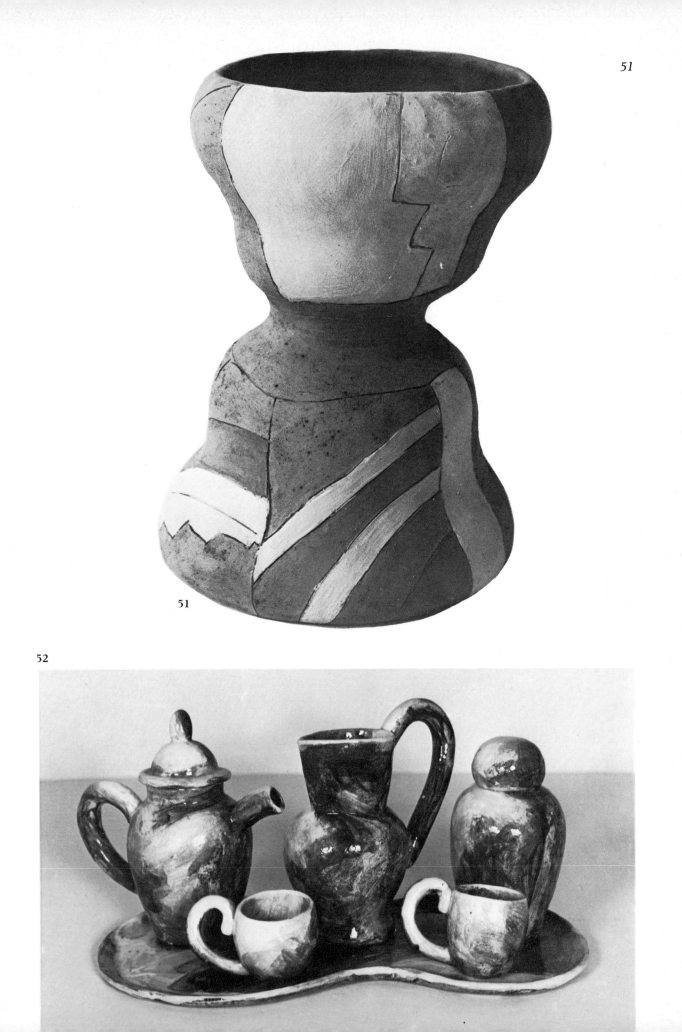

51

52

Bryan Newman

Bryan Newman is a lightly-built nimble man, but active and strong, and he needs to be: together with his wife Julia, and sometimes one assistant, he produces around 9,000 pots per year from the small studio pottery he established in 1966 in Somerset. A well organized and hardworking life is indicated, for there are less than 9,000 hours in the year, night-time included, and Bryan Newman is one of the most energetic of potters. The majority of work produced at Aller Pottery is domestic stoneware, robust but finely thrown tea and coffee sets, water jugs and lidded jars, steadily modified over the years, made of light-coloured clay, and economically and distinctively decorated with overlapping tongues of glaze by dipping and pouring.

The pots are fired in two home-built and designed oil-fired kilns: one single-burner kiln with 18 cubic feet capacity, the other a twin-burner kiln with a chamber of 55 cubic feet. There are twelve biscuit firings each year and twenty-four densely-packed glost firings. In amongst the tableware is fired the composite architectural pottery which has brought Bryan Newman world-wide fame since the 1960s, the result of his special skill in assembling thrown and slabbed units into intricate forms, once abstract and now more and more figurative as he explores the subjects that interest him most.

Bryan Newman, born in 1935, was trained at Camberwell in the 1950s, learning precision and fluency in throwing from the late Dick Kendall and his colleagues, and experimenting with glazes and kiln firing. He began teaching at Camberwell in 1958, when his own workshop was in Dulwich, London, and later taught at the Bath Academy of Art when he and his wife had moved the pottery to Somerset.

Here, in converted farm buildings stepped up a hillside, the pottery gives an impression quite strikingly Japanese, as the photograph opposite shows, although Bryan Newman is very little influenced by oriental pottery either in its form or the philosophy attached to it. He works too quickly to be a contemplative potter. His constructions, though finely finished, are the result of a helter-skelter flow of impressions, and he responds to a ceramic project which is also a physical challenge, such as making an outsize storage jar, capacity a hundred litres, with delight. He does not have an over-reverent respect for clay, nor does he claim any special affinity or affection for it, but he shares with Ruth Duckworth a deftness in the manipulation of clay which makes most competent craftsmen seem fumble-fingered.

His earliest composite pots were combinations of slabs and thrown pieces, often splinters of clay clustering round the tops of towers like iron filings on a magnet. Showing no respect for the pot as a container he made perforated structures and pots

with 'storeys' and stages like lifts in a mine shaft. Handling his clay in a drier state than many slab-builders, sober-sided shapes would be decorated with clusters of sharp fins like rusting clockwork or prickly vegetation. In 1960, for a memorable exhibition in London at the Craftsmen Potters Association, he produced fifty variations on the theme of a teapot, turning the thrown barrel at an angle, on its side, partitioning it off, doubling it up, flattening it and elaborating the handle into a complexity of thrown straps, as shown in Plate 57. Around the same time, he made several globular pots in which the form was distorted with string and cord so that the structure of the pot bulged out much as a building would do under similar stresses.

A series of large ceramic drums – real ones, with skin membranes across their mouths, tunable and playable – led to more pots echoing the shapes of certain musical instruments, and in particular their sound boxes. These in turn led to a distinctive taut arch form which recurs in his more recent work. Since 1970 his interest in the architecture of buildings and of ships has dominated the composite pots, with the occasional return to large decorated bowls as shown in Plate 59, and strapwork figurative wall panels. One thing has led to another. The instability of the early towers was replaced by rocking forms shaped like Egyptian boats or gondolas. The profiles of the boats are catenary curves, evocative of Bryan Newman's favourite man-made form, the bridge. His composite constructions became more unashamedly figurative and complex as he introduced architectural elements to the boat forms (see Plates 64 and 70) and clustered onion domes around tower slab forms (Plate 65).

Introducing the elements of townscape on to the basic boat form brought about the concept of the Ark, and a selection and combination of architectural motifs of different periods makes each work a microcosm of history, spanning in miniature perhaps a thousand years of invention and ornament. He envisages in clay an aggregation of buildings ancient at the centre and progressively more modern and high-rise towards the edges, but miniaturized, portable and unpretentious, without social comment.

He has made clay slices of townscape like Leonardo's plans for the ideal city and multiple arch bridges in clay which are both intricate and simple. His most baleful and haunting sculpture is almost completely plain: the multi-storey tenement building, gaunt and tall, as illustrated in Plate 72. This kind of sculpture, half toy, half symbol, lies awkwardly across contemporary trends in pottery. Like Ian Godfrey, Bryan Newman is open to the criticism of working to a formula, and too fast: a kind of ceramic tricotage. In this he has many imitators, and his work rises above theirs because of his sense of design and an essential humility. His ceramic assemblages are never designed to be important objects. They are the sculptural expression of an alert and enquiring mind.

Having given up teaching, thankfully, in 1973, Bryan Newman has punctuated lengthy spells of work with travelling abroad. In 1969 he visited the United States for the first time to give a 'workshop' course in Portland, Oregon. In 1971 he toured Canada giving pottery lectures and demonstrations from Prince Edward Island to Vancouver. He repeated this exhausting performance in 1975, but this time in Australia at the invitation of the Australian Crafts Council, giving workshop demonstrations in each state capital. Travelling on this scale gives him the opportunity to study architecture and folk art at first hand, and he chose to return from Australia to Britain westwards, via Japan and the Trans-Siberian Railway so that he could see Russian churches and villages en route.

He enjoys visiting potters in countries such as Hungary, where ceramics are not exploited as a high art form but developed as a folk art, attracting a simple response. Accordingly, he has steered clear of potters in America and countries where craftsmen are lionized. Although his own distinctive work as shown in this book is decorative and not functional, he is firmly attached himself to the clay roots of pottery as the maker of domestic tableware, and prefers to exhibit in group ceramic shows rather than to be a gallery virtuoso.

He has shared his own pottery with other artists for short periods. Perhaps fifty potters have worked with him and with his wife Julia at Aller, either as assistants doing everything from preparing the clay to providing thrown shapes, or working as potters in their own right. Bryan Newman does not want apprentices working for him and adopts a very democratic attitude in the running of the workshop. He always makes it clear to pottery helpers that their stay is temporary, for he sometimes needs to have the studio to himself for experiment or self-assessment.

New glaze tests go into most kilns, though most of his domestic ware uses a well-tried dolomite glaze underlain with oxides. His composite pots are usually covered with a dry stoneware glaze comprising potash felspar 20, whiting 40, china clay 80, plus 4 per cent colemanite and 5 per cent ochre. The warm-coloured result varies from burnt to raw sienna as the thickness of the glaze is increased, but nickel and copper and cobalt are often used to give Indian reds and greens, and manganese is sometimes wedged into the clay to give colour and dark flecks. His clay for composite pots is a mixture of Doble fireclay and ball clay with Diamond Clay Company saggar marl which contains pyrites and gives metallic spots when fired to stoneware temperatures.

Bryan Newman's work first became known when he exhibited at Henry Rothschild's gallery Primavera with Ian Auld in 1964. He has exhibited in numerous exhibitions in London including the one-man show of teapots in 1970, and also in Cambridge, Stratford, Munich, Hamburg, Geneva, Copenhagen, Tokyo, San Francisco, Sydney and Melbourne. His work is to be seen in public collections including the Victoria and Albert Museum, London and the Inner London Education Authority.

54 Slab form This pot has no base and has no use as a vessel, but there are two platforms, visible in the photograph, in the upper part of the pot.

The seals and stamps, and the holes which pierce the slabs, were put in before the slabs were cut in order to preserve the crispness of the main shape, and the pot was assembled with the slabs harder than usual for the same reason. The striated surface on the lower face, dark side, is made by a twisted wire, used for cutting the slabs.

The pot is unglazed, and has a uniform dull purple colour from oxides wedged into the buff body, including 4 per cent manganese dioxide. 18 in. high, 1,280°C oxidized.
Collection of the artist

55 Composite pot Bryan Newman describes this pot as *'the only worthwhile pot I've ever made while teaching'*. It underwent a complete metamorphosis in the making. It was started as a slab pot; next the horizontal fins were coiled on; coils were then added at the bottom (so that the 'base' comes half way up) and then the fins were beaten and cut.

The pot has three glazes over a coarsely grogged body. The dark iron glaze inside is shiny. The upper part of the outside has a whiting-ochre glaze, greenish and matt. Below the unglazed band, the bottom is covered with a lighter, creamy ash glaze. 6 in. high, 1,280°C reduced.
ILEA Circulating Collection

56 Standing forms Bryan Newman likes to make the contrast between a simple, undecorated stem and a frenzied, spiky top. These two menacing shapes like watch-towers are made out of four slabs, textured lightly with a bamboo comb. Where the holes and barbs appear, the construction is from thrown forms, cut square. A trough-like section of a thrown cylinder is placed horizontally on the top of each pot. The horizontal barbs are cut sharp and joined to the main body with slip. Both pots have a uniform colouring of manganese oxide and red clay painted over buff body. 22 in. and 24 in. high, 1,280°C oxidized.
Collection of the artist

57 Teapot fantasies Apart from the wedges that keep the barrels from rolling over, all the parts in these fantasy teapots are thrown. The smaller pot in the foreground is coated with Indian red slip but glazed inside. The forward disk under the handle is a removable lid, so the teapot can be used if desired. The larger pot abandons function. The body consists of two barrels set end to end, so there was a central partition to give the pot strength in the kiln. The screen-like 'handle' is made from strips of shallow thrown cylinders, and there is no lid. It has a dry glaze containing copper and cobalt – dark green where it is thin, ochre coloured where thick. 7 in. and 12 in. long, 1,280°C reduced.
large pot: Collection of the author
small pot: Private collection

58 Round pot Thinly thrown in dark clay containing white grog, this globular shape was then immediately tied in string soaked in white slip, so that the shape bulges out like a balloon under the strain, but does not collapse because of the inherent strength of the near-spherical shape. When dry, the pot was dipped top and bottom into two different engobes, colouring the base Indian red and the top grey green (with copper and nickel), leaving a bare midriff. In the kiln the slip in the string fused on to the top under the engobe, and fell away from the unglazed sides. The photograph shows the pot actual size. 3 in. high, 1,280°C once-fired, reduced.
Collection of Leslie Birks-Hay

59 Bowl This heavy but shallow bowl was glazed with a semi-matt opaque white glaze of china stone 50, dolomite 20, china clay 25, whiting 5 and quartz 15, then painted in wax with the tree and bird design and the hatched border. The linear design was then scratched through the wax and an iron oxide/china clay pigment painted over the whole surface on the wheel. The design details were then reinforced with black pigment containing iron oxide 4,

cobalt oxide 1, china clay 4. 18 in. diameter, 1,280°C reduced.
Private collection

60 Apple pot This tiny pot is like a cycladic toy, made 4,000 years ago. Its two disks were combed with a bamboo comb on the wheel before being stuck, still wet, on to the sides of the pot. The top was twisted askew. The uneven rusty colouring is the combined result of manganese in the buff body and a thin coating of glaze made simply from 50 per cent ash and 50 per cent china clay. 4 in. high, 1,280°C reduced.
ILEA Circulating Collection

61 Composite pot The thrown stem has no base. The central shape is a hollow globe extended with a long but solid 'tail' to a broad disk (dark, on the left of the photograph), and attention is drawn to the concave outside profile of the tiny repeating shapes which lie across the pot's back. Some of the disks are scored with a bamboo comb. As in Plate 60, the rusty surface is the result of a thin coating of ash and china clay glaze over buff body containing manganese oxide. 9 in. high, 1,280°C reduced.
Private collection

62 Composite pot The many thrown pieces which make up this pot were cut from thrown cylinders to expose the rapid throwing lines on the inside surface. In order to keep the razor-like edges, the cylinders were allowed to go quite hard before cutting. The throwing lines are accentuated by the ash glaze which turns yellow where it is thick, brown where it is thin. 11 in. high, 1,280°C reduced.
Collection of the artist

63 Siberian village This slab-made catenary rainbow of dark brown clay, with small holes drilled in inconspicuous places to let the air out, is crowned with a village of solid clay pieces, and one house slides down the side. The top surface of the arch has a pattern of incised lines. It was glazed by pouring with a dry whiting glaze, pale lemon in colour, and the two feet dipped into a blue pigment to darken the ends. The pot was fired on its side to prevent collapse or distortion. 20 in. long, 1,280°C reduced.
Collection of the artist

64 Ark This pot, made towards the end of a long series of slab-built boats with architectural superstructures, the artist intends to keep permanently in his own collection. The two sides of the hull contain the same square-cut holes, for they were cut in a large block of clay *before* the slabs were sliced with a wire bow, but they are out of phase in the finished pot so that light can be seen straight through the pot only in certain positions.

The observer, like Gulliver, has to make a quantum jump of scale from the windows in the hull to the windows in the houses, though he may not notice it. Bryan Newman's slab-cut houses are expressive with extraordinary economy of detail. The top two thirds of the pot are glazed with a dry whiting glaze, overlapped by a shiny dark brown iron-rich glaze on the bottom part, like many a hulk. 10 in. long, 1,280°C reduced.
Collection of the artist

65 Citadel with onion domes *Architecture without Architects*, by Bernard Rudolfsky, has introduced Bryan Newman to the accidental agglomerations of buildings over time, and he mixes architectural elements from different times and cultures in tall slabbed citadels with thrown detailing. All the faces of the buildings are unique, though usually with openings near the bottom, and gouged designs. The citadel shown was glazed all over with a dry blue glaze of ash 40, china clay 50 and 2 per cent cobalt, and a dry whiting glaze was then poured over and in some places flicked on to the surface by hand. 18 in. high, 1,280°C reduced.
Collection of the artist

66 Slab box Designed like the sound box of a stringed instrument, this slab box is no resonator, but its details suggest frets and intervals. With a hole in the rear it was designed to hang on the wall, but it also stands, or rocks when on its back. It was coated with 20 per cent cobalt/ash mixture, then glazed all over with whiting glaze. 13 in. high, 1,280°C reduced.
Collection of the artist

67 Composite sculpture At least forty tiny thrown shapes are combined in this form. The shapes have been cut to show the insides of the cylinders. The material is white clay, glazed all over with a single glaze containing tin and iron, yellow where it is applied thickly. 12 in. long, 1,300°C reduced.
Collection of Geoffrey Monk

68 Two pots Both pots have a thrown shape underneath pieces of thrown pots applied to their surfaces while still damp. The smaller pot seems like a ripe chestnut, bursting open its outer case. The traditional shape of the taller pot is accentuated by the cladding on its shoulder, and this pot was squeezed oval after throwing.

Both pots are partially glazed, the smaller one with an iron-rich felspathic glaze, the taller pot with the same glaze inside and a whiting glaze outside. The dark diagonal striations are caused by the variation in the colour according to thickness, and correspond to throwing lines. The dark colouring of the body comes from manganese oxide wedged into the body. $4\frac{1}{2}$ in. and 7 in. high, 1,280°C reduced.
small pot: ILEA Circulating Collection
tall pot: Collection of the author

69 Standing form This is a composite form made from three thrown pieces. The method of construction is simple: it is distinguished by the skilful handling of the clay while still wet. The thrown stem has no base; the opening of the central portion was broken and folded while the pot was still on the wheel. Afterwards, its base was turned so that the finished form has a bullet-like rear. The mushroom on top was folded up immediately after throwing. A single glaze is used all over, based on Daniel Rhodes's dolomite glaze No. 32. 11 in. high, 1,280°C reduced.
Private collection

70 Boat with minarets A slab-built gondola shape with superstructure of slab-built houses and thrown minarets. It is glazed with a dry whiting glaze, creamy coloured. 10 in. long, 1,280°C reduced.
Collection of Mrs Mavis Bland

71 Bridge section Slab built, the rhythmical arches each have a seal of clay stuck on at the centre. The houses, churches and tree are cut from slabs, and all is glazed with a dry blue glaze. 16 in. long, 1,280°C reduced.
Private collection

72 Tenement block *'I used to do a paper round up twenty-one blocks like this when I was fourteen, and there were no lifts.'* Windows are cut through a thick block of clay, and the slabs then sliced from this so that there is a degree of conformity between the faces, though near the bottom of the block the windows are smaller, or not completely pierced. The tiled roof and chimneys are carefully detailed but the walls are left bare. A dry whiting glaze is thrown and dribbled on, and the colour is ochre to brown where the glaze is thin. 19 in. high, 1,280°C reduced.
Collection of the artist

54 55

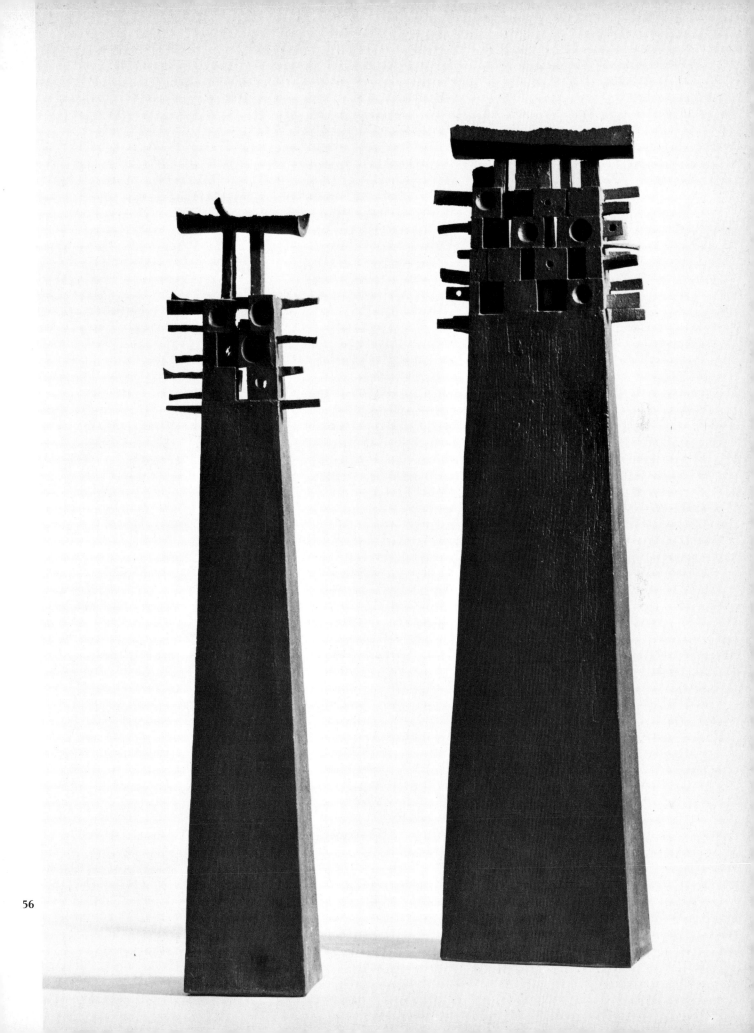

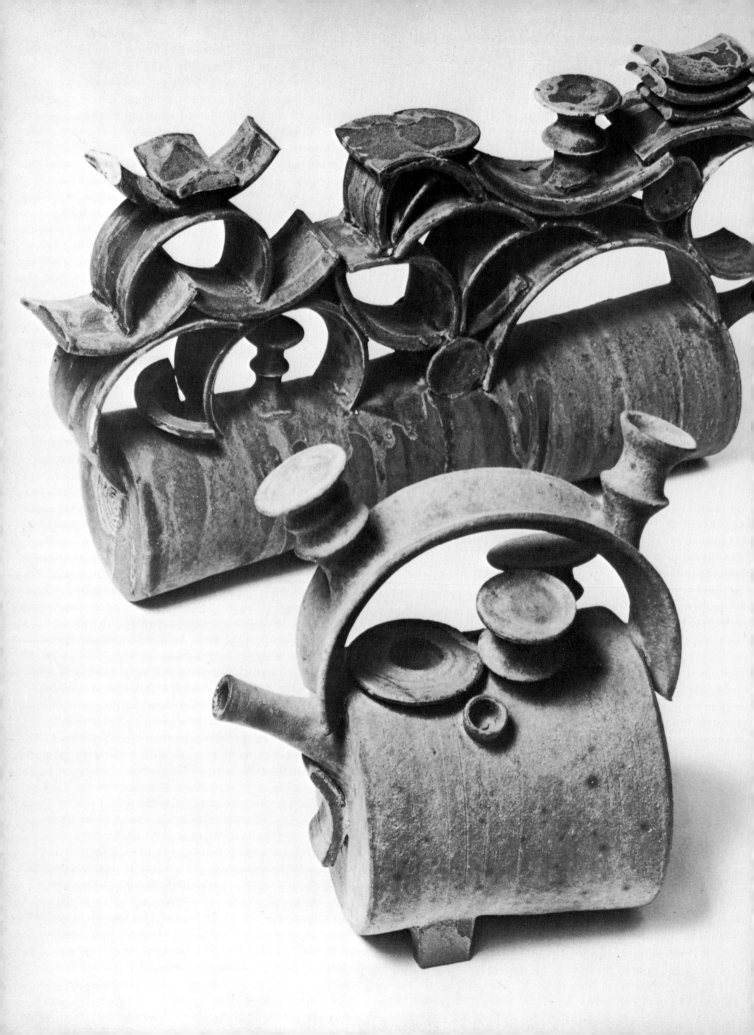

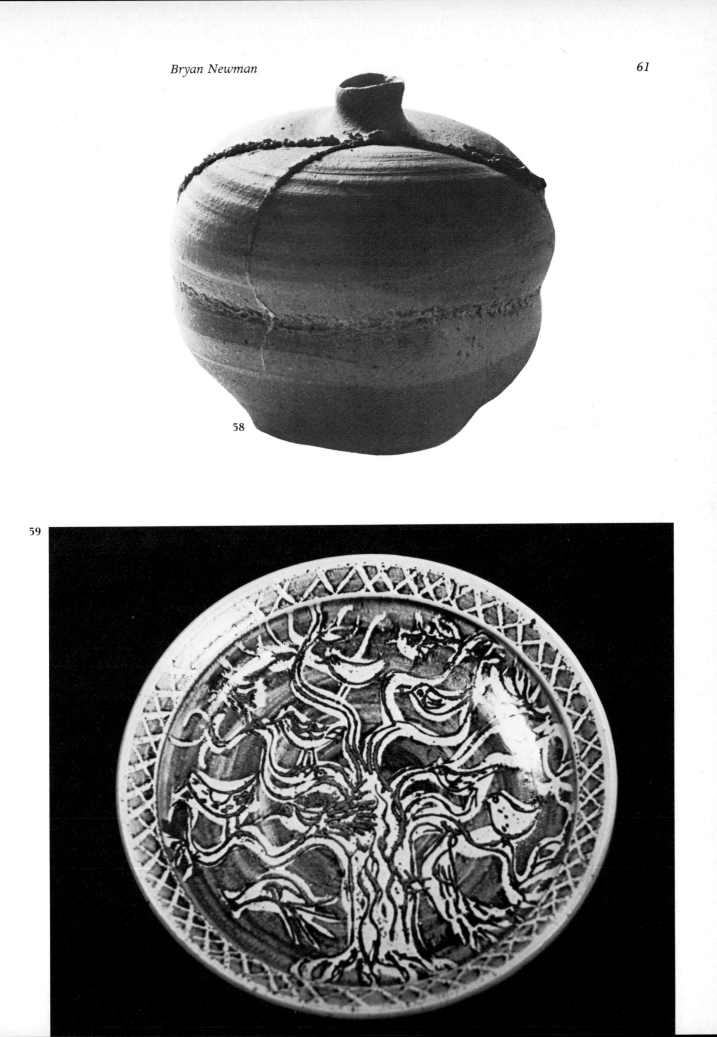

58

57 59

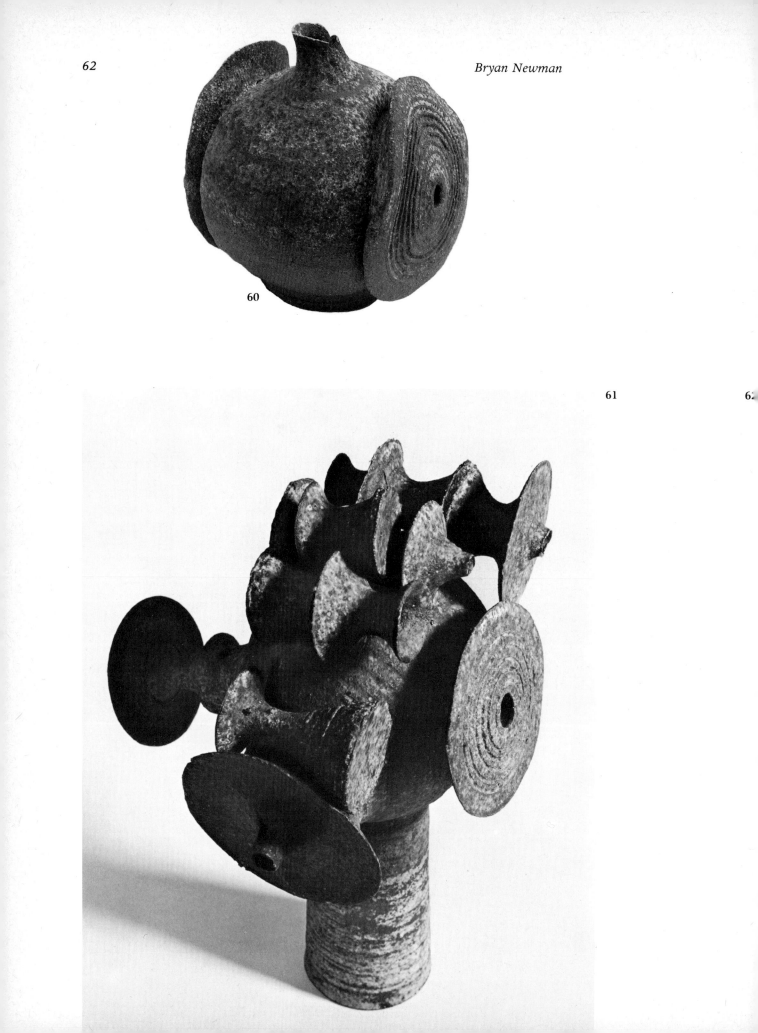

60

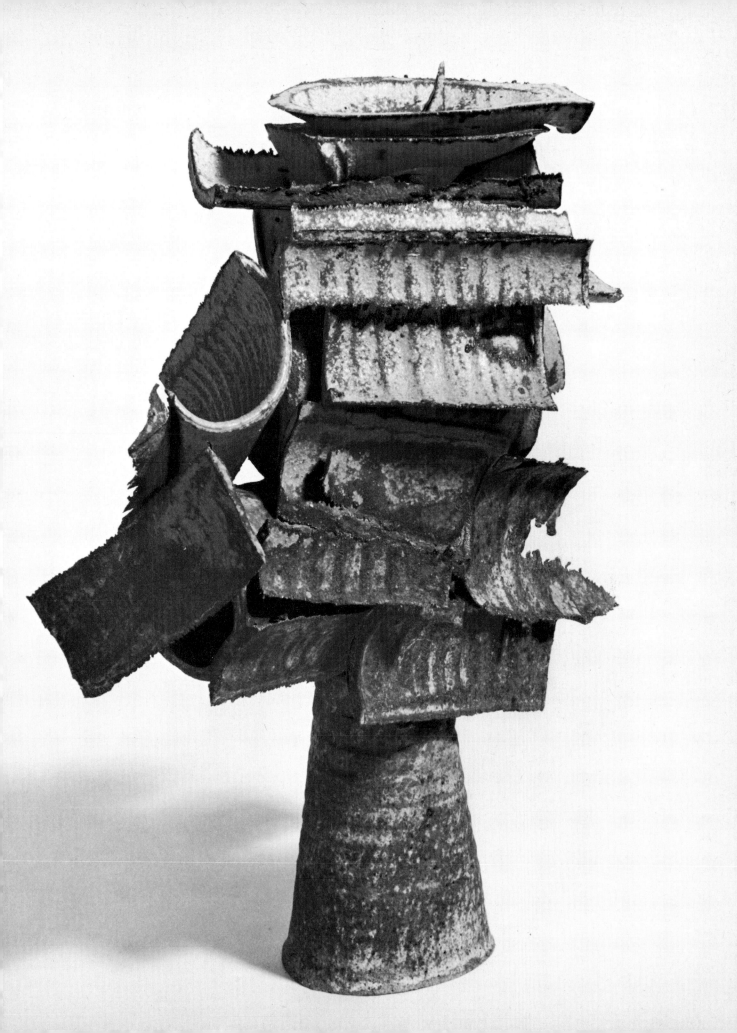

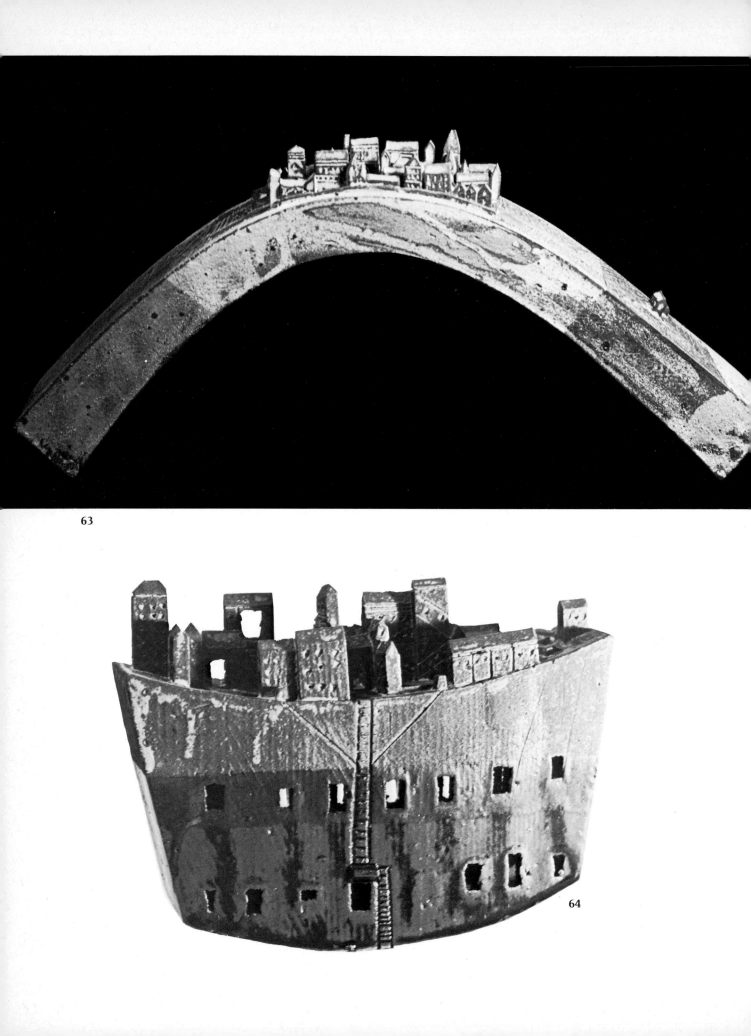

63

64

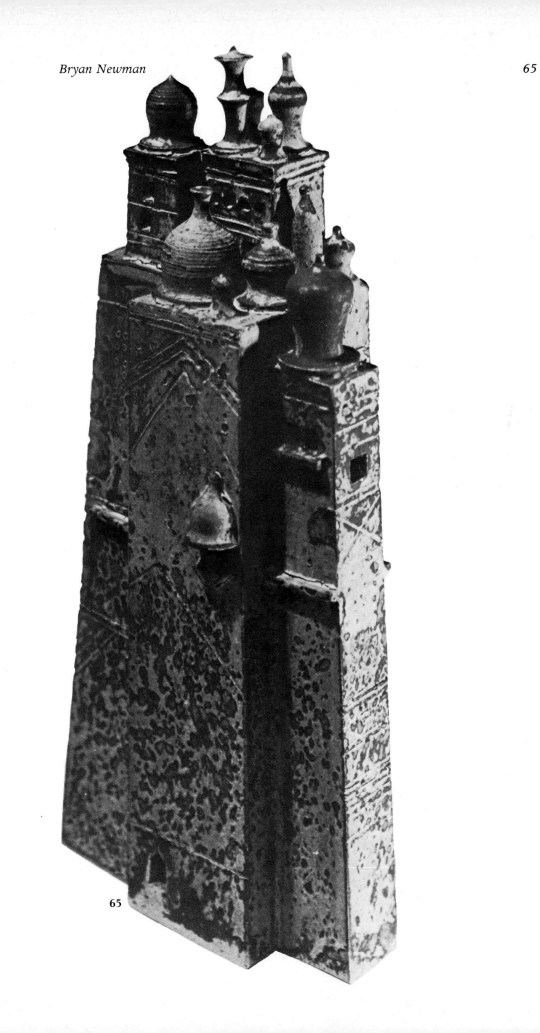

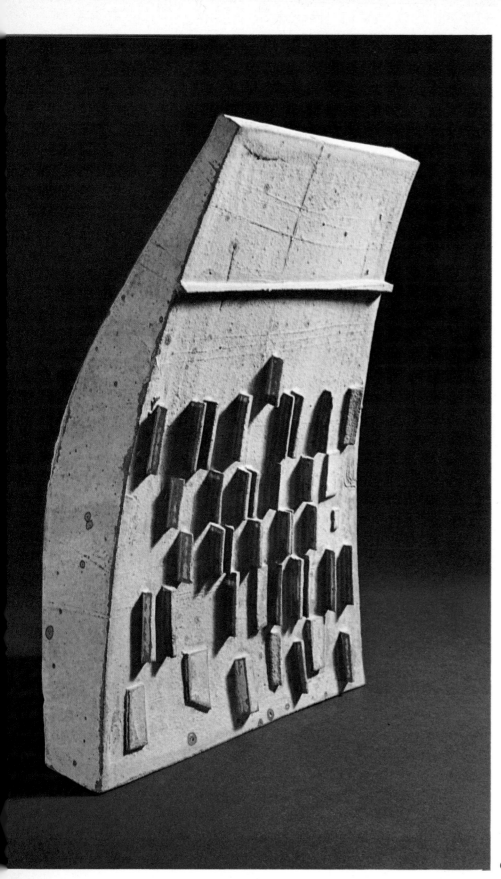

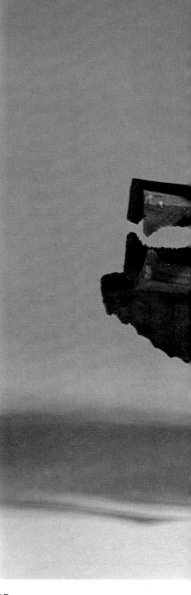

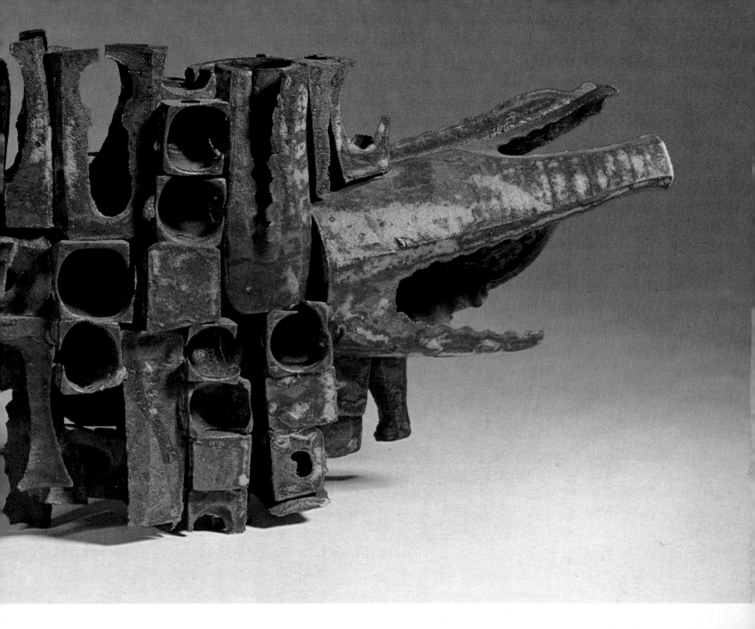

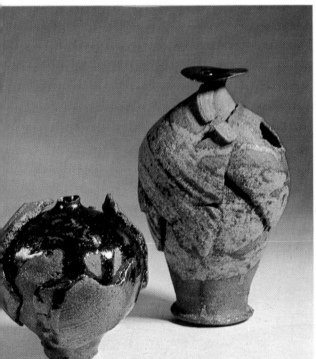

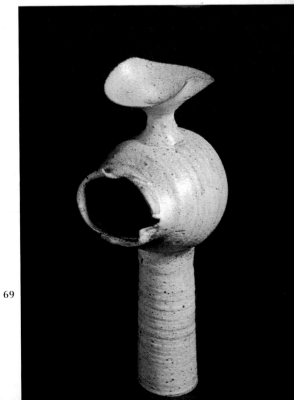

68

69

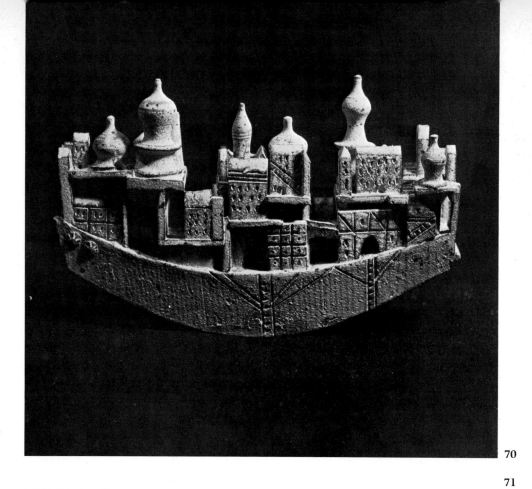

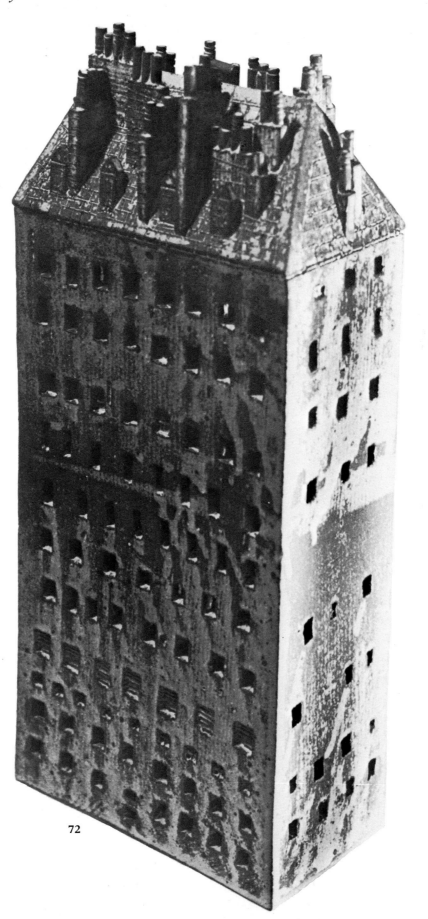

72

Hans Coper

Hans Coper's pottery stands alone in twentieth century ceramics. At ease amongst great pottery of all ages, it relates more to the present and to the future than to the past. It shares with ancient Mediterranean pottery a relentless refinement, and with oriental ceramics a search for perfection and rightness, but it carries with it the spirit of the modern world. It is sculptural yet functional, abstract yet endowed with human qualities both in shape and mood. Plain in surface and uncompromising and clean in profile, Hans Coper's readily recognized black, cream and white ceramics have a precision and intensity which make other potters' work appear clumsy and crude.

Hans Coper was born in Germany in 1920. He was being trained as an engineer, but had already become preoccupied with painting and sculpture when he left for England in 1939. His first contact with pottery came in 1946 when he went to assist Lucie Rie in her London studio. Gradually, and unexpectedly, he began to find that pottery encompassed the particular problems which he had found most challenging in sculpture. He did not turn to pottery as a substitute for sculpture, and feels, like many other potters, that there is very little connection between the two. For him pottery is the opposite extreme as an art form – an accumulation of sensations and not an expression of emotion.

Many potters delight in clay as an expressive medium, and make full use of its versatility. Hans Coper uses clay simply as a consistent means of interpreting three-dimensional relationships. What fascinates him about clay and its ceramic product is its timeless quality. Through the ages it has linked man with his activities and his environment and provides a continuous thread connecting the past and the future. From its very durability, pottery-making is a very daunting project – in an age of expendability one is making today the litter of tomorrow – and non-functional pottery needs to be very good indeed. Hans Coper feels that in making ceramics that are not for everyday use, there is no excuse for making anything which is not to the highest possible standards. He believes that in attempting to meet aesthetic criteria a potter is justified in making individual pieces, and by so striving can avoid the absurdity of being a craftsman in the present day. This view and his avoidance of experimental work for its own sake binds him closely to the oriental philosophy of pottery, and he admires many oriental pots, including the work of the great Japanese potter Hamada; yet his own work shows very little direct oriental influence and his limited range of shapes and surfaces is purely personal.

His early pottery consisted of small but heavy stoneware shapes, often boldly

decorated with painted and incised designs, jagged and violent, reminiscent of Nigerian and South American decoration. It has changed, and for the last quarter of a century he has concentrated on the pottery which interests him most – lighter forms which are constantly refined and modified. Since the problems which preoccupy him are insoluble questions of form, colour and texture relationships, he has deliberately narrowed his range, especially of surface qualities, and his efforts become more concentrated. He has abandoned all painted decoration, uses one clay and one glazing formula and the simplest possible techniques. His pots always have an opening at the top and a glazed surface inside. Although few are designed to be functional flower vases, Hans Coper feels that the action of putting flowers or branches into them links them with their traditions and emphasizes the humility of pottery by comparison with sculpture. He also appreciates the way in which pottery resolves for itself the problems of scale. For technical reasons a pot cannot be infinitely large, and if it is very small, whatever qualities it has will be concentrated and not lost.

Hans Coper is aware that many people think that to concentrate always on the same basic thrown shapes could become boring. His pots are like beads on a rosary. Although he returns again and again to half a dozen basic shapes he is not undertaking mindless repeat throwing. Each pot is intensely individual, and is made with the dedication of a violinist who tries to come ever closer to a perfect sound by practising, but is never satisfied with the result.

Like Lucie Rie, he uses a continental-type wheel, foot operated, with a large wooden flywheel. He enjoys the control it allows and all his pots are either thrown or composite, made from thrown pieces. Sometimes he cuts a thrown form in two and reassembles it with the insertion of one or more thrown pieces, in this way helping to preserve a flow which is often lost in a composite pot. Often he will add a flange or disk by throwing out from a coil of clay added to a leather-hard pot (Plate 82). Some of his large pots, swelling from a small base to a wide rim, or tightly collared in with a horizontal disk top (Plate 83), are thrown in several stages; the lower half is allowed to dry and the upper part is thrown up from a coil when the base is leather hard. Fascinated by shapes on very tiny bases, he has attempted to solve the problem of getting them to stand up by fixing several together, so that they help to support one another, or by cementing them on to blocks of clay which give them stability. He makes pots in batches, but when pots demand two thrown pieces, as in Plate 75, he will make bases and tops specifically for each rather than throwing a number of pieces and assembling them afterwards at random.

There is inevitably experiment involved in making new shapes, but Hans Coper prefers to digest forms thoroughly before producing finished pots, and never allows pots to emerge from his studio until he has made many examples of an archetypal shape. He does not try to make new glazes or body mixtures and deliberately eliminates the surprise element of accidental decoration. His dark pots are coated with manganese oxide and burnished. The surface which he applies to his light-coloured ware is a series of layers of white slip and manganese oxide, put on with gum arabic to the outside of a bone-dry pot. With such concentration on a single if complicated technique only minor variations of surface and texture can occur and he is therefore able to bring about subtle changes of colour and surface with considerable control. Like a worker in silver or in mahogany, he knows what his material will look like when it is finished, and he concerns himself with shape and scale.

Hans Coper's technical expertise with clay has been used in co-operation with architects to produce various types of specialized brick. These were designed for their acoustic qualities, but have also been used for decorative purposes. He has also co-operated with architects in providing free-standing ceramics within buildings, as at Coventry Cathedral and Sussex University, but prefers to tackle the more familiar abstract problems of design provided by the pots themselves.

Hans Coper has taught pottery both at Camberwell College of Art and the Royal College of Art, but on leaving London to work in Somerset in 1969 he reduced his teaching commitment and stopped altogether in 1975. He works extremely hard, and alone, preparing batches of pottery for exhibitions in Britain and abroad and for which there is a constant demand. The clay he uses is a mixture of which the principle ingredient is white refractory 'T' Material, with its well known granular texture. All his pots are once fired to 1,250°C in an electric kiln, and are glazed inside with a clear glaze over manganese oxide to make them watertight. Because the final surface takes so long to prepare, many of his pieces are in work for some time. The particular and painstaking technique of applying layer upon layer of similar materials gives the surface depth, variety and above all luminosity. However small his pots, they are objects of dignity and presence, and he is one of very few creators of ceramics of real worth for future generations.

Since 1950, when he first exhibited in the Berkeley Galleries, London, Hans Coper has shared five exhibitions with Lucie Rie, in Britain, America, Holland, Germany and Sweden, and has held five one-man shows in New York and Britain. In addition, he was invited by the Victoria and Albert Museum in London to share a major exhibition with Peter Collingwood in 1969, and has participated in major ceramic exhibitions throughout the world including the International Exhibition in the Keramion in Frechen, Germany, in 1976.

The artist's work can be seen in public collections in Australia (Melbourne), Canada (Toronto), Holland (Amsterdam and Rotterdam), Sweden (Stockholm and Gothenburg), Switzerland (Zurich), United States (Detroit, Minneapolis and New York) and Britain (Bristol, Leicester and the Victoria and Albert Museum, London).

74 Vase The photograph shows the pot actual size. Inside the shape is a small thrown cylinder to confine flower stems and help the arrangement of flowers. The rim is squeezed to an ellipse, and four symmetrical dents are made, two on each side. The textured surface has dominant diagonal striations, all around the pot, which has a very thin coat of slip. 1972. 7½ in. high, 1,250°C once fired.
Collection of the author

75 Standing form This is made from two thrown pieces, pinned and glued with Araldite to a solid base of clay. The lower section is squeezed at the top and turned after squeezing so that the profile is true and the top line of throwing shows like a belt. The inside is glazed, the outside coated with manganese and burnished. 1975. 9 in. high, 1,250°C once fired.
Collection of Lucie Rie

76 Black pot This hard-edged shape was thrown in two pieces and joined at the deep central groove. The pot is turned throughout to give a hard profile, and made with clay containing manganese oxide, burnished to give a dull sheen on a dense black surface. 1967. 6 in. high, 1,250°C once fired.
Boymans Museum

77 Standing form The top of this pot is a thrown cylinder, squeezed flat and sealed at the base. The envelope shape is supported by another thrown cylinder. The thick surface painting almost obscures the incised lines top and bottom. 1967. 6 in. high, 1,250°C once fired.
Collection of Miss B. de Neeve

78 Vessel Waisted and indented symmetrically, this large pot still gives the feeling of being round as a bell. The slip coatings are relatively thick and white near the top. 1975. 11 in. high, 1,250°C once fired.
Private collection

79 Vase on base Two intersecting thrown forms, squeezed, assembled, and turned to a point. The upper part is a bowl squeezed to a tight ellipse. It is inserted into a tall cone, but this is also squeezed nearly flat at the top, so that the centre point sticks out sharply on both sides, and when viewed from the side the profile is unexpectedly different. The base to which it is glued and pinned is heavy to keep it stable. 1976. 9 in. high, 1,250°C once fired.
Collection of the artist

80 Group of tall pots Hans Coper has made many pots of this shape, varying the relationship of top to base, and varying the total width in relation to the waist. Each pot is made in two pieces, joined at the narrowest part. The insides are matt black throughout. Nothing interrupts the grace of the forms. They are beautiful even if turned upside down. 1966. 11 in. to 17 in. high, 1,250°C once fired.
Collection of the artist

81 Standing form This tall pot, thrown in one piece and turned, is an arresting image. The central groove is on one side only. 1967. 11 in. high, 1,250°C once fired.
Collection of Mrs D. Kuyken

82 Stoneware cup A favourite shape from 1966, this cup is made in two pieces with a flange thrown out from a coil at the join when the rest of the pot was leather hard. The pot in the photograph shows a wide brush mark of white slip at an angle down the pot. 7 in. high, 1,250°C once fired.
Private collection

83 Stoneware bottle This bottle was thrown in two stages, the flat disk top being added when the pot was leather hard. In this example of a well-known shape the manganese oxide on the top is covered with a thicker glaze than usual, making a fine counterpoint to the rough texture below. 1965. 8 in. high, 1,250°C once fired.
Collection of W. Ismay

84 Vessel Round at the base, squeezed like a blunt chisel at the top, this pot has an added cylindrical neck and a flat disk top thrown out from a coil. With some animals, inbreeding improves the race; likewise with Hans Coper pots. This one is the ultimate in the line. Painted with manganese oxide and burnished. 1972. 6 in. high, 1,250°C once fired.
Private collection

85 Three standing forms Each of these symmetrical shapes consists of a cylinder base, two identical thrown disks, and a bowl squeezed flat and cut to make the wide open top. These pots are tense and taut, tuned like a musical instrument. Later versions of the shape have a wider top and taller stem. 1965. 6 in. to 8 in. high, 1,250°C once fired.
left and centre: Private collections
right: Collection of Miss Muriel Rose

86 Stemmed vessel Made in two parts, the pot has two dints on each 'side'. 1975. 10 in. high, 1,250°C once fired.
Private collection

87 Two vessels These two pots epitomize Hans Coper's work in the early 1970s. The barrel base to the small pot is slightly convex – it later becomes concave – and the mouth is elliptical – it later becomes squared off (see Plates 88 and 89). The taller pot shows a transformation from the pots on Plate 80. Both pots have deep marks from a turning tool, some horizontal, some spiralling. The surface is burnished manganese. 1972. 6 in. and 11 in. high, 1,250°C once fired.
Private collections

88 and 89 Two-piece vessels Where the two thrown units are joined, the lower one has a slightly dished top, more sensitively to accommodate the squared-off bowl above. In the lighter pot, this concave ring is darkened and emphasized with manganese. The black pot is burnished, its patina greenish-grey. 1976. 5 in. and 7½ in. high, 1,250°C once fired.
Collection of the artist

90 Standing form This pot is made in two pieces, the upper one squeezed and scored. Almost without any manganese darkening on the outside, the pot is thickly coated with hard white slip, polished and luminous like a gannet's egg. Made in 1975, it is slimmer and lighter than the shape shown in Plate 81. 10 in. high, 1,250°C once fired.
Private collection

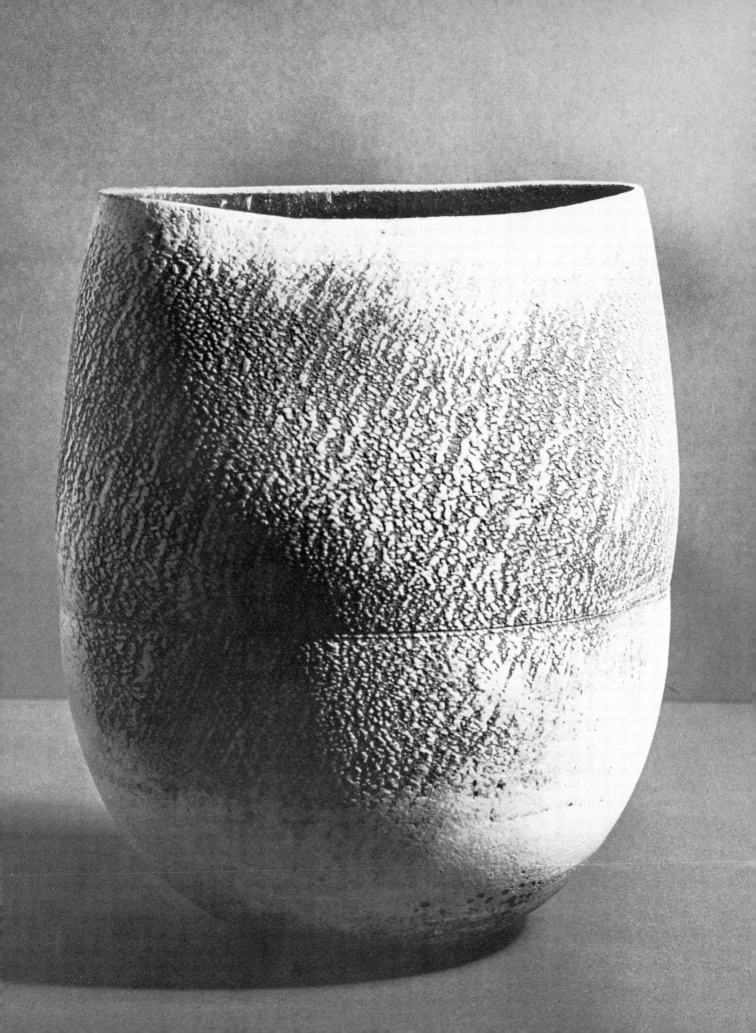

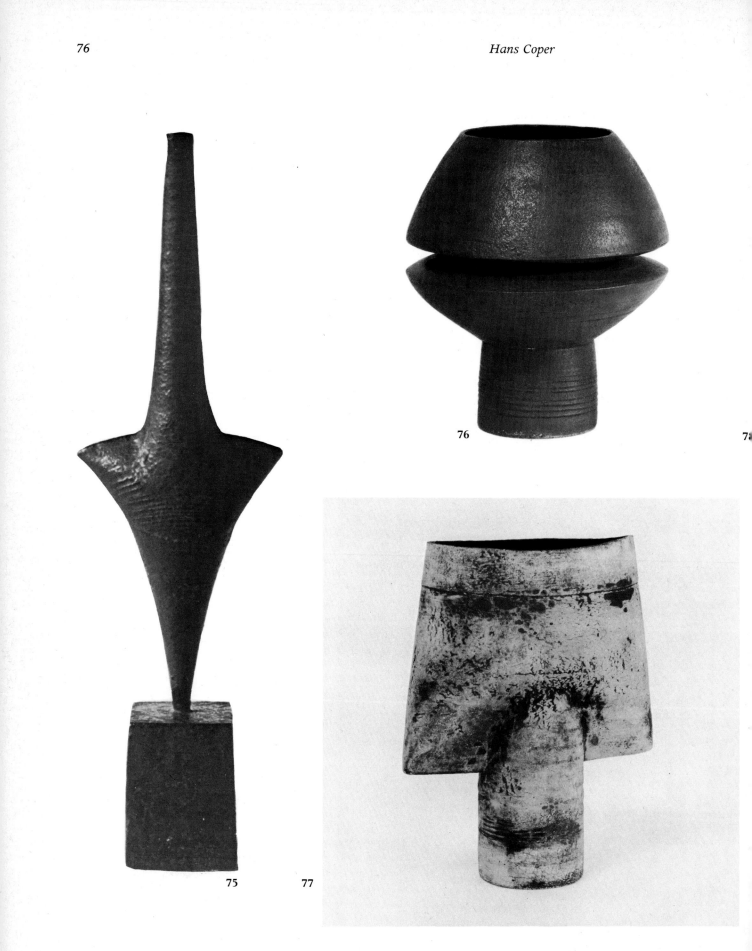

76

7

75 77

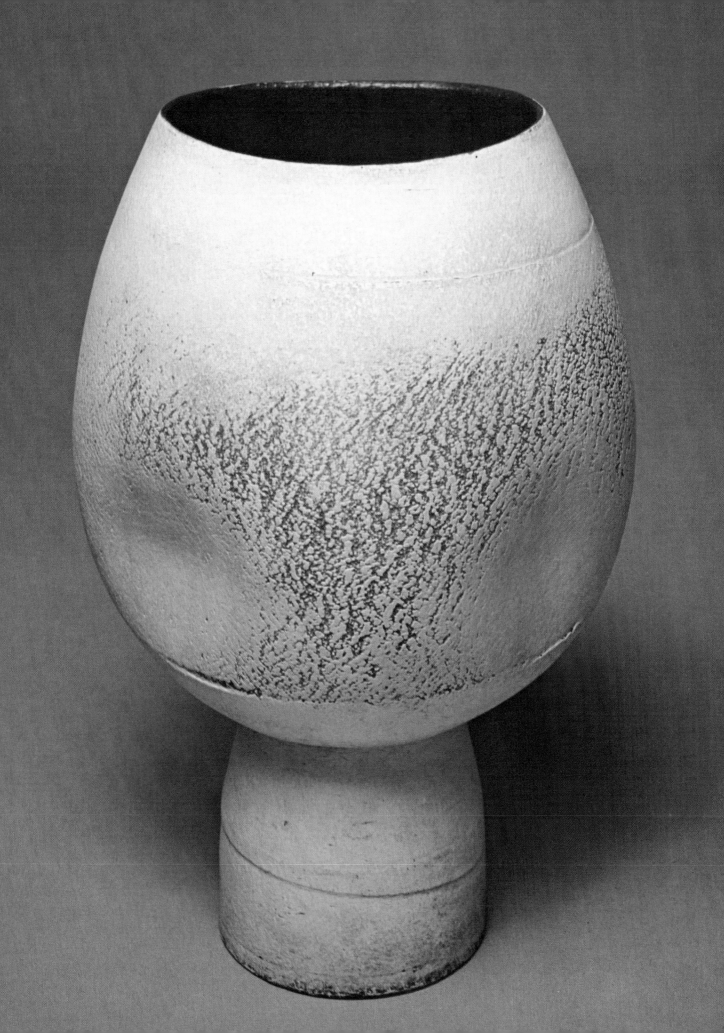

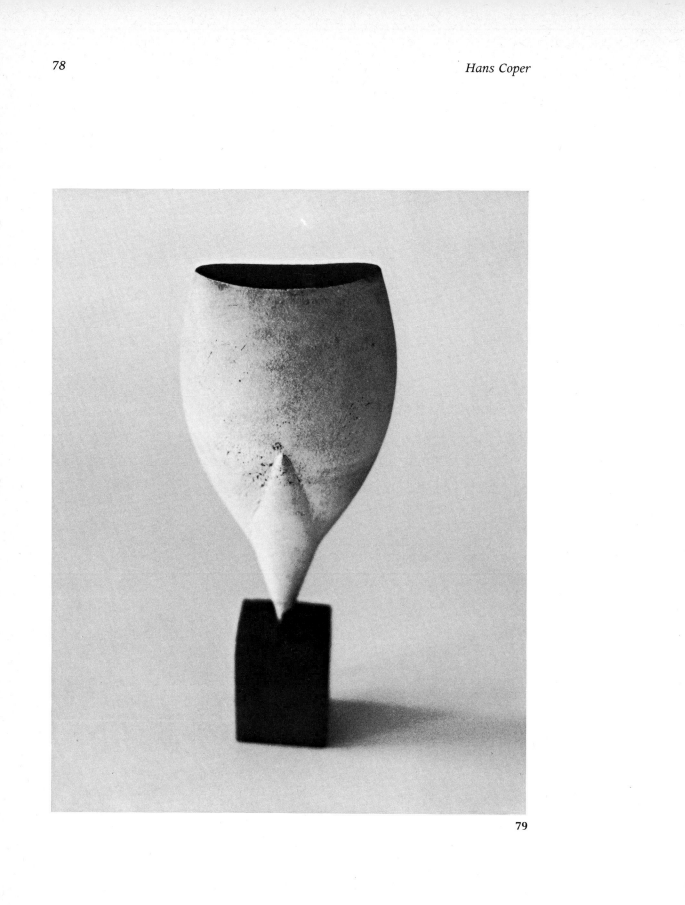

79

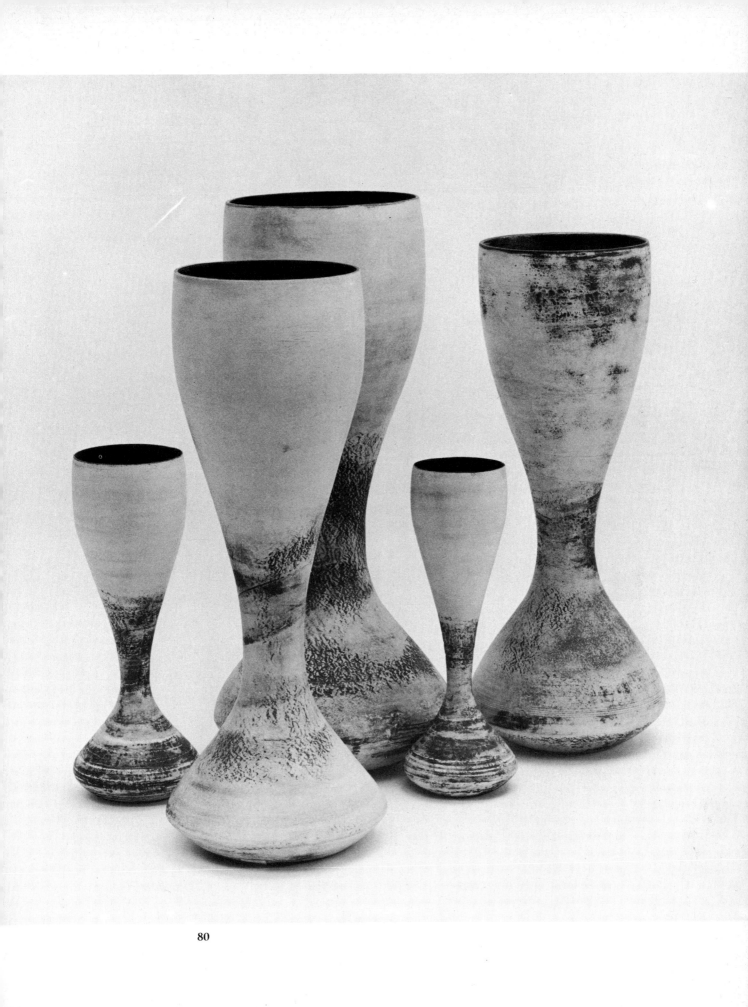

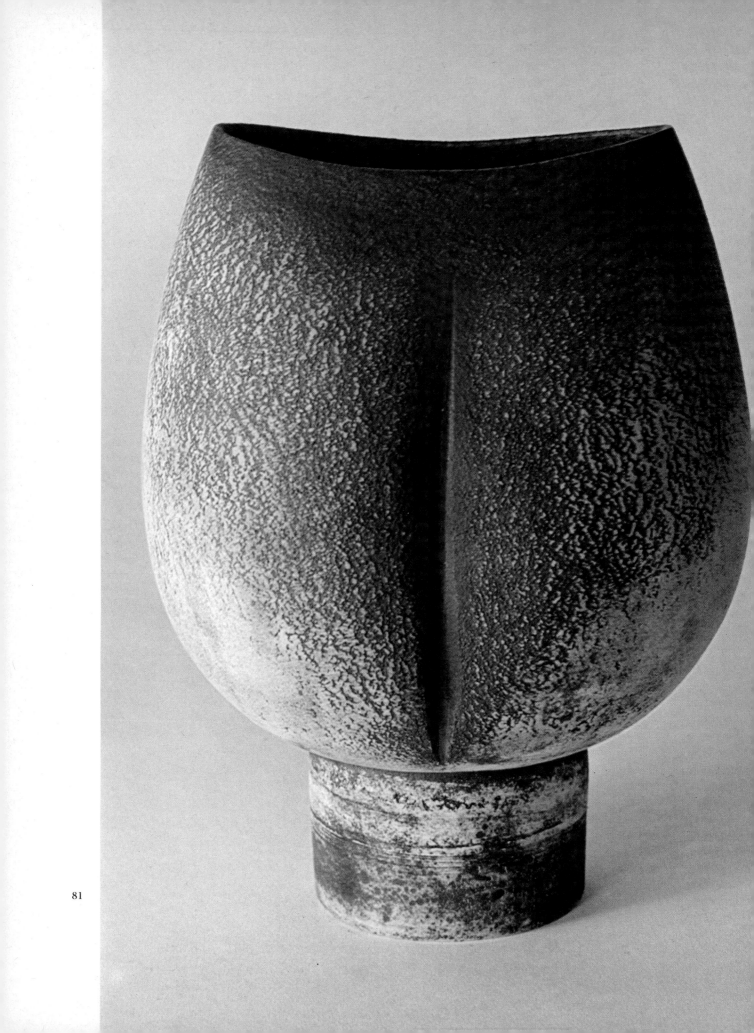

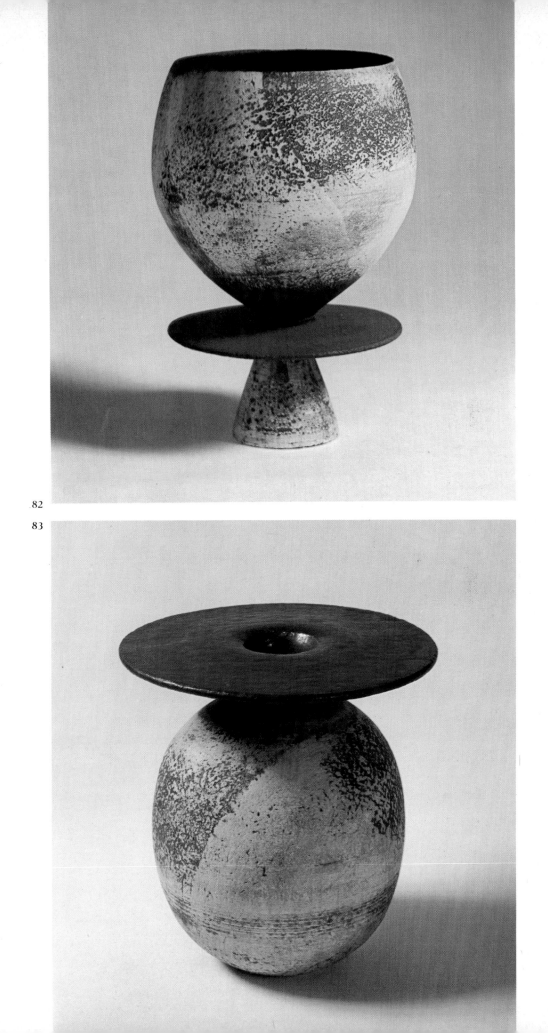

82

83

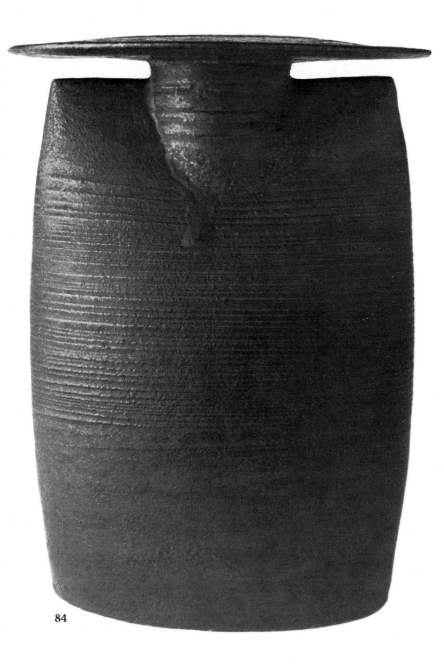

84

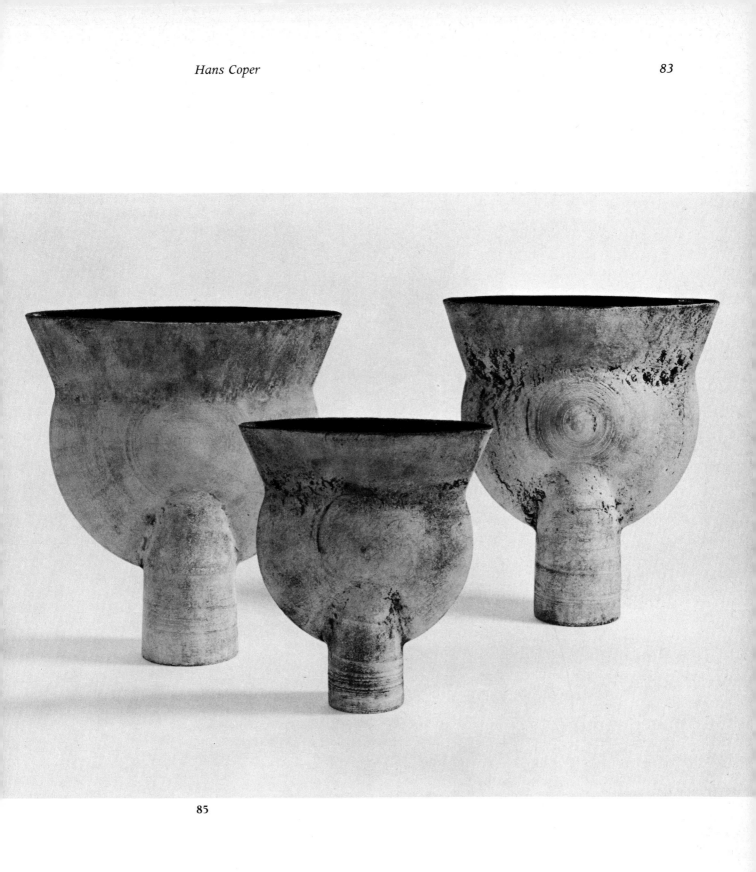

85

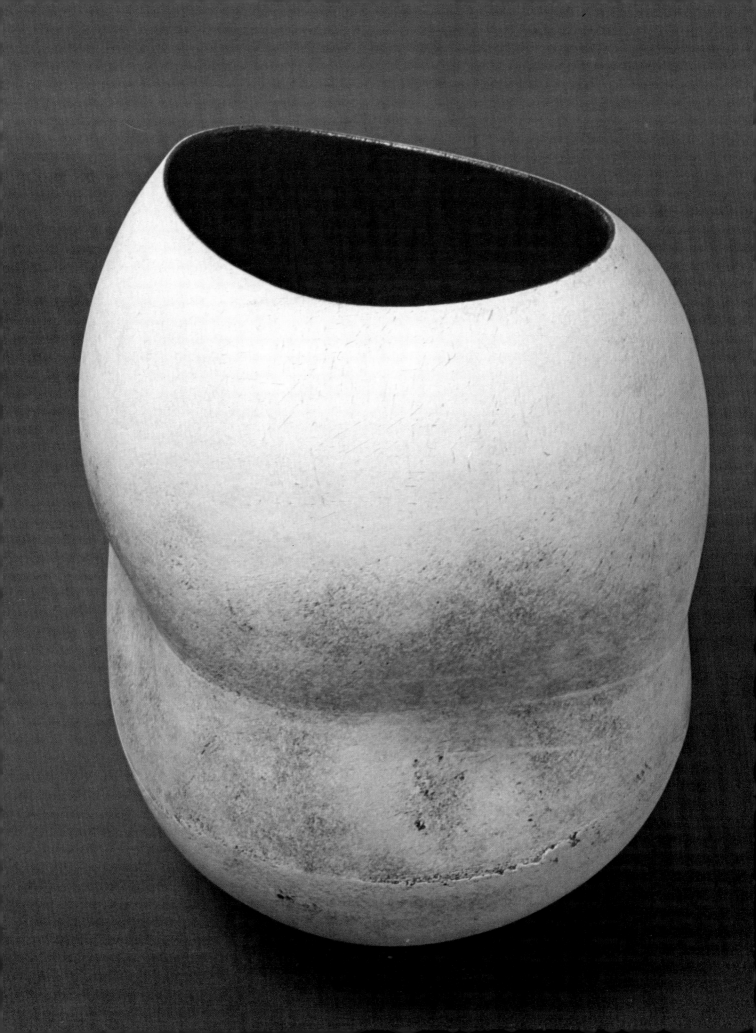

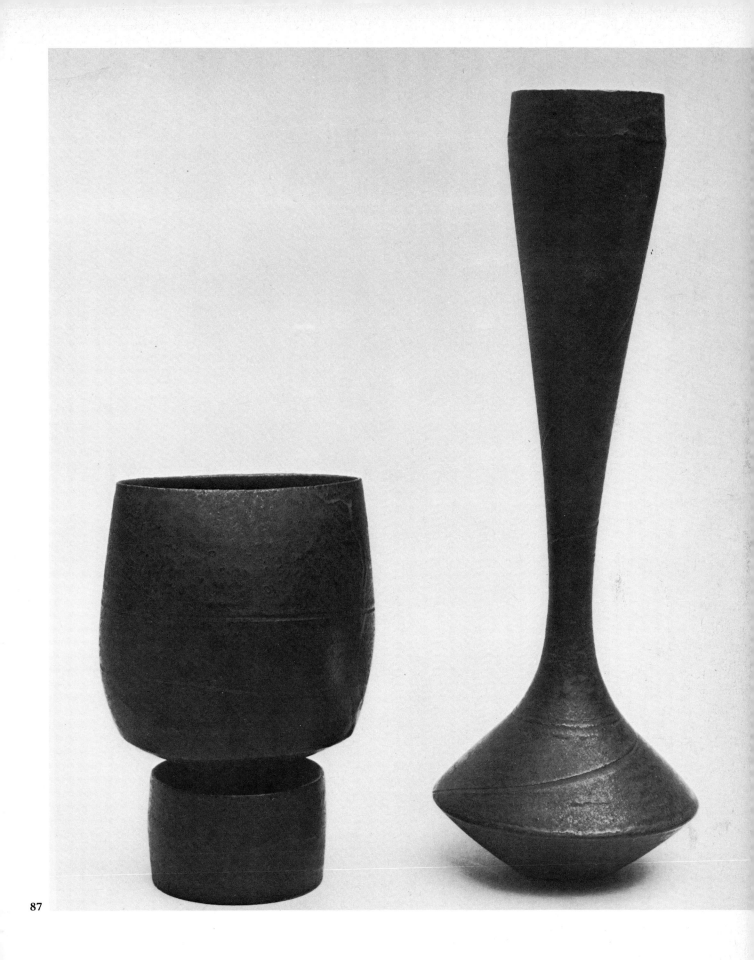

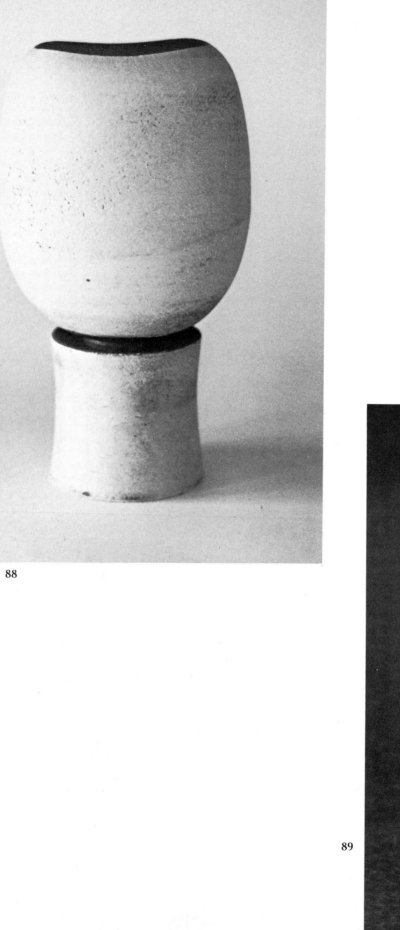

88

89

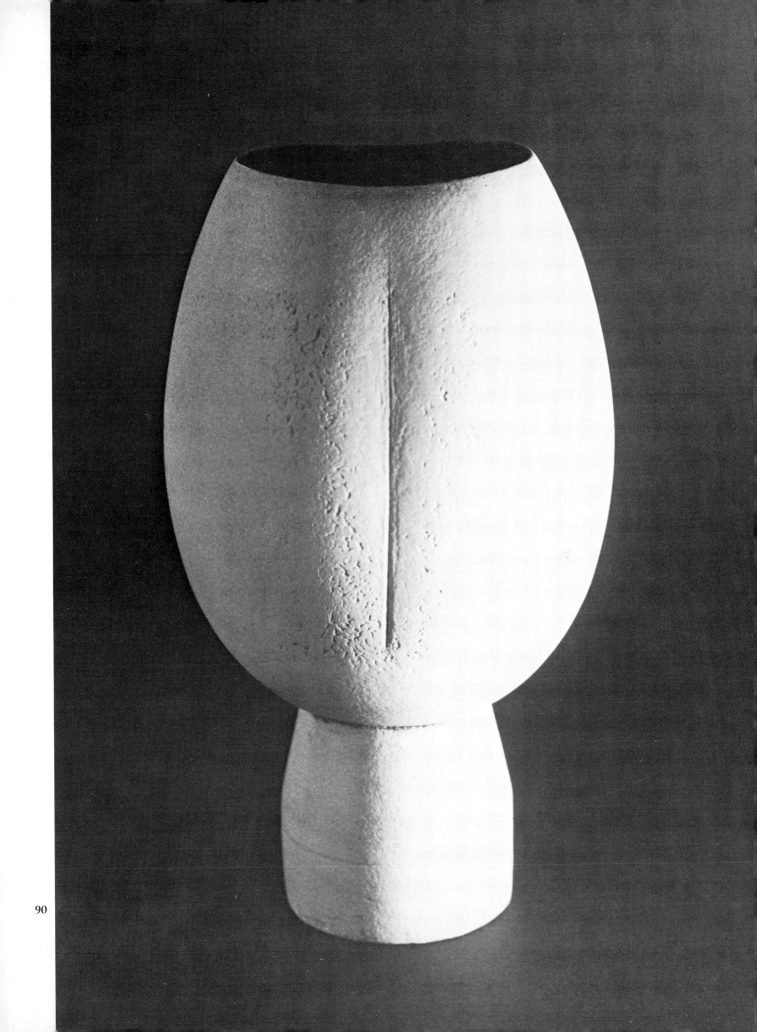

Ian Godfrey

Ian Godfrey's stylized work has become widely known since the mid 1960s. It has frequently been described as the realization of a private fantasy world in ceramics, drawing deeply on oriental precedent and with a series of touchstones in the toy-like creations of past civilizations. In a sophisticated twentieth century it is anachronistic and in danger of being adopted, to the artist's irritation, as either quaint bijou art for the decor-conscious or over-reverenced as encapsulating a philosophy of life which does not exist. What Ian Godfrey has created is a vocabulary of shapes and animal forms in combination with wheel-made bases — barrels, drums and bowls — finished with a glazed surface and texture which is perfectly married to the shape, giving his work an ageless quality. To this he brings his talent for composition, both in the decoration of a two-dimensional surface and in the arrangement of zoomorphic and architectural shapes of different scales inside or on top of the wheel-made forms.

His oriental and Mediterranean sources are so obvious that one of the most serious bogeys the artist has to face is that his derivative work is a collector's substitute for the real thing. Unearthing a Godfrey pot at a Cretan excavation would indeed be puzzling, for there is such a catholic mixture of symbols, such an arkful of animals from different continents under the same ceramic lid, and Sumerian pictographs alongside the unmistakable marks of shirt button and ball-point pen. It is in the combination and arrangement of symbols that Ian Godfrey's invention lies, and he has a unique creative talent. He associates himself if possible with craftsmen of the past civilizations he admires: his work has nothing to do with the present day. It contains ancient rhythms and nothing strident. In that respect it is not 'modern' ceramic, and he is not a 'modern potter' as one would describe his contemporary and one-time fellow student Anthony Hepburn. The astonishing thing is that the two men once shared a studio.

Ian Godfrey was born in 1942 and spent his childhood in London, becoming a student at the Camberwell School of Art soon after leaving school. Here he was taught by Ian Auld, Hans Coper and Lucie Rie, whose work he much admires, although his early training at Camberwell was as a painter. Leaving the art school in 1962, he began a decade of intensive work and part-time jobs in which his style and technique were consolidated, and by the end of which his efforts were rewarded with a torrent of recognition and success which, like a prolonged rainstorm after drought, begins by being welcome and ends with fears of drowning.

In 1962 he set up a workshop in City Road, London, with other students, and his work — slab boxes containing rectangular lakes of blue frit — was taken up by Henry

Rothschild and exhibited at Primavera in that year. With a part-time job at the London Zoo, he worked towards his first one-man show at Primavera in 1965. He was awarded a Samuel Jones scholarship *'for world travel – £70 a year'*, and with the help of a Royal College fellowship in 1967–8 he and his workshop survived to the next one-man show at Primavera in 1968, which was a major success. His toy-like farms with removable animals were becoming well known, and he exhibited in Istanbul, Stuttgart, Stockholm and Osaka. He moved to a larger workshop in nearby Goswell Road, Islington, and prepared an exhibition of two hundred stoneware zoomorphic pots at the British Crafts Centre in 1972. He held his fourth London one-man show at this gallery in 1974, when he also won a gold medal at the international exhibition in Faenza (see Plate 92) and exhibited pots in Antwerp. He taught part-time at Camberwell School of Art and for short periods at other art schools until 1975, when he was awarded a government bursary, with which he intended to study the technique of working glass. In 1976 he visited Denmark and took an interest in a Danish government-sponsored country pottery in north-west Jutland, and at the same time began a tentative return to his first love, painting.

He now divides his time between urban London and northern Denmark, where he can get practical experience in the archaeology of the Danish megalithic peoples. The jade and amber emblems of neolithic Jutland provide a visual link with Sumerian and Mediterranean artifacts that have fascinated Ian Godfrey since his childhood. He wears, always, runic necklaces of jade and stone, and carries a tiny Sumerian carved duck in his pocket, not for religious or mystical reasons but simply because they are treasures, objects of visual and tactile delight.

Another object which is always to hand is his favourite tool – a penknife. It is with this that he cuts and scores the surfaces of his thrown ceramics when they are drying and pares down the solid blocks of clay like Eskimo ivory into houses and birds, rosettes and horned animals. Inconsistencies of scale are insignificant when the organic objects are combined together; formal, placid, patient, they are touched by magic when unified under a common creamy glaze. Over and above the faintly irritating quaintness of the Japanese miniature garden to which these ceramics are often compared, Ian Godfrey's pots have a superb tactile quality, which comes from an instinct for the right finish or decorative treatment: a line of dots is made with a ball-point pen, or a sharp clay hill is softened by rubbing it down with wire wool. However small, his ceramics are never simple. Every surface is decorated, even on the unglazed base. His two and three-piece forms have stylized details applied inside, and even inside the lids, until there can be no surprises left; yet each discovery is a new delight. Major pieces may contain up to two hundred hand-made elements, some of which are removable, and the total piece is sometimes very fragile.

The perforated bowls for which Ian Godfrey is also noted, illustrated in Plates 100 and 101, are more abstract in design and more austere. In the rapid cutting of cheese-hard clay after turning, without distortion or damage, they are a technical tour de force, and again his only tools are a sharp penknife and a ball-point pen. Many of these bowls are finished with a coating of manganese dioxide, copper oxide and china clay in equal parts, giving an appropriately metallic but unglazed surface to a spiky shape, and recalling the plainer bowls of his mentor, Lucie Rie. By adding to the above mixture one part of felspar he can produce a dark, dry glaze, though most of his work is covered with the frothy felspathic glaze well illustrated in Plate 97. He also uses ash glazes of felspar, ash and china clay in equal parts, and mixes up glaze

remnants without much system but often with good results. The thinner the glaze coat, the darker the surface, and the clay itself is often darkened with manganese and copper. For many years Ian Godfrey has used a single body of Potclays' standard clays: Crank Mixture, St Thomas's Body and red clay mixed in equal proportions.

To produce his work in large batches for exhibitions and for sale demands intense periods of work and often he works through the night. His London workshop is shared with several other potters, and although always under pressure of one kind or another, Ian Godfrey does not fail to rise to all challenges. It is tempting, in writing about Ian Godfrey's work, to digress about Ian Godfrey as a person, for he is infinitely fascinating. In an understanding and sympathetic portrait, Rosemary Wren wrote: 'Talking to Ian Godfrey is like playing a Chinese paper kite. You are on the solid everyday ground, and he in aerial dippings, flutterings and swoopings ever escapes from your string. . . .' He is independent, yet ever constrained by life's practical needs. He is an inveterate traveller, but always on his own terms, and his favourite means of travel is a bicycle. A prophet, in his modest way, of simplicity, yet fascinated by glamour, he is a great creator of fantasies. A man of paradox, and multiple contradictions, he is not what he seems.

Ian Godfrey's work can be seen in the Victoria and Albert Museum, London, Paisley, Glasgow and Aberdeen Museums, Scotland, the International Museum of Ceramics in Faenza, Italy, Adelaide and Melbourne Museums, Australia, Boymans Museum, Rotterdam and Cleveland Museum in the United States. He has been invited to contribute to the International Exhibition in the Keramion in Frechen, Germany, in 1976.

92 Fox box This pot is a container, coming apart at the centre. On to the two basic thrown elements are placed well over a hundred hand-modelled details, carved or modelled from solid clay. The dished flower forms on the sides are carved from clay pinched out by hand, the foxes heads and ducks modelled individually. The decoration on the thin slab crest or fan is not combed but scratched in single lines with the point of a knife. Additionally, there is sgraffito decoration on all the vertical surfaces, rather obscured by the thick and bubbly ash glaze. This pot was awarded a gold medal at the Faenza international exhibition in 1974. 14 in. high, 1,250°C oxidized.
Collection of the International Museum of Ceramics, Faenza

93 Double pot The scale of this pot, compared to the Fox box in Plate 92, makes it less overwhelming and more jewel-like. As usual with Ian Godfrey's composite fantasies, it is impossible to tot up the number of applied pieces, as it is so difficult to know where one started counting. Part of the appeal and excitement of an Ian Godfrey pot is the anticipation of revelations, like wondering and half knowing what will be on the other side of the moon. The houses on the top are double dipped in glaze, as if with a coating of snow, and in between the rosettes on the sides are small pads of clay impressed with one of his favourite marking tools – the blunt end of a ball-point pen. 8 in. high, 1,250°C oxidized.
Private collection

94 Double pot In order to show some of the complexity of the inside, this single two-piece pot has been illustrated taken apart. The lid, with stylized mountains and animals, has more additions on its own underside, and the lower part of the pot, with nine ducks glazed in the centre and an unglazed patterned rim, stands on three small carved feet.

The cusped edge of the pot was carved with the two parts together, and the cusps vary in size so that there is only one position in which the lid makes a regular join with the base. 5 in. high, 1,250°C oxidized.
Private collection

95 Landscaped drum Even more oriental than most, this decorated drum on high carved legs is covered with a thin dry glaze, made of one third felspar, one third ash and one third china clay, slightly thinner than usual so that the decoration – with both ends of a ball-point pen and penknife – is clear and sharp. The drum is hollow. 7 in. high, 1,250°C oxidized.
Private collection

96 Two ring pots Classic Ian Godfrey constructions of about 1974, the upper pot has a rainbow and a removable pyramid, all glazed in dry ash glaze, and splashed with a second glaze containing copper. The lower pot has emerging mountains and a felspathic glaze, characteristically bubbly. Both the thrown rings are hollow. 8 in. and 9 in. diameter, 1,250°C oxidized.
Private collections

97 Landscape pot A two-piece pot on carved legs, and more decoration under the lid. The pot is thickly glazed with a creamy white felspathic glaze. 6 in. diameter, 1,250°C oxidized.
Collection of the artist

98 Two ring pots One dark and one light. This time the circle is turned on its side, and the objects, decorated on their tops with solid carved figures, look like objects of ritual. The patterning on the sides, made with the point of a penknife and almost filled up by the glaze, is reminiscent of the carving on the ancient jade beads which the artist always wears round his neck. 11 in. and 13 in. high, 1,250°C oxidized.
Private collections

99 Ring pot The decorated horizontal circular form has a sunburst at the 'back', but because of its carousel-like form, and the relatively plain outside of the drum raised up on small feet, one expects to see it rotating, and indeed gains by doing so, as the relationships of the animals, houses and forms change. The rosette is detachable. The upper part of the pot is double dipped in dry ash glaze. 6 in. high, 1,250°C oxidized.
Private collection

100 Perforated bowl Ian Godfrey has made a great many perforated bowls, usually of doubled cusped shape, with the outer section and the rim cut away with a knife while the pot is leather hard. The pots are thinly thrown, and the timing of this cutting is critical, before the clay becomes too dry and brittle. The solid parts are punched with small holes or impressed with the end of a ball-point pen, and the centre of the bowls is often carved in low relief with less angular leaf-like designs. The small bowl shown in Plate 100, made in 1973, has got the balance exactly right, and has for a long time remained the artist's own favourite example. The design and even the perforations are thickly smothered with an ash glaze containing titanium and cobalt, green-blue, not unlike jade. 8 in. diameter, 1,250°C oxidized.
Private collection

101 Bowl This majestic perforated bowl is 18 inches wide. All the carving, including the small circles near the rim, is done with the small blade of a penknife. It is finished in dead matt black, with a mixture of manganese dioxide, copper oxide and china clay in equal proportions, painted on to the surface. 5 in. high, 1,250°C oxidized.
Private collection

102 Barrel landscape Ian Godfrey has frequently used an elongated thrown barrel form, often made in two pieces, as the basic form on which his carved animals and houses are arranged. In this hollow barrel form, precariously supported on a short central thrown stem, the 'landscape' of tall hills like sponge fingers dominates. More abstract, less cluttered with figurative detail, it stands apart from his more familiar work. The tall forms are carved from solid clay and rounded down with wire wool when the clay is dry. 8 in. long, 1,250°C oxidized.
Collection of the author

103 Three bird bowls Small bowls with curved bases, each with lugs so that they can be suspended on strings, and covered in clustering birds. They are reminiscent of Etruscan terracottas, or decorated vessels of the prehistoric Near East, but they are smaller than most. 3½ in. diameter, 1,250°C oxidized.
Private collections

104 Barrel pot with birds A decorated hollow barrel form with sunburst, birds and oriental house. The patterning on the barrel is not combed but incised with a penknife blade. 8½ in. long, 1,250°C oxidized.
Private collection

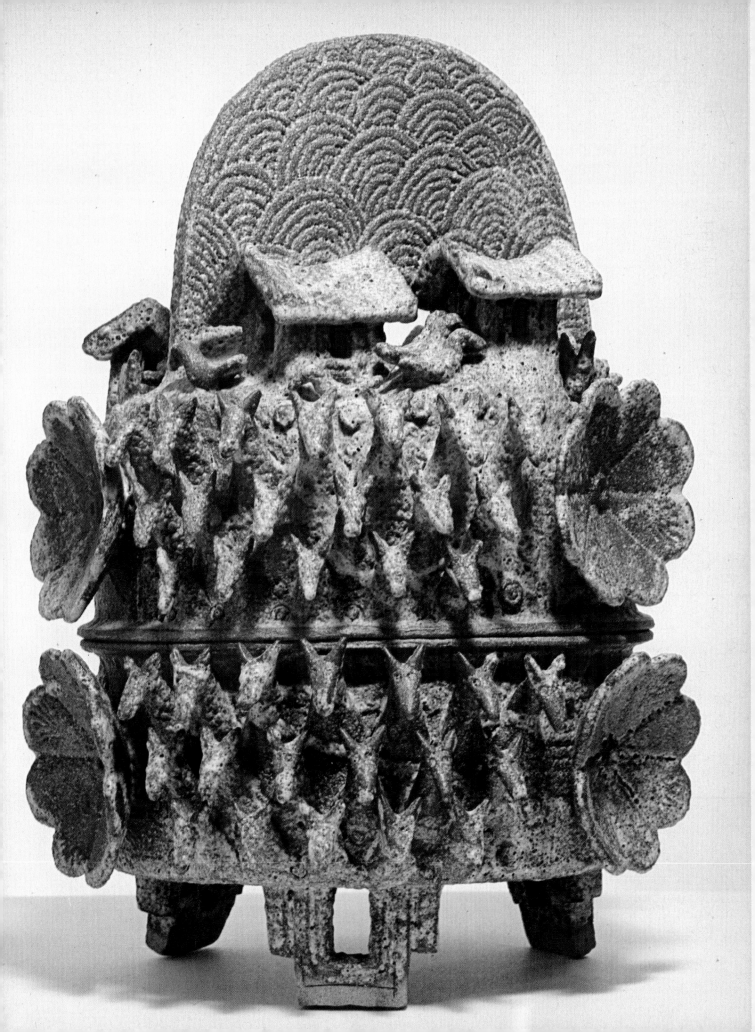

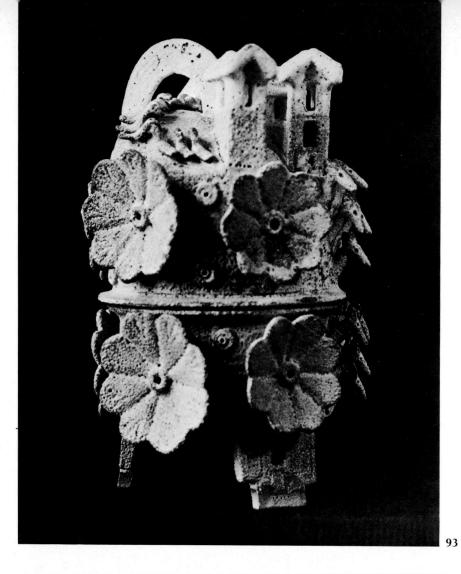

93

94

9

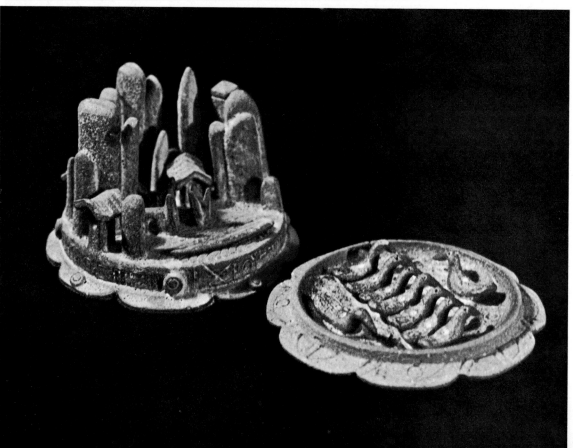

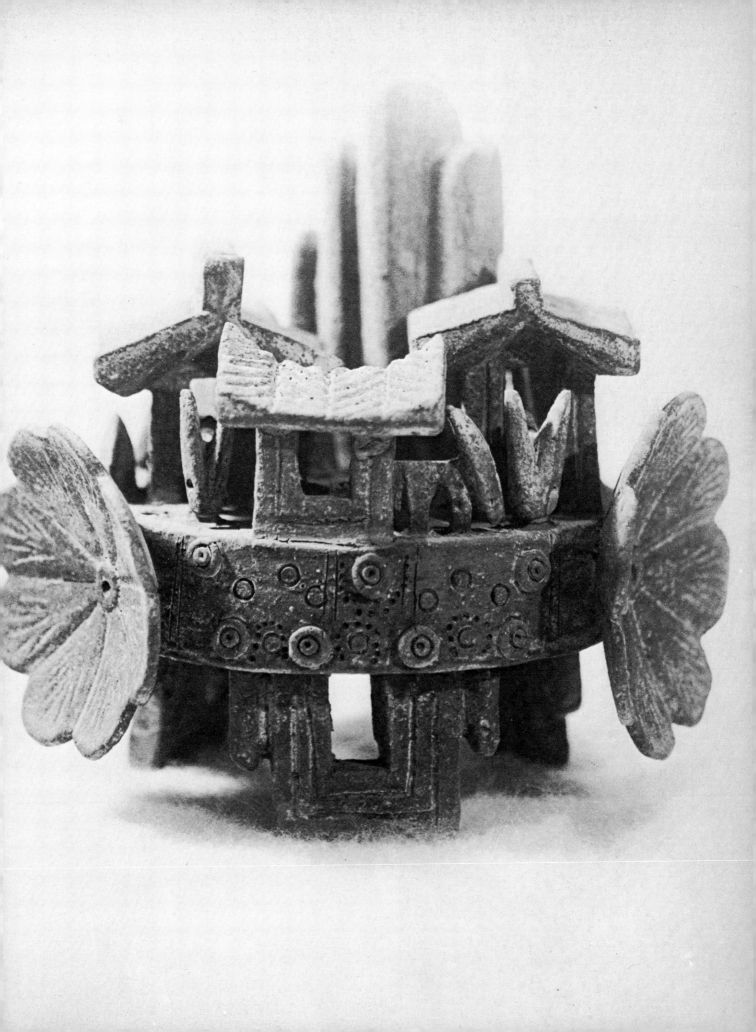

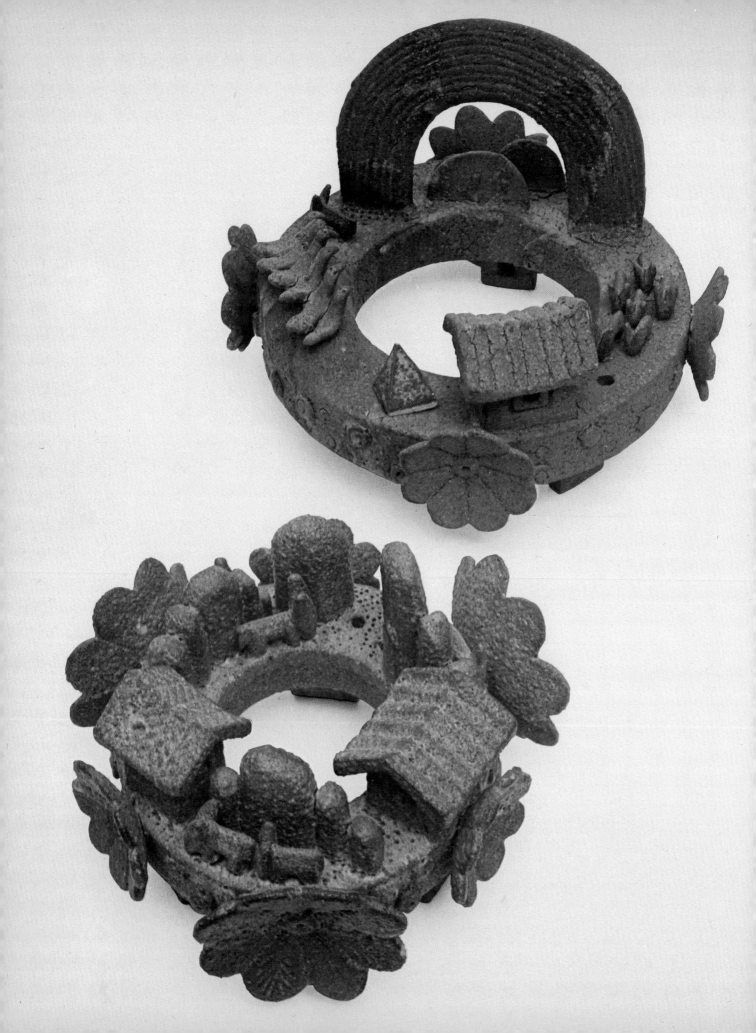

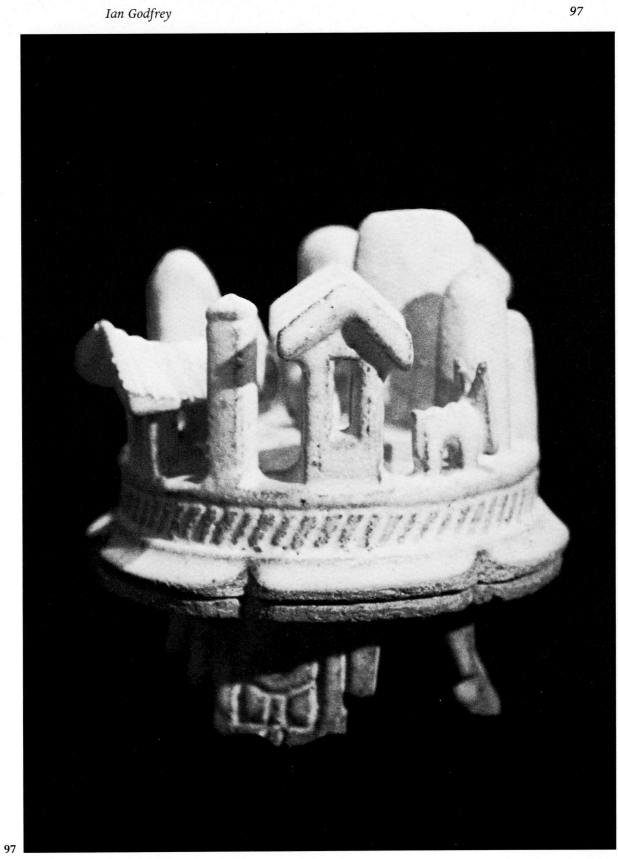

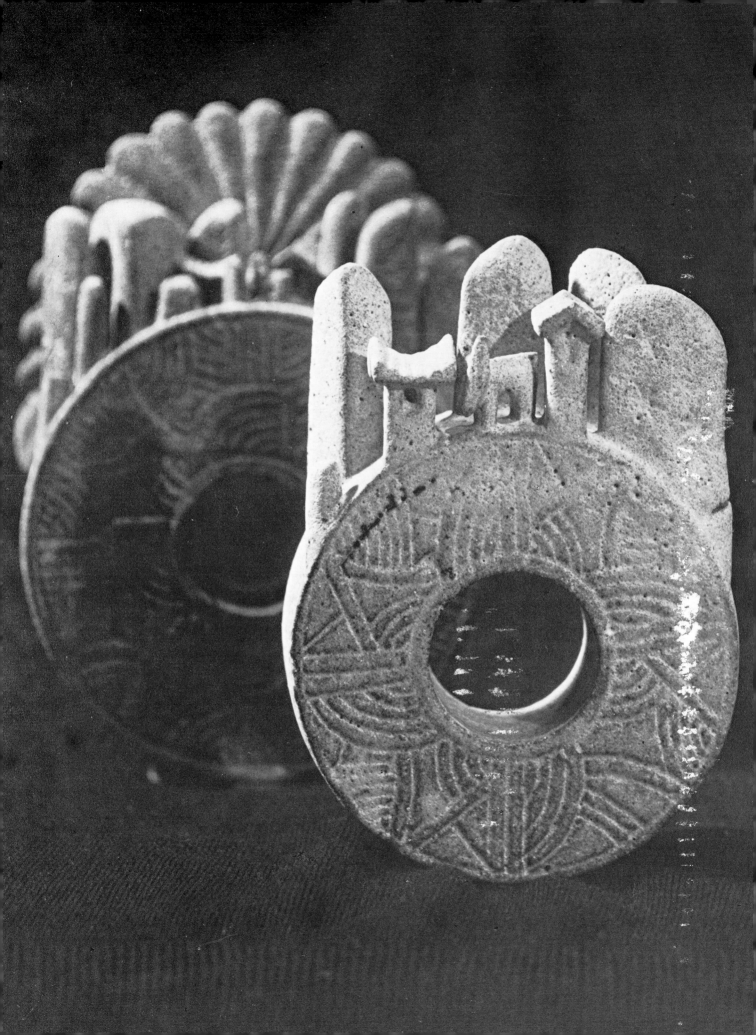

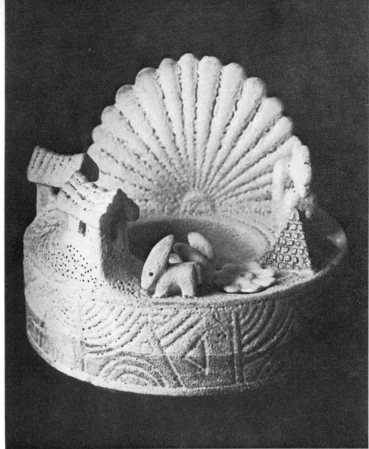

99

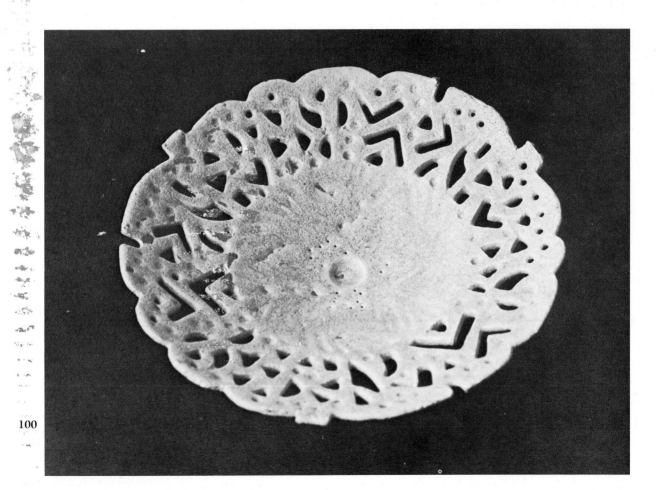

100

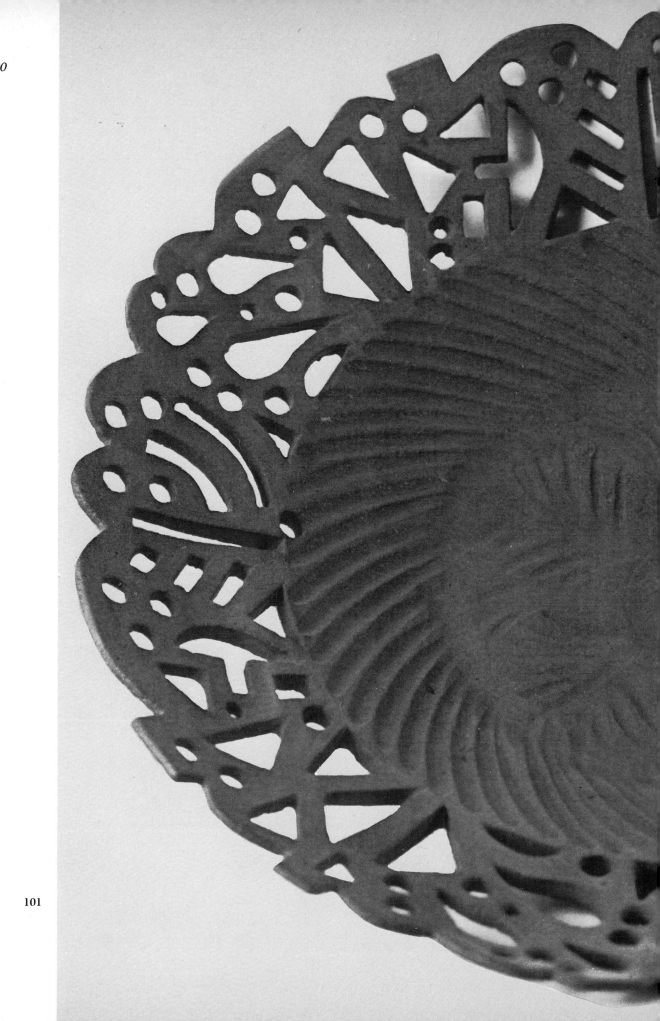

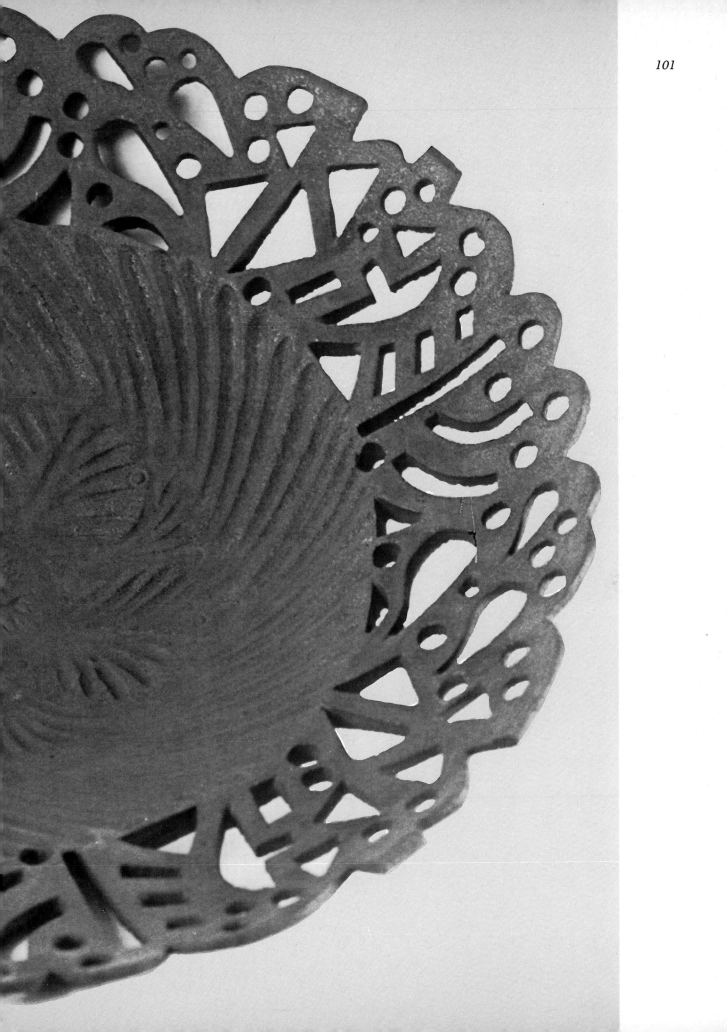

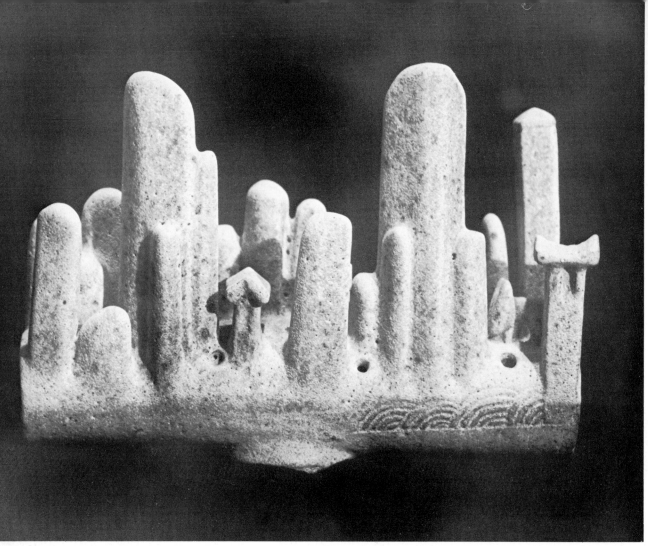

102

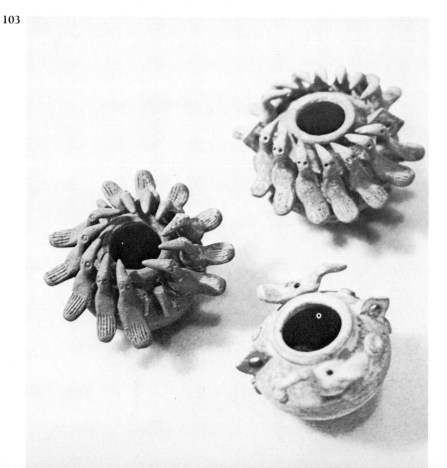

103

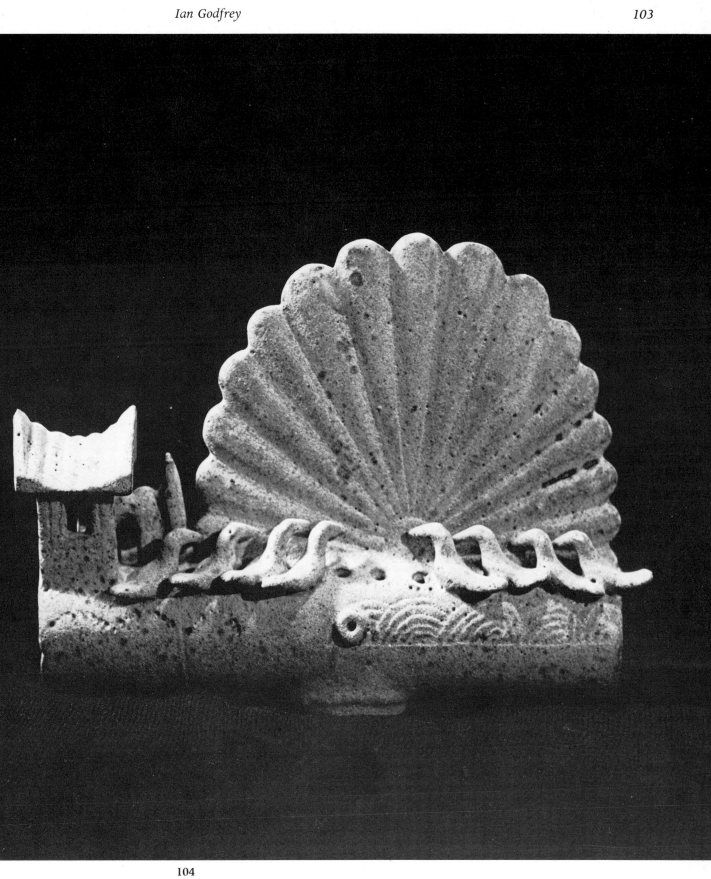

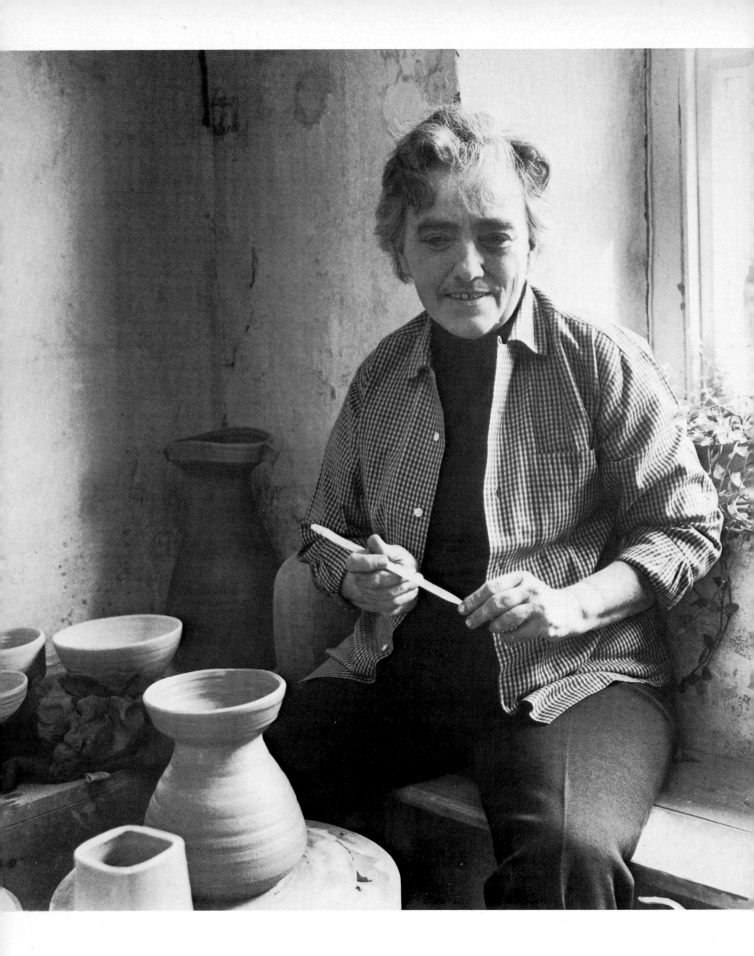

Janet Leach

'Janet's work is adventurous, free, often large and well contrived and yet showing a primitive eclectism.' Thus wrote Bernard Leach around 1966 of the pots made by the Texan he married ten years before. Janet Leach, born 1918, was nearly fifty when he wrote. A full decade later, as she nears sixty, her luxuriant vigorous pottery could be described with more exuberance. For Janet Leach is a *real* potter, turning out unique abstract vessels which could belong to any age. They are not fashionable or modern, nor are they old-fashioned. Naked of any pretentions, they have immense dignity and every quality which a pot needs to stand the test of time.

It is not to her early training as a sculptor, her American resilience, nor her association with the Leach Pottery in England that one must look for the key: it is to Japan. Janet Leach is not an intellectual – if she were she would probably not be making pottery at all – but her absorption of the Japanese philosophy and approach to ceramics, coupled with her sculptural sense and her 'eye' give us these vital pots which get better year by year. Working with a limited range of wheel-thrown shapes and only two or three decorating techniques, she makes pottery which speaks for itself. It is made quickly and handled sternly: licked into shape. If it does not come alive, then it fails to meet the test. Janet Leach has the capacity to breathe life into pots – even tiny ones, so that those around seem dead. At a recent exhibition in London, a rather sterile gallery was transformed by her work, as an iron dormitory might be, filled with beautiful people. It is not, however, the breath-taking, cool physical grace of Hans Coper but a much more fallible ripeness. No one would warm to a melon or a vegetable marrow if its symmetry were perfect. It is so with Janet Leach's ceramics. They bulge where it seems right that they should. They squat and shrug. They are not funny – indeed they are purely abstract shapes – but they are not grave, and they draw a response from the pottery lover. For Janet Leach the approval of discerning collectors in Japan is the acclaim she rates most highly, for there the essence of pottery is understood and nearly everyone is familiar with fine pottery as a matter of course.

Janet Leach did not visit Japan until she was thirty-six. She had moved as a young girl to New York from Texas to study art, and worked for a time as a sculptor's assistant and on engineering and architectural projects. She became interested in pottery in 1947, studied ceramics at Alfred University and began organizing a small pottery in New York State in 1949. In 1952 she met Bernard Leach and Shoji Hamada when they were touring America to draw attention to the oriental approach to crafts, and this stimulated her interest in Japanese ceramics. In 1954 she went to Japan to

live there for two years. She lived and worked at Hamada's pottery in Mashiko for six months and then went to the pottery village of Tamba. It was during this period that she garnered in her convictions and prepared herself with the inventive fuel for later work. She learned techniques and travelled as much as possible. She worked with several Japanese masters and learned the art of Bizen firing with Toyo Kanashigi.

She believes that her serious potting began when she was in Japan, but in 1956 she came to England and married Bernard Leach, since when, in spite of several return visits to Japan, all her creative work has been done in England, at the Leach Pottery in St Ives.

In her organization and management of the Leach Pottery since 1956 is revealed a separate aspect of her personality. The St Ives Pottery works on a larger scale than most artist-potter's workshops in Britain, with upwards of a dozen staff, an apprentice scheme, numerous eminent visitors and a seasonal flood of tourists. Janet Leach handles the business management with great skill and has extended her business activities to retail shops, while reserving some evenings and most weekends for her own work.

She has avoided the loss of identity that might have come upon anyone entering a family with such a daunting reputation as that of Leach, but this is not a surprise, for she is buoyant, determined and capable. She has benefited from the experience, energy and unreserved criticism of Bernard Leach, and although involved in a degree of public life, helping with the mechanics of authorship and accompanying her husband on return visits to Japan and elsewhere, she has maintained her own standards and individuality. Bernard Leach himself regards her work as uninfluenced by his own. She in turn drew little from America in the 1960s, when she wrote: *'A simple round pot thrown and turned in a sensitive manner would be a very small voice drowned out by thunder.'* Although her pottery has none of the self-conscious orientalism which was once so popular with studio potters in Britain, it is her Japanese experience on which she draws again and again in discussing the influences on her pottery. Even in the Japan of the 1970s she feels she could find the peace and quiet for intense working, and would like to return there to work, especially to the mountain village of Tamba, where she has a permanent home. This is not a house in the real estate sense, nor a spiritual niche in a romantic sense, but an assurance of a welcome and of being able to get down to the job.

Apart from some slab pots, all Janet Leach's work is made on the wheel. Like Hans Coper and Lucie Rie, she uses a traditional kick wheel and her pottery straddles the normal size range for thrown ware, from small light pots of a few inches high to massive vessels (see Plate 110) almost too heavy to carry about. All her work is stoneware or porcelain, and she pays great attention to the clay bodies, which she normally mixes herself, adding bauxite and chrome ore for colouring.

The pots are often dented, slashed or scored with a tool immediately after making (see Plates 112 and 116), and the tops are often squeezed to an elliptical form. She likes to see pots made quickly and firmly, and hates hesitant treatment or the touching up of a work. The two sides of a thrown form will rarely match, yet often she will add a pair of ears or lugs, emphasizing the bisymmetry. Handles, too, of a decorative nature, too shrivelled and weak to be useful, are often also added in pairs. All her pots are vessels in a rather nebulous sense, and she likes to feel that they will function – for flowers, fruit, or as lidded containers.

With slab pottery she has a rather harsh way of dealing with surface and edges,

and with slabbed porcelain a very coarse way of presenting the result (see Plate 107). Not for her the thin translucent wafer. Rather a quarter-of-an-inch thick slab with a mixing of refractory grog, a pale green glaze and a savage slash mark on the sides. The slash marks which characterize so much of her work are swords of glaze on the sides of many of her smaller pots, or gushes on her larger ones. If the stripe of glaze is applied to the biscuit surface, it is immediately coated with wax resist before the pot as a whole is glazed. The intersecting arcs of glaze which cross the fat bellies of many of her pots (see Plates 111 and 113) are made by running the pot horizontally under a thin stream of glaze, and if the glaze is thick it may trickle down the sides (Plate 110). For use with dark bodies, her favourite glaze is an oily semi-opaque white which is coloured by the minerals in the body (see Plate 111). On her larger work she uses a friable wood ash which is fired to quite a liquid state and trickles down the sides of the pot, making its own pattern, although Janet Leach will often rub areas of a pot free of glaze before putting it in the kiln.

Turning gravity on its side is a favourite act of Janet Leach, as some of the pots in Plate 107 show. A number of her small pots are fired and decorated in Bizen style, without a coating of prepared powdered glaze, but glazed by the vitrification of wood and straw ash heaped unburned into the kiln with the pots. Thus she works *with* the kiln to complete her work.

Janet Leach does not really like the allusive or figurative pots that are so prominent in modern work. She is dismissive of whimsical pottery as more appropriate to a sculptor's indulgence than the work of a potter, which is made permanent so easily by the kiln. She is critical, too, of the over-exposure of the immature work of young potters and feels that earning one's living as a potter rather than potting subsidized by bursaries, grants and teaching is a useful part of the hardening-off process which leads to good pots later. She is uneasy about teaching pottery to students, although she administers the apprentice scheme at St Ives, and is immensely kind and encouraging to young potters. As a council member of the British Crafts Council she makes her views known widely.

She believes strongly in the value of exhibitions, which bring out something in the potter which otherwise would not be produced. Pottery coming from a concentrated burst of effort for an exhibition will have an aura of unity lacking in a selection of pottery made over a long period. She is ready to work hard herself for such displays, using a lot of energy. She has said of Bernard Leach, '*He is like a bicyclist. He only wobbles when he is going slowly.*' The same can be said of Janet.

Apart from early shows at Henry Rothschild's Primavera in London (1961, 1963, 1965) she has exhibited mainly in Japan – in 1967, 1968, 1969, 1970 and 1974. She has had three one-man shows in London since 1972, including the British Crafts Centre 1976. She has also exhibited in group shows in Rotterdam, Copenhagen, Washington DC, Aalborg in Denmark and Hamburg. She also exhibits in the Work of the Leach Potters, and the annual Primavera exhibition in Cambridge. Her work is in private collections in America, Japan and Europe and in museums including Boymans Museum, Rotterdam, Newark in the United States, and the Victoria and Albert Museum, London.

106 Vase with handles Thrown in red clay and turned up to the attachment point of the handles. The vertical marks on the side of the pot are made with a bamboo tool. An ash glaze covers the inside and top of the pot. It is partially rubbed off the side. 7 in. high, 1,280°C reduced.
Private collection

107 Porcelain vases Using coarse grogged porcelain clay, these six pots were built from curved slabs, some with added lugs. The dark streaks were made by running the pots horizontally under a stream of tenmoku glaze, wax resisting immediately afterwards and glazing the rest of the pots in a transparent glaze, so the pots are white with a hint of green. $4\frac{1}{2}$ in. to 9 in. high, 1,280°C reduced.
third from right: Collection of the artist
rest: Private collections

108 Flat dish A simple slab of red clay, bent up at the edges, with black slip decoration, combed through, and a white glaze over part of the surface. The rest is unglazed. 8 in. square, 1,280°C reduced.
Collection of Bernard Leach

109 Porcelain dish This pot is made from a dished slab of coarse grogged porcelain clay on a foot made from a single bent slab. It is glazed with a celadon glaze, with a run-on design in tenmoku. 8 in. wide, 1,280°C reduced.
Private collection

110 Large pot A large thrown shape in purple clay, darkened with chrome ore and bauxite, this pot is unglazed outside apart from the runs of white glaze which have trickled down the form at the application stage, not in the kiln. 11 in. high, 1,280°C reduced.
Private collection

111 Bottle and vase Two thrown shapes with ears and lugs, typical of Janet Leach, each made with clay darkened with chrome ore and bauxite and glazed with a white glaze inside and with streaks on the outside. Each arching curve is a straight line – the line of the pot being moved under a stream of glaze. 6 in. and 8 in. high, 1,280°C reduced.
Private collections

112 Vase This thrown shape shows the marks of the turning tool on its profile and fingermarks on its sides. It is made from grogged brown clay and the remaining decoration comes from straw and other matter pressed up against the pot in a typical Bizen firing of a wood-burning kiln. 8 in. high, 1,280°C reduced.
Private collection

113 Vase with lugs Using her distinctive purple-black clay, darkened with chrome ore, Janet Leach has glazed this thrown vase inside and on the rim with white. The outside is unglazed apart from two intersecting arcs of tenmoku. 11 in. high, 1,280°C reduced.
Private collection

114 Bowl This simple bowl thrown in grogged clay has an ash glaze fired to a very liquid state so that it makes its own pattern of rivulets. 11 in. diameter, 1,280°C reduced.
Private collection

115 Two vases Red clay and grog in the body give a warm colour to the clay, even when reduced. The taller pot, with drooping squeezed oval rim, is partially glazed outside from two dippings in ash glaze, as used inside the pot. The same glaze on the smaller pot, fired slightly higher, is partially rubbed off the neck and rim. Where it is thick it makes its own liquid pattern. 6 in. and 10 in. high, 1,280°C reduced.
Private collections

116 Indented pot A simple thrown shape, indented with a turning tool in four places. The rough treatment seems natural, and the tough little pot a survivor. Ash glaze. 5 in. high, 1,280°C reduced.
Private collection

117 Lugged vase This form, with belly, neck and top bearing two lugs, is repeated again and again by Janet Leach, taking her inspiration from Bizen ware and varying the relationship of the component parts. This pot has an ash glaze. The lighter marks in the glaze come from straw in the wood-fired kiln. 8 in. high, 1,280°C reduced.
Private collection

118 Vase *'One of my tree trunks.'* This form is made from a slab of red clay covered with a mixture of washed beach sand, white slip and black slip sprinkled on to the surface of the slab before firing. It was assembled whilst the clay was very soft, using a bed of sponge rubber to lift up the damp slab rather than the more usual stiff canvas. The varied surface is given a greater richness by the ash glaze. 18 in. high, 1,280°C reduced.
Private collection

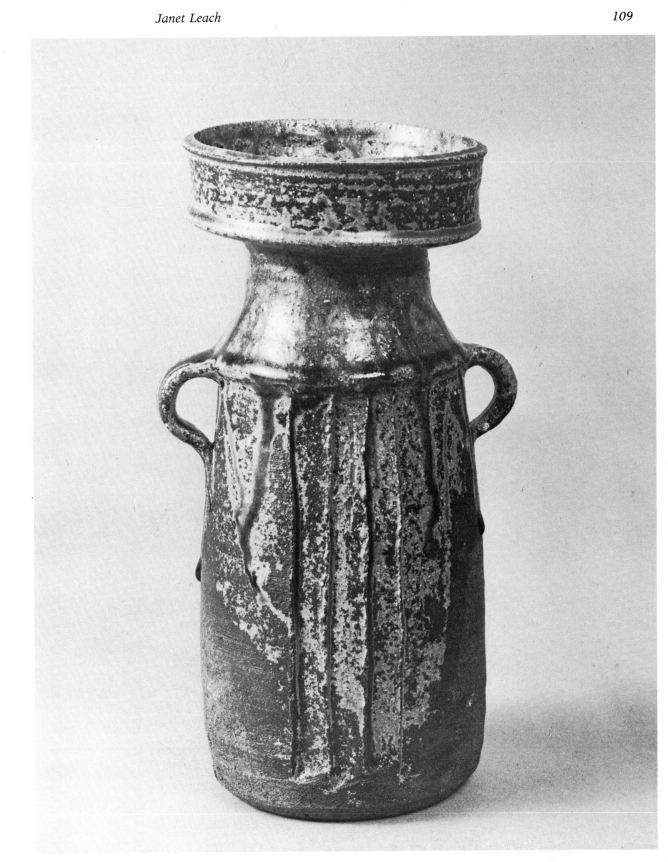

107

108

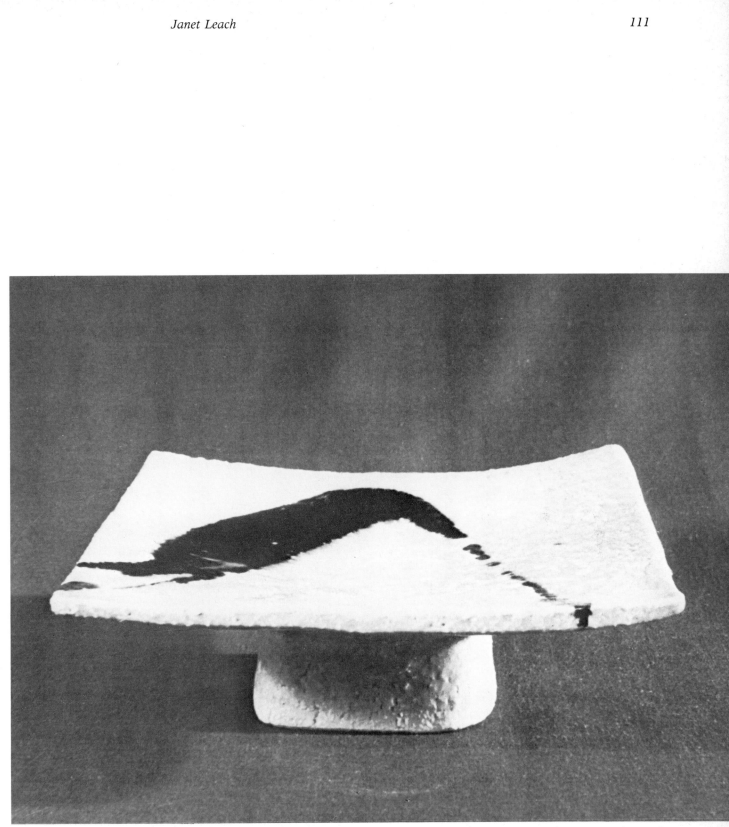

109

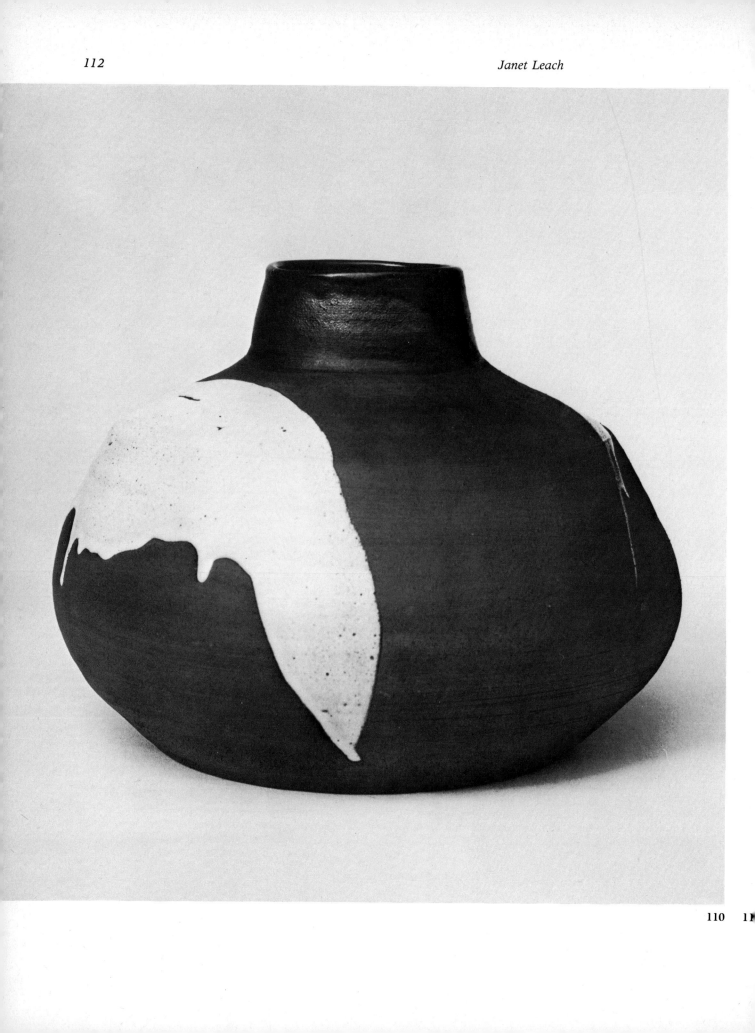

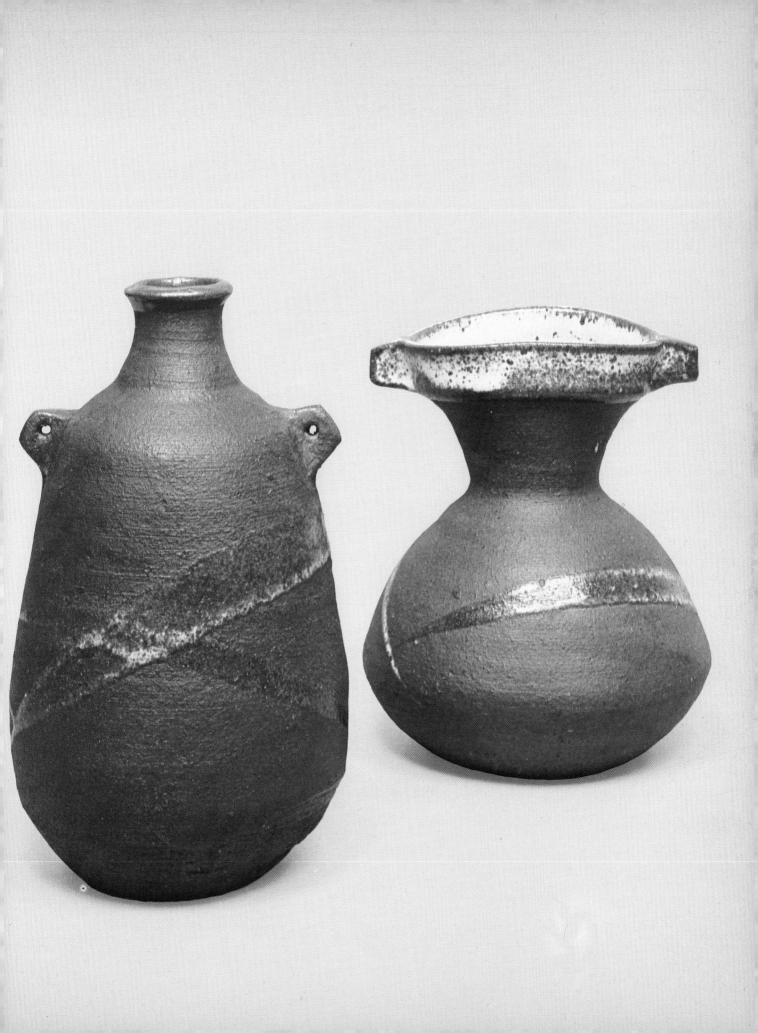

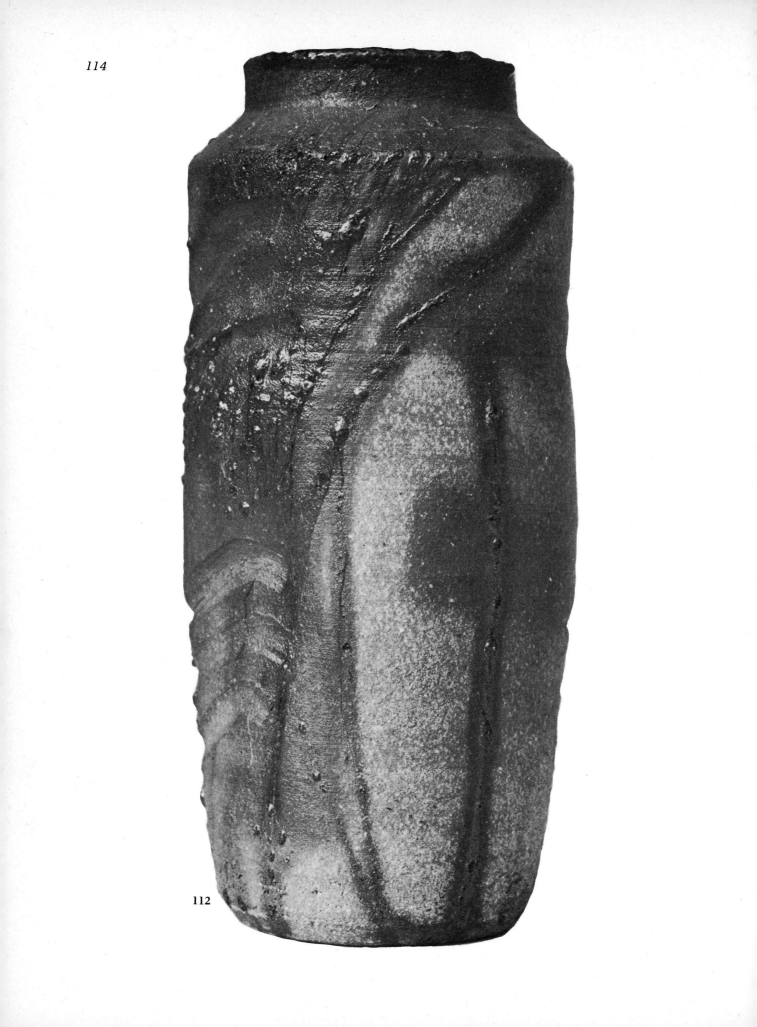

114

112

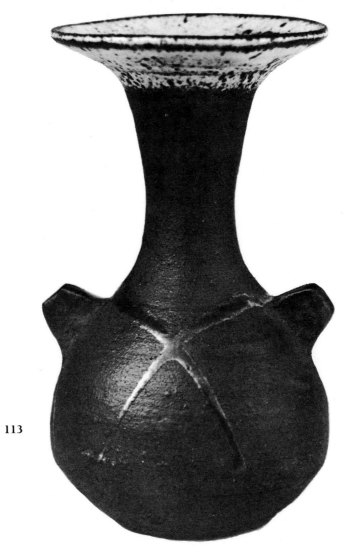

113

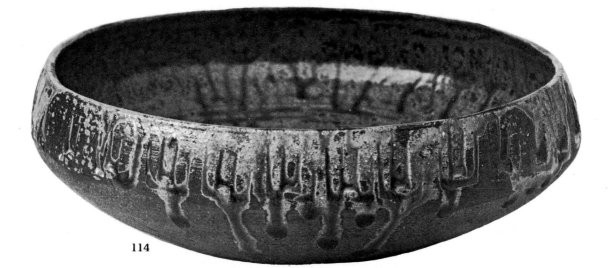

114

115

116

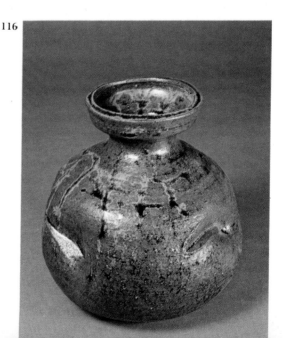

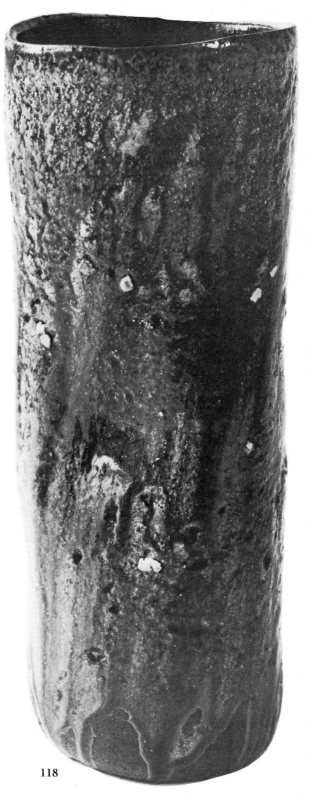

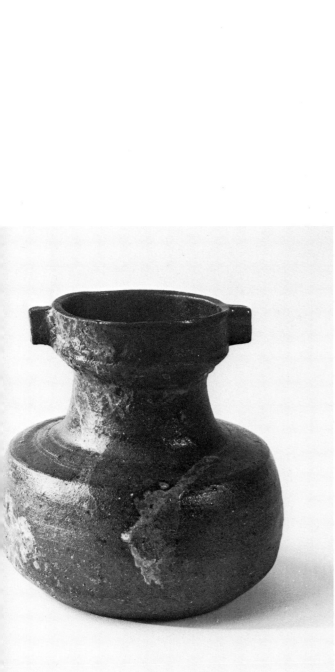

117

118

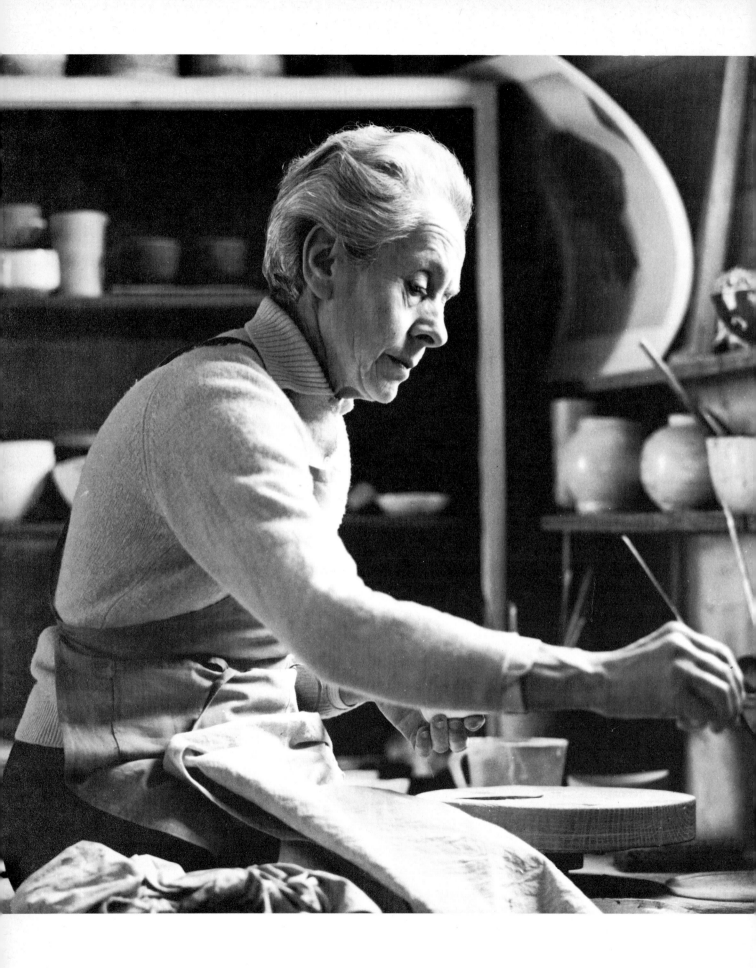

Lucie Rie

Lucie Rie was born in Austria in 1902, and has enjoyed wide renown as a potter for nearly half a century. Her characteristic style of fine springing stoneware and porcelain has been a leading influence in Britain, and her work is well known all over the world. She brings to traditional forms a sensitive feminine touch and pays meticulous attention to detail. Her pots have their roots in classical and oriental ceramics, but they are vibrantly modern and belong essentially to the present day.

Lucie Rie was trained in Vienna at the Kunstgewerbeschule under Michael Powolny, and her work still reflects the discipline of these early years. She set up her own kiln in Vienna in 1926, and started to exhibit her work internationally in that year. By 1936 she had already won two gold medals in ceramic exhibitions and had gained considerable recognition in her native country when she left Austria in 1938. She came direct to London, and made contact with Bernard Leach who was then working at Dartington. She was overwhelmed by the style and assurance of his throwing, and for some years her self-confidence was shaken, though since this early meeting has grown up mutual friendship and respect.

She established a workshop in 1939, and through the difficult war-time period made ceramic buttons and small ornaments rather than pots. Hans Coper, from Germany, came to assist her in the workshop in 1946 and it is clear that although they produced work of totally different kinds each provided the other with a stimulus, and the studio soon became a productive pottery.

Lucie Rie's characteristic style of tableware began to be recognized in England after the war, and set a new standard of precision in hand-made pots for daily use. She approached the problems of designing tableware in an entirely fresh way, making straight pulled handles for milk jugs, fine-rimmed coffee cups and wide pulled spouts that pour without dripping. 'Here was a studio potter . . . not rustic, but metropolitan', said George Wingfield Digby of Lucie Rie's work in the 1950s, and some of these designs, far removed from the robust forms of English country ware, she still produces to order.

Porcelain is currently regaining favour as a medium for thrown pottery, in spite of its technical hazards, but it has been used for many years by Lucie Rie. She is a master of the medium, and can coax porcelain by hand into delicate shapes on the wheel. As a potter who is undoubtedly well equipped in experience and sensitivity to design practical tableware in porcelain for factory production, it is sad that Lucie Rie has confined herself so far to her studio, and has not designed for industry.

Everything she makes is thrown on the wheel, a continental wheel with a wooden

wheel head and a large flywheel. Her small porcelain pots are always thrown in one piece, and immediately after throwing are often squeezed and pressed into shapes which are non-cylindrical rather than asymmetrical. Some of her porcelain work is very small indeed, resembling seed pods, bells and shells. Large porcelain and stoneware shapes will sometimes be thrown in two or three pieces, joined with water when leather hard (Plates 123 and 129). The generous open tops of her tall pots are typical, and are often, as in Plate 121, gently eased into an undulating oval form, making a counterpoint with the regular base or shoulder. Groups of two or three pots together show how one shape has given rise to another in a process of infinite refinement. Lucie Rie works away from a single idea which is finally expressed not by one perfect pot but by a series – a limited sequence of variations on a basic relationship of forms.

An early interest in Roman pottery, stemming from archaeological finds on the Austro-Hungarian border which she saw in her childhood, is sometimes discernible in her work, although the light bowls for which she is best known have more in common with Korean and Chinese pottery. All her pots have a very definite mood, sometimes springing and upward-thrusting, as in Plate 131, right, sometimes solid and severe. Her bowls often have the cusped inner profile of two intersecting curves (Plates 122 and 132) while the outer profile is gently lifted from the ground on a delicately turned base. Lucie Rie enjoys the process of turning best of all. It is for her a creative part of pot-making, not a corrective one, and her favourite turning tool is a sharp razor blade. Her pots are always beautifully finished. Examine the foot of a Lucie Rie pot, however small, and you will find the same care and attention to detail as elsewhere: often fine sgraffito work like the delicate underside of a sea urchin or starfish. Her tiny plaster of Paris seal is one of the few distinguished seals used by modern potters.

Although she never indulges in free brush decoration, and always allows the profile of the pot to make the design, sometimes supported by fine sgraffito or spiralling gouged lines, the surface and colour of the glaze is of vital importance and the subject of constant experiment. After over half a century of such searching, the range and subtlety of her glazes is breathtaking, but like the best of cooks, she is always tempted to try something new, and recipes are never hard-and-fast things. A deep-textured bubbly glaze as shown in Plate 131 is characteristic of her stoneware, often coloured green or blue by metal oxides in the clay. Her early porcelain bowls sometimes have a coating only of manganese oxide, and are decorated with spiralling sgraffito lines (see Plate 124), but more recently she has used manganese and copper to produce a dusty but rich gold which becomes fairly fluid at $1,250°C$ (see Plate 135). Pinks and turquoise colours are used in combination with this gold, and she also uses an intense uranium yellow on her porcelain ware. It is the cool alabaster-like surface of her semi-matt stoneware glaze, however, which I personally find most beautiful, especially when it is coloured or broken, as in Plates 126 and 130, by oxides in spiral bands on the pot. These are the result of throwing from a lump in which two separately coloured clays have been left unmixed. She uses Podmore's clay and Denby clays for porcelain, and much of her stoneware is made from a mixture of 'T' Material and red clay with her own oxide additions. She sometimes borrows from Eastern tradition the use of an unglazed ring in the centre of a glazed bowl so that another pot can be placed inside to save space in the kiln (Plate 132).

The production exclusively of once-fired ware virtually halves the hours of firing,

but the large top-loading electric kiln is fired once a fortnight and Lucie Rie works hard and steadily in the orderly environment of the workshop she has occupied for nearly forty years. She also uses this as her showroom, and much of her work is sold today direct from her studio, although certain smaller galleries in Britain have a small but regular supply of her pots.

For twelve years from 1960 she taught part-time at Camberwell School of Art, but stopped when the emphasis in art schools was placed more and more on subjects such as silk screening which she was unable to teach. Of all the pottery in this book, Lucie Rie's has been the most widely exhibited and acclaimed around the world. Her first important exhibition was in the Austrian Pavilion at the International Exhibition in 1937. She has won awards twice at the Milan Triennale and has exhibited at Gothenburg, Minneapolis, Monza, New York, Rotterdam, Copenhagen, Dusseldorf and in Japan. She has gained gold medals at Brussels and Munich. Most of her exhibitions in London have been held at the Berkeley Gallery and some have been shared with Hans Coper. In 1967 a retrospective exhibition of her work was shown by the Arts Council in London and also, together with the work of Hans Coper, by Boymans Museum in Rotterdam and Gemeentemuseum in Arnhem. In 1968 she was awarded the OBE, and in 1972 the Museum for Art and Craft in Hamburg organized a large exhibition of her work together with that of Hans Coper. In Britain she takes part annually in the Primavera exhibition in Cambridge, and her work can be seen in Bonniers in New York. Her pots are in many private collections throughout the world, and in public collections in Amsterdam, Detroit, Dusseldorf, Hamburg, London, Melbourne, New York, Ontario, Rotterdam and Stockholm.

120 Stoneware vase This elegant form was thrown in two pieces, joined at the waist and squeezed oval at the join. The ellipse at the top is at right angles to the ellipse below. The wide top, 8 inches across, makes the pot ideal for a large branch or flower arrangement. Manganese oxide in the clay breaks through the deeply pitted oatmeal glaze as dark brown specks. 24 in. high, 1,250°C once fired.
Collection of the artist

121 Vase This vase was thrown in one piece from a body made of 'T' Material with an addition of red clay and manganese oxide, and squeezed oval at the neck, the rim eased symmetrically upwards. The spiral fluting was carved when the pot was leather hard, and it was then covered with white porcelain slip and a dolomite glaze. $7\frac{1}{2}$ in. high, 1,250°C oxidized.
Collection of the artist

122 Porcelain bowl This thin porcelain bowl is decorated with manganese and a band of matt white glaze. 12 in. diameter, 1,250°C once fired.
Collection of S. Pick

123 Three stoneware vases The shape on the left is a thousand years old. It is reminiscent of a porcelain vase from North China, yet in fact its inspiration was an Arabian jar, bought at a stall for a few pence. It was thrown in three pieces. Lucie Rie readily acknowledges the sources of her work where there is a source; the forms on the right are purely her own. Thrown in two pieces – the stem and the rim – and joined with water, not slip, they were pressed into an oval shape while the clay was still soft. As flower vases they are functional, weighty at the base and wide open at the top. Manganese oxide breaks through the matt felspathic glaze of the pots on the right. The white glaze of the pot on

the left is softer, and the manganese is beginning to run. 15 in. to 18 in. high, 1,250°C once fired.
Collection of the artist

124 Porcelain bowl Dark brown manganese oxide is painted over the inside and outside of this bowl. The fine sgraffito bands are made with a pin, with the pot turned upside down on the wheelhead. The spiralling sgraffito lines are repeated on the inside of the pot. Also inside is a single band of china clay with 10 per cent cobalt oxide, which fires to a bright opaque blue. Inside the foot, sgraffito decoration through cobalt surrounds the seal. $2\frac{1}{2}$ in. high, 1,250°C once fired.
Collection of the artist

125 Porcelain bowls Very thinly thrown in porcelain, the bowls were covered with a thick white glaze. The rims, cleaned of this glaze, were then painted with a thick coat of manganese and copper, which has run down into the glaze, both inside and outside the pots, making a design of dark brown and gold. 4 in. and 6 in. wide, 1,250°C once fired.
Private collections

126 Porcelain vases Thrown agate porcelain. The body contains copper carbonate, making pale greenish spiral bands through the white porcelain glaze. The smaller pot is oval. 6 in. and 11 in. high, 1,250°C once fired.
left: Collection of Mrs Dell
right: Private collection

127 Stoneware bowl The inside of the foot is glazed, and the pinky-grey glaze is soda felspar and dolomite. Manganese and grog in the body affect the surface, and specks of manganese streak the inside. 5 in. high, 1,250°C once fired.
Collection of Mrs Walter Raeburn

128 Three stoneware pots These three thrown shapes could hardly be simpler. The two squared-off cylinders behind are oriental in mood, especially the smaller pot with its thick creamy glaze gathering around the base. The yellow pot gets its colour from uranium oxide. The small pot in the foreground, flaring towards the bottom, has cobalt and manganese wedged into the clay, and these break through the thick waxy glaze. 6 in., 8 in. and 11 in. high, 1,250°C once fired.
Private collections

129 Porcelain vase This thrown porcelain pot was made in three pieces. The shoulder towards the top of the bulb-shaped base catches the light partly by taking up the glaze rather thickly. Apart from iron oxide, sparingly applied at the edge of the rim, there is no decoration other than the glaze. This is slightly crystalline, and varies considerably around the pot. The pale blue, from copper and cobalt, is flushed in places with pink, from copper reacting to soda felspar. The base is glazed inside the foot, over the potter's seal. 9 in. high, 1,250°C once fired.
Collection of the artist

130 Stoneware vase A strong and heavy stoneware pot, ideal for flowers with its wide mouth. It has a broad coloured spiral band made when the pot was thrown from a body containing manganese and red clay with 'T' Material, but left unmixed. After throwing, the pot was coated with a porcelain slip and a thick white glaze. Where the oxide in the body is concentrated it has bubbled, giving a varied surface texture. 11 in. high, 1,250°C once fired.
Collection of the artist

131 Two stoneware bowls The bowl in the foreground is turned at the base, the bowl behind is squeezed to an ellipse. Manganese oxide mixed into the body is responsible for the dark spots breaking through the greyish-white volcanic glaze. Left: 9 in. diameter; right: 15 in. wide, 1,250°C once fired.
left: Private collection
right: Collection of the artist

132 Stoneware bowl Manganese oxide in the body breaks through the grey-green glaze. The central ring is turned clean of glaze. 15 in. diameter, 1,250°C once fired.
Collection of Henry Rothschild

133 Two porcelain forms Both of these pots were thrown in three pieces. A hint of classical pottery is found in these two forms, especially the Lekythos-like shape on the right. The pots are glazed inside up to the bell-like rims. Manganese oxide is painted on the outsides, and used to fill the sgraffito decoration inside the tops. 8 in. and 9 in. high, 1,250°C once fired.
left: Collection of J. Pike
right: Collection of the artist

134 Bowl A thinly thrown porcelain bowl with a white dolomite glaze containing tin oxide. The dark bronze band at the top, consisting of manganese and copper, applied to the unglazed clay at the fine rim, bleeds into the glaze below. $6\frac{1}{2}$ in. wide, 1,250°C once fired.
Collection of the artist

135 Vase Thrown porcelain made in two pieces, coated with manganese and copper, with a sgraffito design on the upper part. The pot is dark brown and metallic gold in colour. 10 in. high, 1,250°C once fired.
Collection of A. Egner

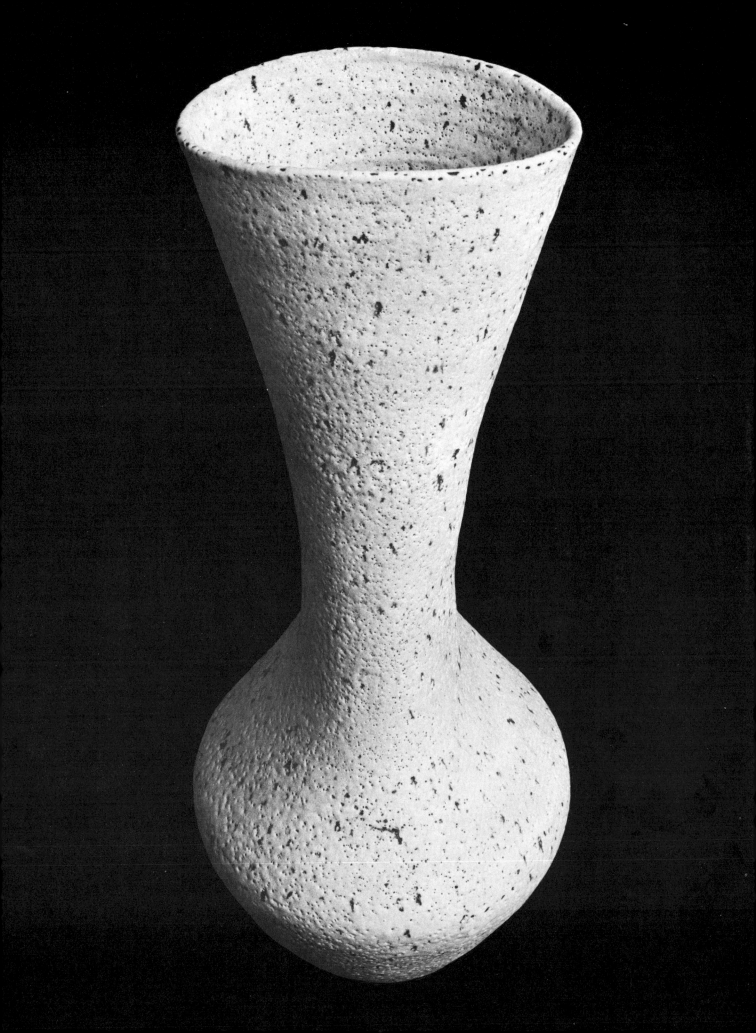

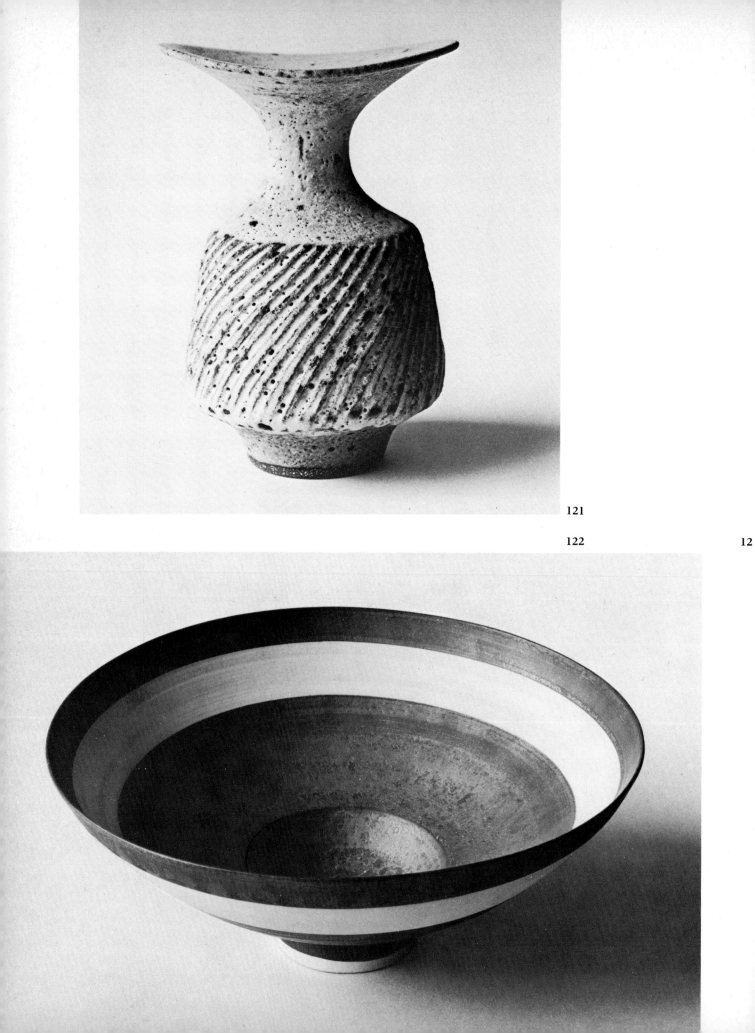

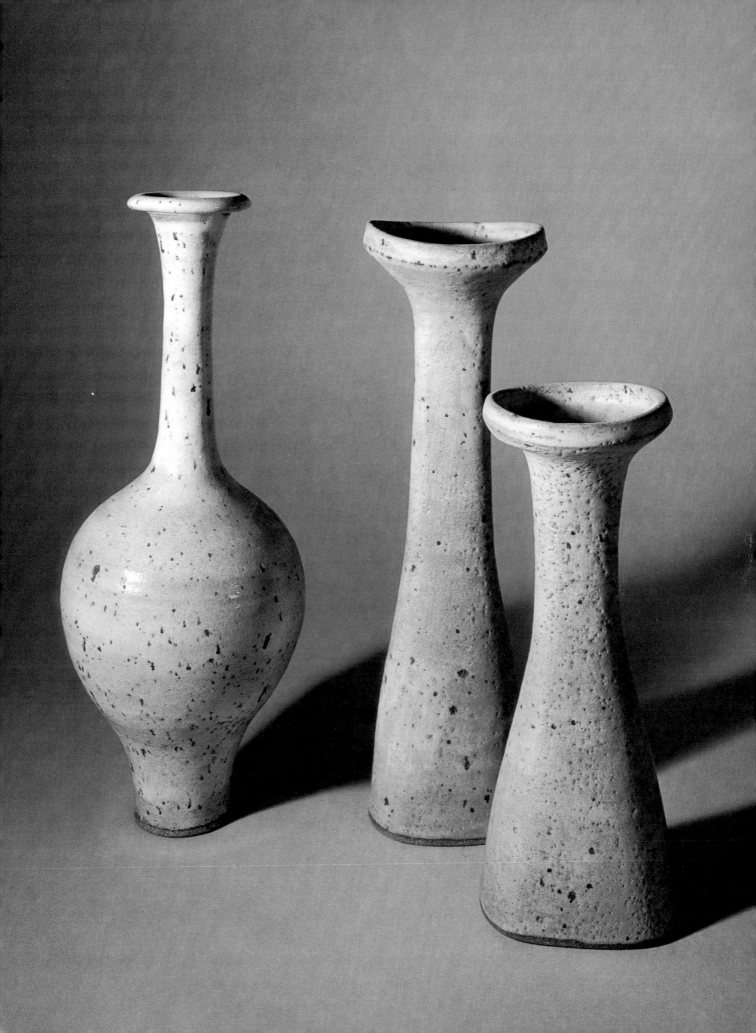

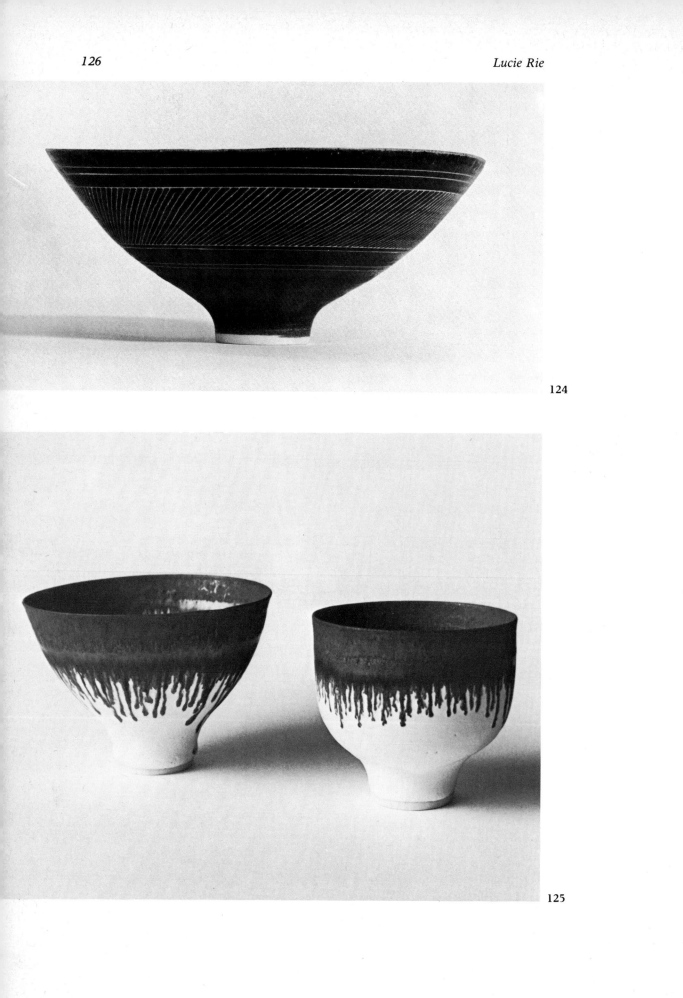

124

125 12

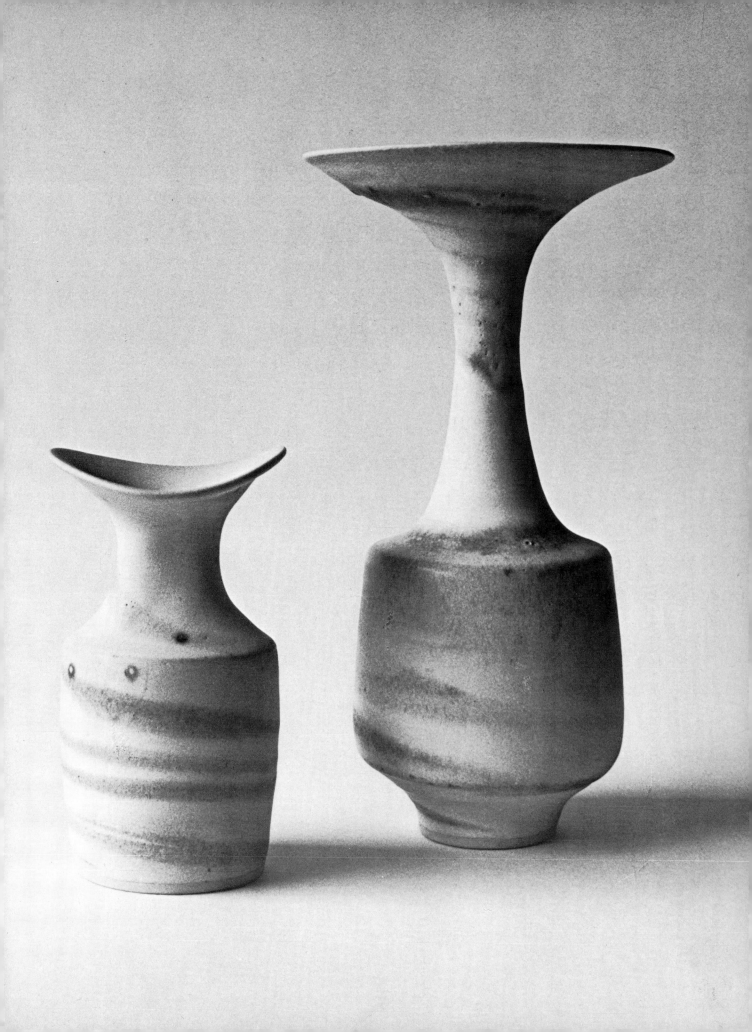

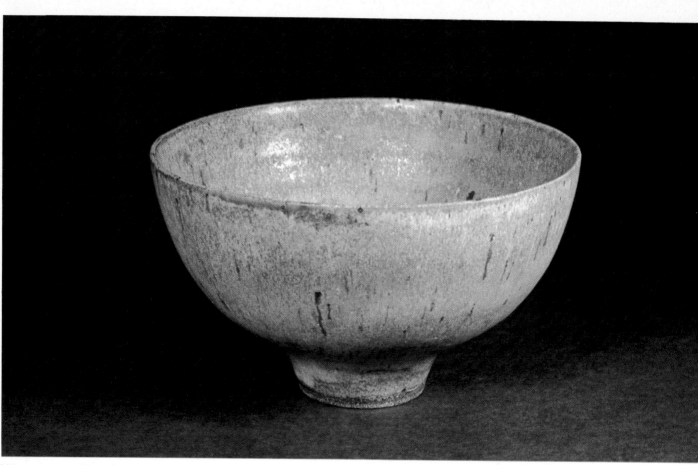

127

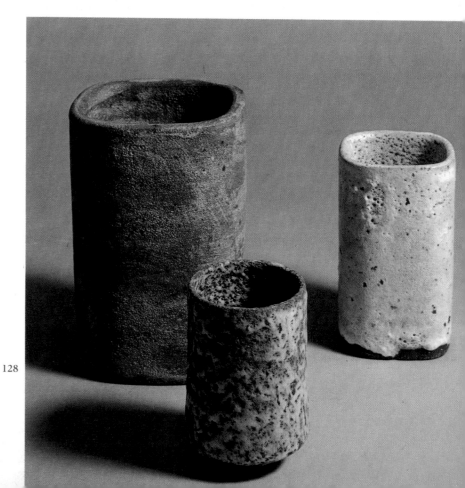

128

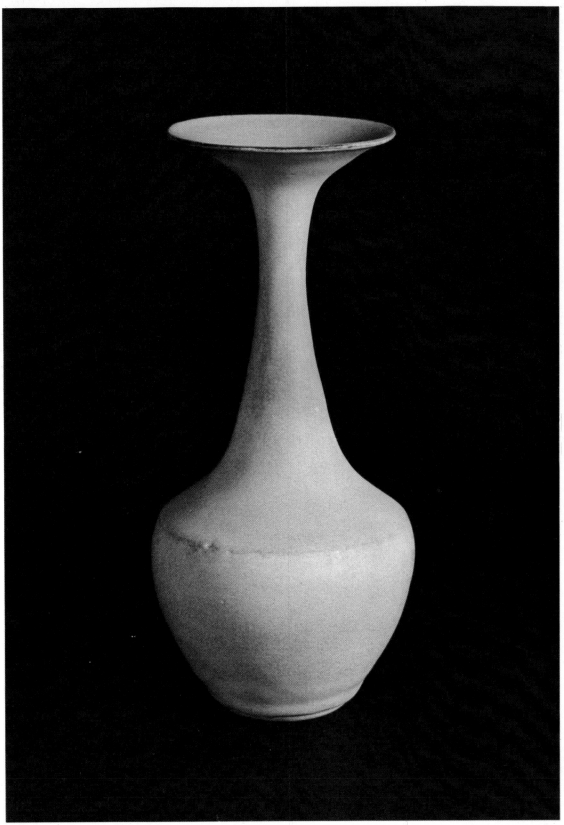

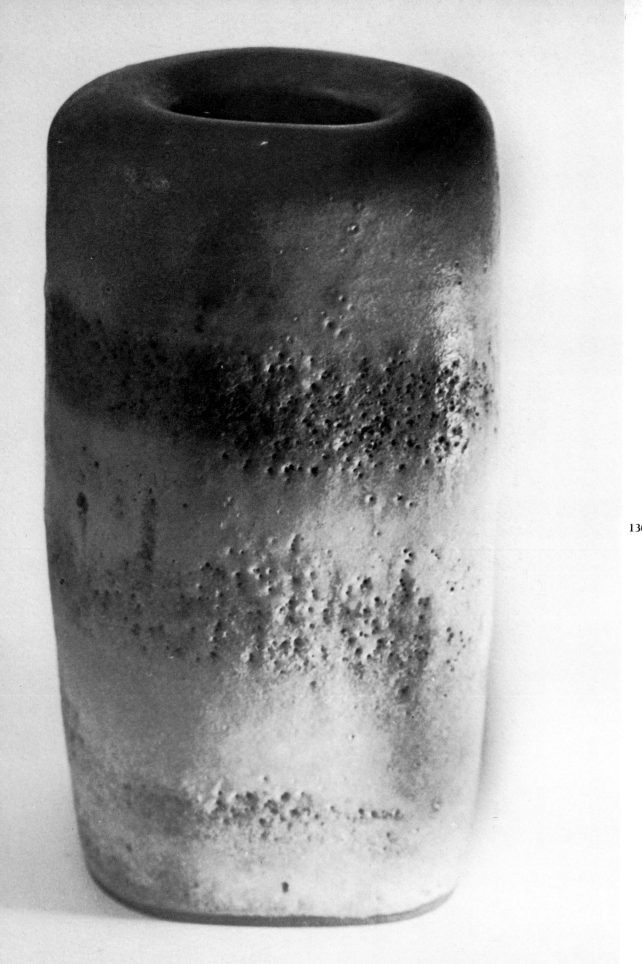

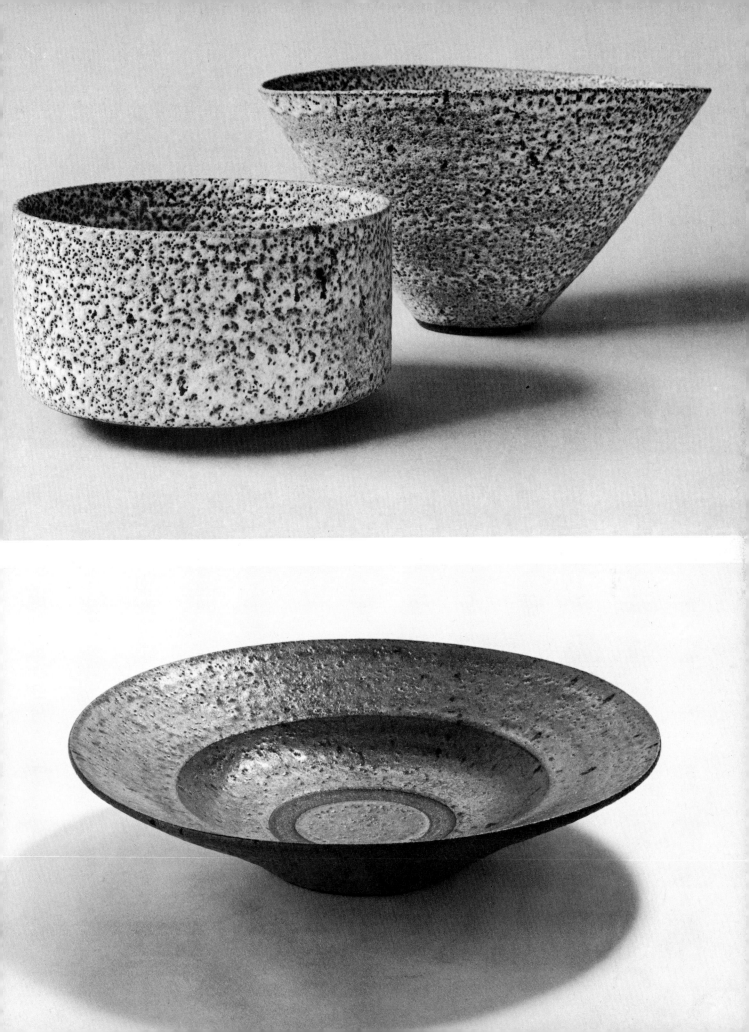

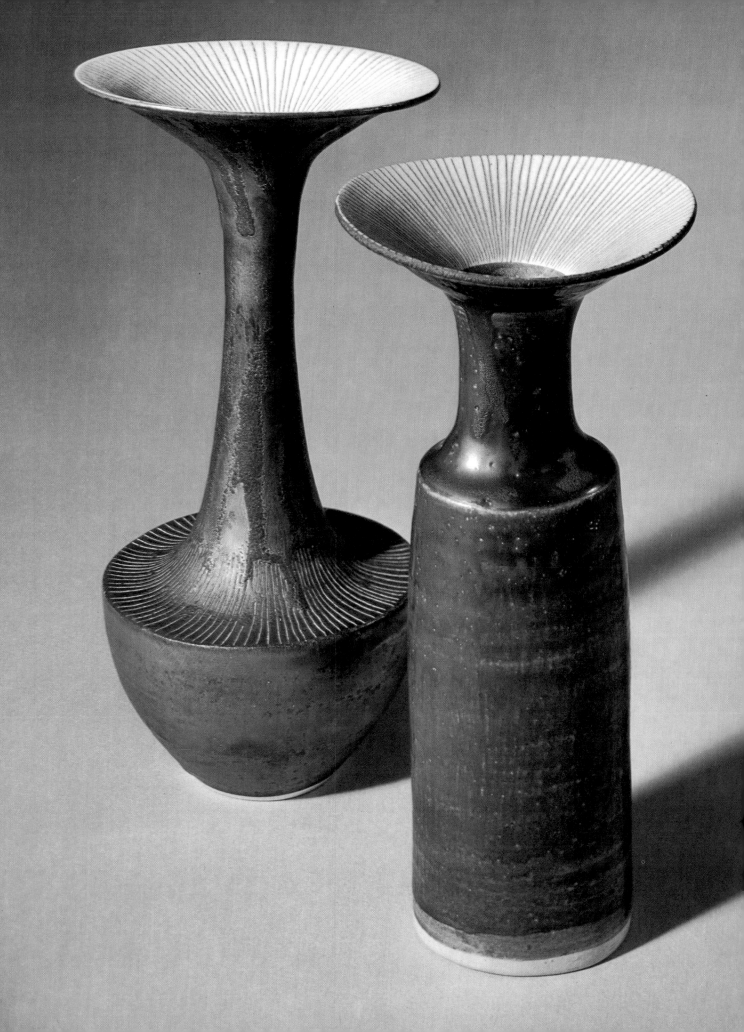

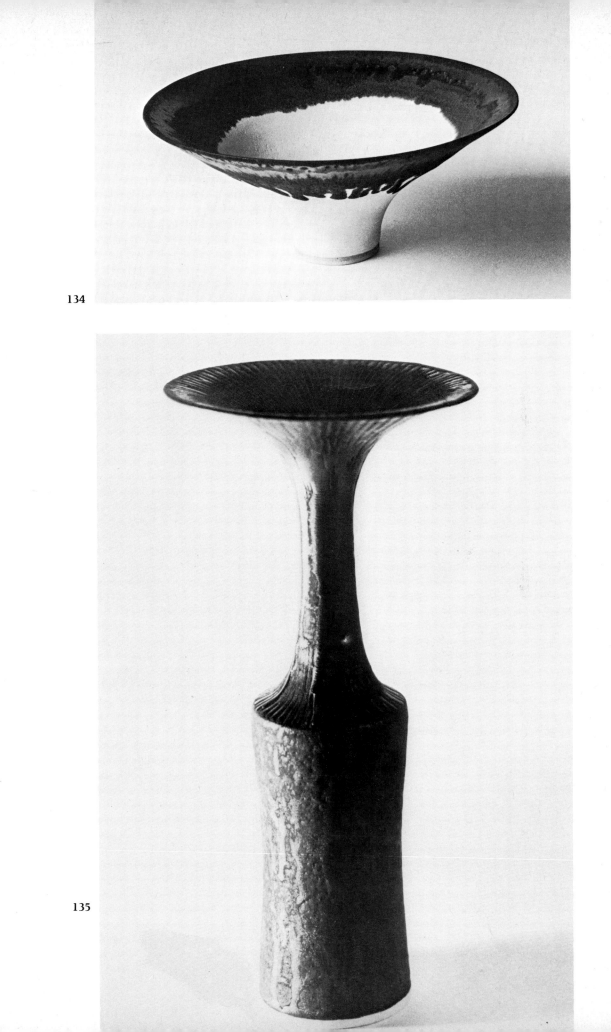

134

135

Gillian Lowndes

Gillian Lowndes is a ceramic artist whose sculptural pottery combines arresting forms with fine tactile quality, bringing unexpected shapes within the compass of ceramic materials. She is uninhibited by traditional purposes and disciplines, and uses her own techniques with clear-cut intentions.

She is excited by oriental pottery, particularly Japanese pottery of all ages, but it is contemporary American free pottery and the work of American artists such as Claes Oldenburg which is the strongest influence on her own work. In addition, her interest in European sculpture as represented by such artists as Brancusi, Arp, Zadkine and Miro have had a bearing on her pottery, as the illustrations show. Her ability to translate sculptural forms fluently into ceramic objects earns the respect of more inhibited potters. 'She will make a shape which is more drainpipe than anything else,' says Hans Coper, 'yet somehow it is a pot.' Her new work is eagerly awaited, not, as with Lucie Rie, to see how a well-established range of shapes and textures has been explored and refined, but rather to see what new aspect of three-dimensional form she has been able to realize as pottery.

Like the other women potters in this selection, Gillian Lowndes belies the image of the tough country craftswoman who does a man's work with horny hands and ground-down fingernails. She is slight in build, and while strength is an asset to a potter she has turned her small hands to advantage in making delicate coiled and pinched pots (see Plate 140), which gain from her lightness of touch. Not all her work is small. In fact, like Ruth Duckworth's, it is largely divided between massive stoneware and fine porcelain shapes, made as individual pieces and not as repeat work.

Born in 1936, Gillian Lowndes lived in India as a child. From 1955 to 1958 she studied at the Central School of Arts and Crafts in London, working under Gilbert Harding-Green, Bill Newland and Gordon Baldwin. In 1958 she went to Paris to work at the Ecole des Beaux Arts. She hired an improvised studio – it was a garage – and kiln in Montparnasse, but it was some time before her wide interest in the arts crystallized into a determination to work as a potter, using only ceramic materials to express her ideas about form.

Returning to London, in 1960 she joined with Robin Welch and Kate Watts in setting up a pottery in Old Gloucester Street, Bloomsbury, and began to concentrate on hand-built work. Her first real enjoyment of pottery came when she began to coil pots in this workshop, and imaginative and original work began to flow freely as she shook off earlier disciplines. Her first one-man show – an exhibition of pinched pots –

was held in 1961 at Primavera in London. After working for six years in London she moved to Chippenham in 1966, sharing a workshop there with Ian Auld. In 1970 she travelled with him to Nigeria, staying nearly two years at Ife, where Ian Auld held a university post. Although she travelled to some extent in Africa, a visit to Italy in late 1971 was more stimulating to her work in ceramics, particularly seventeenth-century painting and architecture, and the flame and sun patterns in Italian decoration. She has also been influenced since by European eighteenth-century furniture, especially its flamboyant details.

Gillian Lowndes' pots are very sensual, yet the shapes which interest her are different from the organic shapes which inspire Ruth Duckworth. Very often they are man-made objects, from grid covers, railings or ventilators, originally designed without any thought to their decorative qualities, to chair legs and bed covers. She returns repeatedly to the theme of cyclical curves, undulating rhythmic forms which are truly biological, though not very easy to see in nature. Like many contemporary painters, she responds to some of the more puzzling aspects of physics and optics (she once coiled a Klein bottle – the tube with a continuous surface inside and out), is responsive to textures, shapes and relationships which come about by accident in everyday life, and she often succeeds in recreating and stabilizing fleeting images.

Her hollow pots have no function and apart from large thrown or coiled bowls she has made no attempt to align her pottery with domestic use. She finds throwing disappointing, and even if she throws simple cylindrical shapes, to her the result seems dull and lifeless compared with the same form when made by hand. Thus the cylindrical base of the pot shown in Plate 142 was not thrown on the wheel, but coiled instead. The large pot on page 134 was quickly coiled in her London workshop when the photograph was being taken. In more recent years, however, she has abandoned coiling for slab and press-moulding, and a combination of the two.

In decorating her pottery Gillian Lowndes was once associated with incised decoration, made with a needle and filled with oxides for tonal emphasis, like abstract tattooing, sometimes contradicting and sometimes emphasizing the main form of the pot (see Plate 143), but as her press-moulded shapes have become more complex she has tended to leave them undecorated, simply covering them all over with a plain creamy semi-matt glaze.

Like many potters, her work in the 1970s has become more figurative, including slipcast objects like cowrie shells, and borrowing details from furniture, either as enigmatic motifs such as ball-and-claw feet, or as repeating decorative elements such as beading or quilting. Thus the decorative wall panels as shown in Plates 144–147 are assemblages of scraps of eighteenth-century formal living, transformed into modern ceramic. They are outstanding examples of Gillian Lowndes' sense of design in which a dominant pattern asserts itself above intricate sub-rhythms.

The technical achievement of much of her work is very striking: trailing porcelain shapes, daring combinations of thick-slab panels with delicately coiled tubes. Other potters often wonder how the tall twisting forms like those shown on Plate 141 stand up. The answer is simple: they often break down. Gillian Lowndes has no easy relationship with clay, no ingrained rhythm of work that makes a weekly kiln firing an unexceptional event. Her work is experimental in that it breaks new ground, but she does not enjoy experiment, glaze preparation or body testing. The result is that every kiln firing is an ordeal. She does not attack technical problems with enthusiasm, but seems to work on the principle that if you want something enough it

is worth trying again and again until finally it works. Thus the casualty rate in her pots is high, but it is not through poor workmanship; rather because she is attempting to fire very difficult forms to very high standards. Like all artist potters, she is critical of her own work, and allows only the best to leave her workshop. She also regards her pottery-making as a very private activity and prefers to keep everything she makes unseen until she is ready for an exhibition.

As a hand-builder she requires very little equipment for making pots. She has worked for some years with a large-capacity Cromartie electric kiln, avoiding reduction atmospheres and always taking the temperature to 1,280°C. She uses Crank Mixture and Moira buff clay for all her stoneware, mixing the two clays in varying proportions, and she makes her own porcelain body.

Gillian Lowndes has undertaken part-time teaching since 1959. A sensitive draughtsman, she taught plant drawing within the ceramics department of the Central School for three years, and was involved as a teacher in the famous Harrow School of Art workshop course. She has also taught at Brighton, the West of England College of Art, later the Bristol Polytechnic, and at Camberwell where her undogmatic approach has won her many admirers as a teacher, and she has undoubtedly influenced a wide range of students. As a potter, however, she feels detached from all movements current in Britain. She welcomes the opportunity to exhibit her work, and regrets the relative lack of recognition of non-functional pottery, especially in Britain. However, she is unlikely to campaign actively on its behalf, for she does not enjoy discussing pottery. She sees her sculptural ceramics in very personal terms and they are made primarily for herself.

Family responsibilities together with teaching commitments have reduced the amount of pottery she has produced since 1970, but a commission or exhibition, such as the London Crafts Centre exhibition in 1976 with Ian Auld, gives a spur to her work, which progresses both in haunting originality and in vigour.

Her exhibitions have included Primavera, London and Cambridge, 1961, 1965, 1966, 1968, 1969, 1974; Munich 1963, 1965, 1966, 1970; Bristol (Guild), 1962 (Craft and Industry) 1967 and the British Crafts Centre 1970 and 1976. She has also exhibited in Edinburgh, Copenhagen, Sydney, Geneva (Silver Medallist 1967), Istanbul and Tokyo (British Council 1970), and in America in 1970, in New York and in the Smithsonian travelling exhibition. Her work is in many collections in America and Britain including Newark Museum, the Victoria and Albert Museum and the Inner London Education Authority.

137 Drum form This pot has hollow walls and a hollow space between the flat bottom of the inside and the base. Evocative of many biological and topological forms, it is best seen when placed on the floor. Striations on the outside wall are the result of tooling with a saw blade. The pitted glaze is the colour of a white cheese. 15 in. diameter, 1,280°C oxidized.
Collection of the artist

138 Pipe forms These two striking pots are entirely made from coils, apart from the flat slabs across their bases and across the ends of the cap to the form on the right. This cap is attached to the main form with Araldite and metal pins. The form on the left has a coating of white slip, painted on, and is glazed with a thin ash glaze containing fireclay grog. The form on the right has a felspathic titanium glaze, thin and very matt. 26 in. and 30 in. high, 1,280°C oxidized.
Collection of the artist

139 Two coiled forms These two symmetrical pots, coiled throughout, recall both lathe-turned wooden forms like the banister shafts at one of the potter's workshops and the tiny metal weights of a chemical balance. There are two glazes: a thin dark brown ash glaze overlaid with a thick white ash glaze which has turned honey coloured. The surface is slightly pitted owing to the double glazing. 14 in. and 15 in. high, 1,280°C oxidized.
Collection of the artist

140 Pinched bowl This porcelain bowl is pinched to a delicate seven-sided shape, finned like a seed pod. The incised decoration, filled with iron oxide, was sandpapered before firing. The bowl is based on an oval plan, and rises from a very small base. The dark brown decoration contrasts with a pale green semi-matt glaze. 2½ in. high, 1,280°C reduced.
Collection of Kenneth Clark

141 Four standing forms These twisted pipes are based on cylinders 3 in. in diameter. They are coiled throughout and rather unstable, but the potter rejected the idea of setting them in a concrete base, as this might detract from their form. The buff glaze is a thin titanium glaze, with the body showing through. The soft grey glaze takes its colour from a mixture of nickel oxide and cobalt. 24 in. to 30 in. high, 1,280°C oxidized.
Collection of the artist

142 Coiled pot Coils are used both for the bulging asymmetrical top and the cylinder below the waist. It is glazed first with a cobalt and iron rich glaze, then with a white glaze poured on. 12 in. high, 1,280°C oxidized.
Collection of Michael Holford

143 Tile This tile made from Crank Mixture rises in relief about two inches. Designed as a wall decoration, it is one of several tiles which were inspired by ripples and counter ripples in the bath. The domed-up areas in the centre were supported in the making by balls of hard clay, and the incised decoration which traces around the central shapes was filled with iron oxide before the first firing. The dry glaze, an ash glaze containing cobalt, turns blue where it is thick, and dark brown where it is very thin. 14 in. square, 1,280°C oxidized.
Paisley Museum

144 Wall panel The panel was assembled using press-moulded stoneware casts from moulds taken directly from bits and pieces of furniture: ball and clay feet, plastic quilting and reinforced flexible hose. The applied sun or flame rays relate to Italian Baroque church decoration. This catholic mixture is glazed with a white titanium glaze, and mounted on brown perspex. 8 in. by 11 in., 1,280°C oxidized.
Private collection

145 Wall panel Looking like a decorated inflated cushion, this small panel is made from extruded clay with press-moulded additions in the form of cowrie shells and small claw feet. It has a matt white titanium glaze over a dark rust felspathic glaze. It is mounted on brown perspex. 8 in. by 8 in., 1,280°C oxidized.
Private collection

146 Wall panel Into this composite relief, made from press-moulded pieces, creep elements of eighteenth century furniture – bead moulding and quilting, a ball and claw foot, two rubber stoppers and slightly sinister downward-pointing stylized flames. Near the bottom is decay as if from larval infestation, and in the folds near the top, moths. It has a white titanium glaze, and is mounted on brown perspex. 14 in. by 8 in., 1,280°C oxidized.
Private collection

147 Wall panel Made from extruded clay, mitred and joined, this small form has a claw foot at its centre, and a squashed turned shape like a caterpillar coming up from below. It is glazed in an iron-rich ash glaze, but the white 'peanuts' were added after the glaze had been applied, and are unglazed porcelain. 8 in. by 8 in., 1,280°C oxidized.
Private collection

137

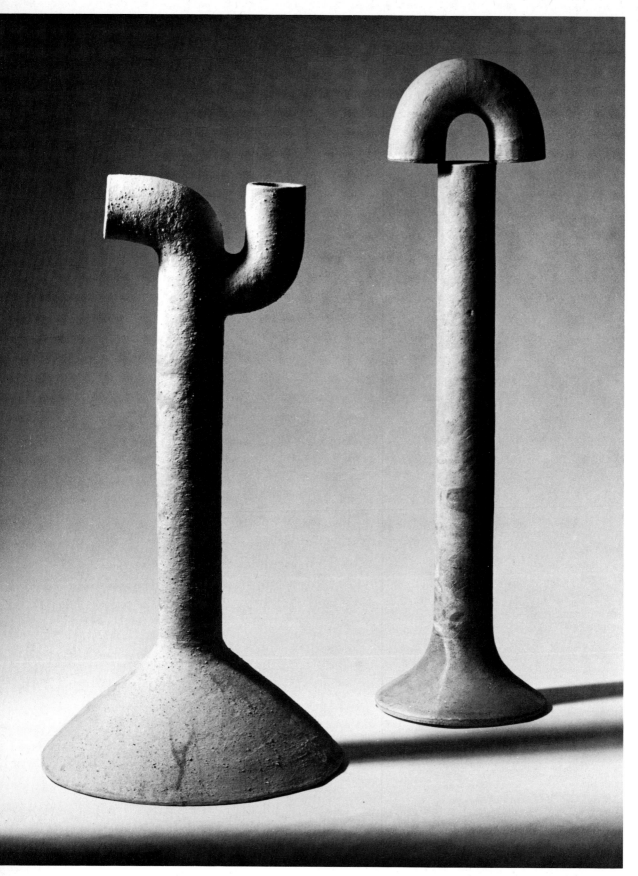

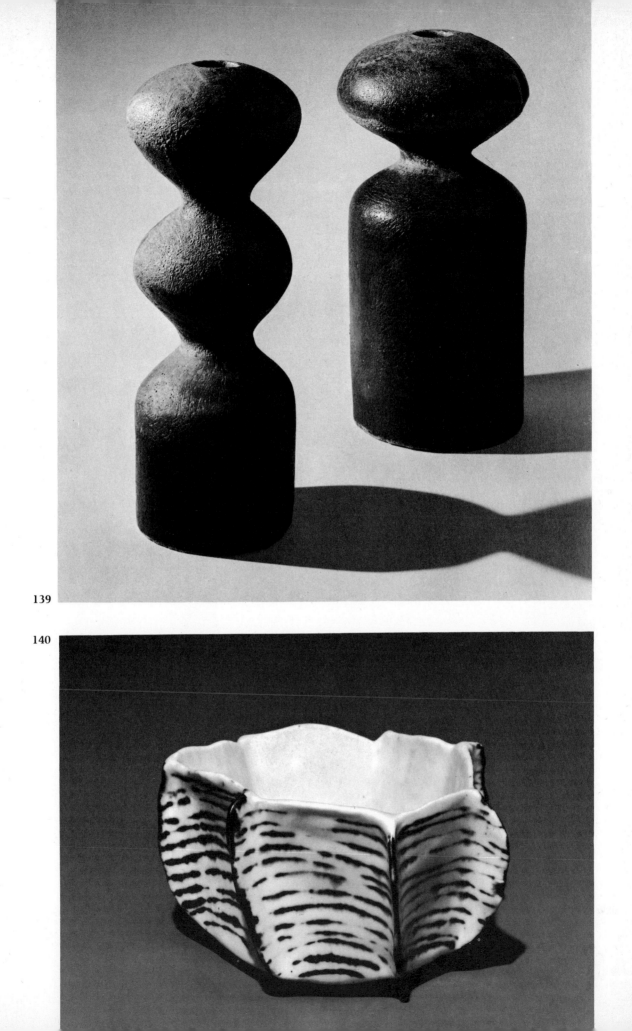

139

140

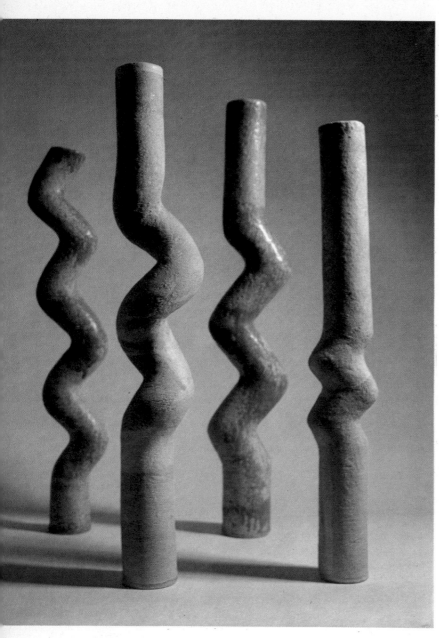

141

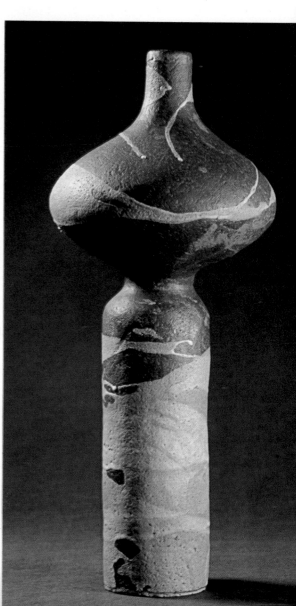

142

143

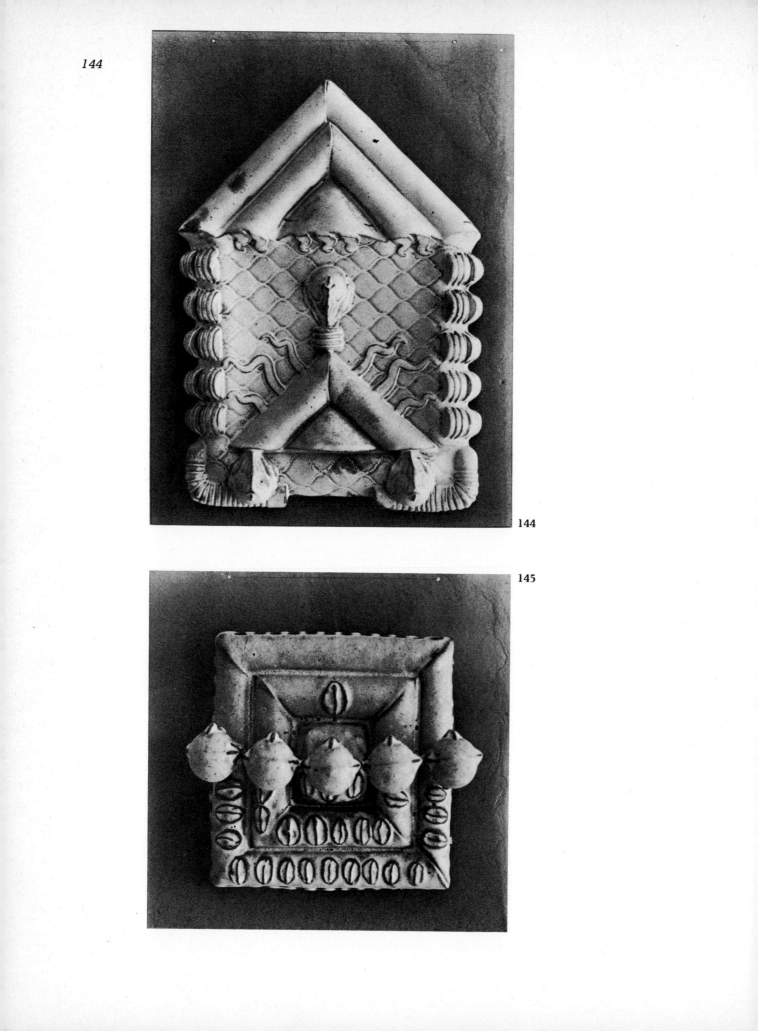

144

145

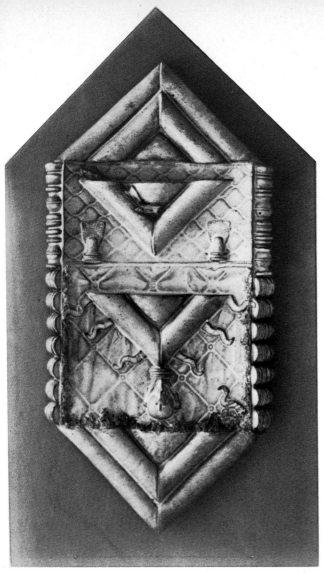

146

147

Alan Barrett-Danes

The positive reaction to Alan Barrett-Danes's work is quite likely to be a recoiling, as one would recoil from finding a grass snake in a green salad. Lovingly using clay, lustre glazed, as a representational medium, he and his wife create pot-based sculptures on the themes of decay and degeneration, closely allied to dream fantasies in which size scales are reversed and organic forms are chosen as obvious symbols of putrefaction.

Unlike the puzzling contradictions in the surrealism of Magritte or Man Ray, the fantasies in the Barrett-Danes's work (ceramics and glaze by Alan Barrett-Danes, figurative details by his wife Ruth) are called up from remembered fears of childhood, peopled by impish creatures half lovable, half hateful, and the more adult fears of physical incapacity and loneliness. Though the subjects are serious, the ceramics are not pretentious; they are not pots which bear a message, they are encapsulated private nightmares, carried out with the same attention to detail and finesse as porcelain figures from Meissen.

No shrill, tortured nature is evident in the man: Alan Barrett-Danes is a gentle, family man, a hard-working potter and a diligent teacher of ceramic techniques. He would probably regard himself as an archetypal example of a teacher whose post allows him to experiment and make exhibition pieces for galleries and private collectors, but his background is one of pottery and clay, man and boy. His great-grandfather was a potter, and his grandfather was Edward Baker, of the Hoo Pottery and the Upchurch Pottery in Kent, England. His mother's five brothers were *all* potters, and worked either in the family pottery at Upchurch or the nearby Rainham pottery which they founded. Alan, born in 1935, played as a child and worked as a youth in the primitive environment of the family potteries, and in 1951 defied family pressures to join the workshop by opting instead for an Art School training, where horizons would be wider. Art schools were, and often still are, anathema to the country craftsman, and it was not until after he had completed an NDD course at Stoke-on-Trent that he shouldered the family tradition and 'made good' by deciding to work in the Staffordshire Potteries as a designer.

The 1950s were a time of anti-elitism in the decorative arts, and Alan Barrett-Danes saw the invasion of the placid design departments of the Stoke-on-Trent factories by a clamorous demand for colour schemes and carpet-matching coffee sets: when at the Paragon Bone China Company he was obliged to transfer curtain patterns on to teapots. The flexibility of the factories at this time, when tooling up for new lines was not so expensive, gave him a great deal of experience in technical matters. It also gave

him the opportunity to experiment against a background contrasting markedly with the unmechanized world of the family pottery in Kent, which survived until 1964 without gas, electricity, running water or pugmill.

After eight years in industry he took a part-time teaching job at Stoke-on-Trent School of Art and, increasingly drawn into teaching, he came into contact once more with the raw material – clay – from which the division of labour in industry had removed him. He began to throw again, making fluent stoneware along traditional lines, glazed in tenmokus and celadons.

By 1970 he had severed his connections with industry and was a lecturer in ceramics at Cardiff College of Art, Wales. This is where the story really starts, on a hill called 'The Wenalt', a name which seems to place it appropriately in Tolkien's Middle Earth. Here, in August and September, toadstools appear, change colour and decay so rapidly that Alan Barrett-Danes, who came across them by chance in the long grass with his children, wanted to record their growth and decay, to draw them and then to make them in clay.

Fungi have had a fascination for many potters of our time, partly because of their form and partly their porcellanic appearance when at their best. Alan's first aim was simply to recreate in clay the fungi he had seen, and to find ceramic equivalents for their qualities, so that they were both toadstools and ceramics at the same time. He found it difficult to make the 'gills' convincingly by hand means and made a plaster mould from a ribbed glass lampshade, using the subsequent casts in a soft and pliable state so that the organic forms of the fungus gills did not have a mechanical appearance when examined closely.

After making fungus growths in all stages of decay and liquefaction, the next step was to make minute 'environments' on a clay 'earth' for the snails and toads which lived cheek-by-jowl with the fungi of the Wenalt (see Plate 151). Then came a series of works – inviting comparison with the earthenware *Natures Mortes* of Palissy – each about the size of a dinner plate, in which paper-thin ceramic empty eggshells in nests are invaded by toads and snails. The perhaps rather unpalatable life cycle of toad-eats-slug became more pointed in these scavenging episodes, but in 1973–4 Alan Barrett-Danes made a change in direction. Though the mushroom stalks and canopies in the set pieces had always been wheel-made, he now made the thrown unit the basic form, and then decorated it with animals metamorphosing into humans.

His long-term interest in lustre was first given scope in his own work with the early narrative pots – the warty backs of toads were glazed with lustres made mobile by a spray of paraffin before firing, and this contrasted with the grey-green dry slip surfaces on the fungi. On the figure-encrusted pots of 1973–4 lustre is used over the whole surface, binding the figure to the vessel and reminiscent of the anthropomorphic work of Lalique. The thrown shapes are fat, two-piece jars; the creatures crawl and drape themselves around the surface in positions of despair and abandonment. These figures are mainly the work of Ruth Barrett-Danes, and both artists readily acknowledge the influence of Bosch, Richard Dadd, Durer and Blake, both as inspiration and reference. Another major influence is expressionist Romanesque carving, whilst homage is paid to the superb naturalism of Netsuke carvings in ivory.

The discipline of the wheel was abandoned for a time with a series of cabbage sculptures beginning in 1974. They give plenty of scope for Alan's experiment in lustre and Ruth's figure fantasies, for the realistic lustrous surface is covered in

glutinous figures far more repellent than any army of caterpillars. The strongly-veined cabbage leaves are cast from moulds made from actual leaves of different sizes, using either slip or plastic clay press-moulded, but in either case removing the cast while it is still pliable to allow it to be curved and combined with other leaves into a convincing and life-size cabbage. This series was followed by another in which the cabbage itself took the form of a human head, with miniature figures sitting on the cheeks or forming the features (see Plates 152 and 155).

Alan Barrett-Danes uses Mellors white porcelanic clay. The biscuit is fired very high, to over 1,200°C. Finding lead glazes unsatisfactory, he uses a soft 960°C alkaline-based glaze made of alkaline frit 85, china clay 10, whiting 5, reduced in very carefully controlled conditions at exactly 800°C. He gets the glaze to stick to his dense white biscuited surface by adding a little calcium sulphate to the glaze before spraying, and the lustre salts go into the glaze through a 200 mesh lawn. Luckily, the quantities required to produce the varying pearly lustres are very small, for materials like gold chloride are expensive, and the extensive lustre testing Alan Barrett-Danes does before committing glaze to work is a costly exercise. The principal salts that he uses are silver sulphide (1–2 grams in a glaze batch of 200 grams will produce a pinkish-gold), silver sulphate and silver nitrate, bismuth sulphide (with a small addition of silver to a total of 3 per cent of the glaze quantity reduction gives a violet lustre, broken with brownish grains), cobalt sulphate (dull blue), gold chloride (gold with pink), chromic potassium sulphate, copper sulphate, copper oxide and copper carbonate. The salts of copper sulphate, familiar in the traditional lustre wares of Islam, Valencia and Majorca for their flame-red colours, he recommends to the beginner who wants to experiment.

The secret of successful lustres is in the reduction, which can either be made 'on the way down' at 800°C, or by means of a special firing. Without a reducing atmosphere metal salts are wasted, yielding only an uninteresting cloudy surface. The pearly iridescence which Alan Barrett-Danes has given to his animal pots and his cabbages comes from 20–22 minutes of heavy reduction at 800°C in a gas kiln. He finds that silver salts need perhaps 2 minutes longer reduction than copper salts, as well as requiring a pale base on which to work; silver in combination with cobalt produces an exciting lustre; copper salts will produce their own colour and iridescence as well.

So often in seeking to produce precise qualities of surface and colour the finality of the kiln's work is inimical. Luckily with lustre the results can be modified by refiring again and again without loss of quality. Lustre is a precise technique, with results which look fleeting but are happily permanent.

Alan Barrett-Danes is meticulous in his methods, and records all his experiments in detail. His search for perfection is like the pursuit of elaborate detail by the illustrators of Germanic fairy stories, where each unimportant constituent contributes to the emotional impact of the whole. Being less sculptural and more concerned with narrative, he is thus quite separate from the other potters in this selection.

The Barrett-Danes's ceramic fantasies were first widely seen in the International Ceramics Exhibition in London in 1972. With a limited production, he exhibits once or twice a year in mixed exhibitions, and the Oxford Gallery acts as a permanent agent. His work is in public collections including Keele University, the Welsh Arts Council, Chunichi Shimbun in Nagoya, Japan, and Portsmouth Museum.

149 Aggression The lidded thrown vessel is bulbous and squat, slightly oriental, but the two applied figures change its mood completely. The attenuated forms have an Art Nouveau feeling, and add an important element of drawing. The female figure on the top lies in glutinous abandonment. The more male figure with frog face and jagged teeth creeps up the side of the pot and chews at the rim. The figures are differentiated from the rest of the pot by the in-glaze lustre decoration, for they are bluish from cobalt sulphate while the rest of the pot is a pearly greenish-yellow. 7 in. high, 960°C reduced.
Private collection

150 Fungi with courting toads The astonishing realism of this piece is increased by the use of vanadium oxide mixed with earthenware clay in the ratio 1:10 and sprayed on to the completed form to give a mould-grey granular surface when fired. The mushroom tops are thrown, the stalks and the toads modelled by hand. There is no decoration on the fungi apart from the slip. The toads are glazed with in-glaze lustre containing potassium, silver and chrome. 8 in. high, 960°C reduced.
Private collection

151 Environment The wheel-thrown fungus forms are arranged on a twelve-inch dome, covered with scraps of clay and sprayed with a slip containing manganese and cobalt. The undersides of the fungi, sheltered from the spray, have a life-like pallor. On this murky purple background selected areas were sprayed with a copper slip to make them green. The many toads and snails are jewel-like in contrast. They have on-glaze lustres, painted on to earthenware glazed forms and subjected to two subsequent firings. A thin spray of paraffin between the lustre coats acted as a weak resist to the second coat, and allows the toad's warts to stand out in bright green from the lustrous dark green skin. 12 in. diameter, 960°C reduced.
Collection of the artist

152 Cabbage head Life-like cabbage leaves reveal a life-size human head, from the recesses of which crawl monstrous dark imps. The horror of putrefying skin and animal forms oozing from mouth and eyes is heightened by the loving care with which the object is finished. The head has an in-glaze lustre using silver sulphate and bismuth nitrate, and has a pearly purple colour, darker in the crevices. 9 in. long, 960°C reduced.
Collection of the artist

153 Animal pot As with Plate 149, the figures transform a neatly thrown lidded jar of oriental shape. The female figure on top sits in passive morose triumph. The male figure below is a straining, pathetic contrast. The in-glaze lustre contains silver sulphate and bismuth nitrate, pearly mauve in colour. 8 in. high, 960°C reduced.
Private collection

154 Shell people Clay cabbage leaves press-moulded in moulds made from real leaves are bent and modelled while still damp. The in-glaze lustre is ideally suited to the form, emphasizing the ribbing of the leaves. Out of the cabbage crawl snails and other creatures, part lizard, part woman, and a creature half human, half goat with a shell on its back sits on the top. The creatures are blue with cobalt sulphate. Such a ceramic has to be seen to be believed. 10 in. long, 960°C reduced.
Collection of J. D. H. Catleugh

155 Cabbage pot Sometimes the figures which sit on the Barrett-Danes' cabbage pots are more complacent, less tortured. Sometimes, instead of emerging from or disappearing into the many crevices, they simply sit immobile, in isolation, but never graceful. The fat woman's hair echoes the striated form of the cabbage stalks and the cabbage she sits on is also the head of a man. As usual the in-glaze lustre, pearly from silver sulphate and bismuth nitrate, is a perfect complement to the pot. 8 in. long, 960°C reduced.
Collection of the artist

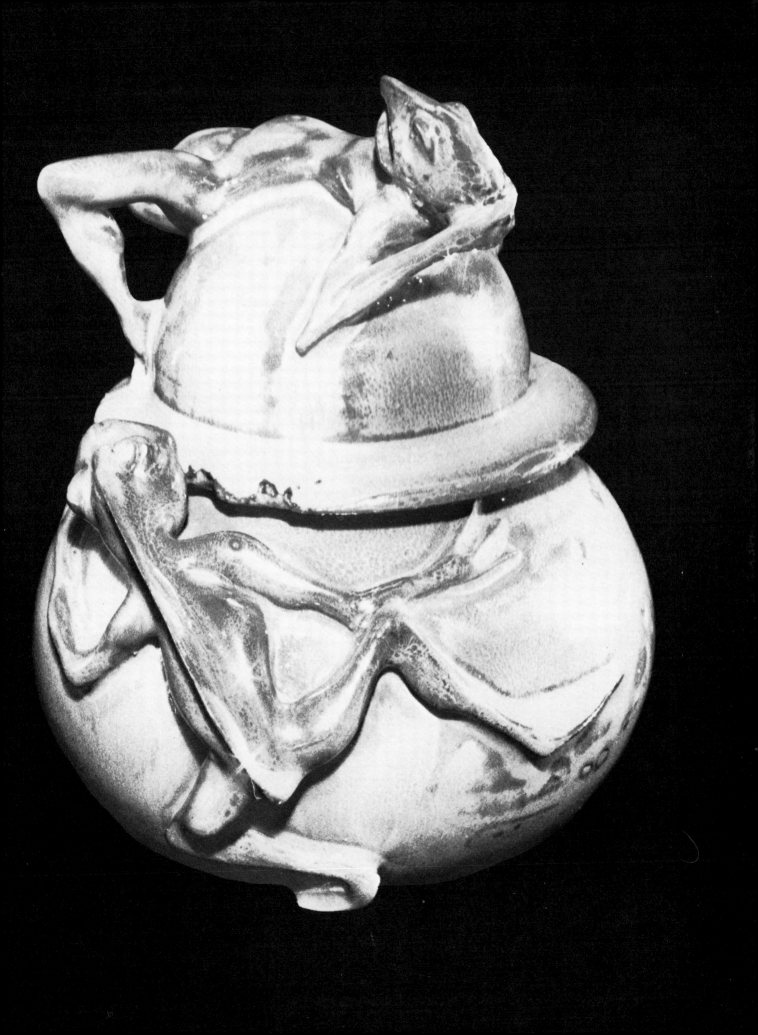

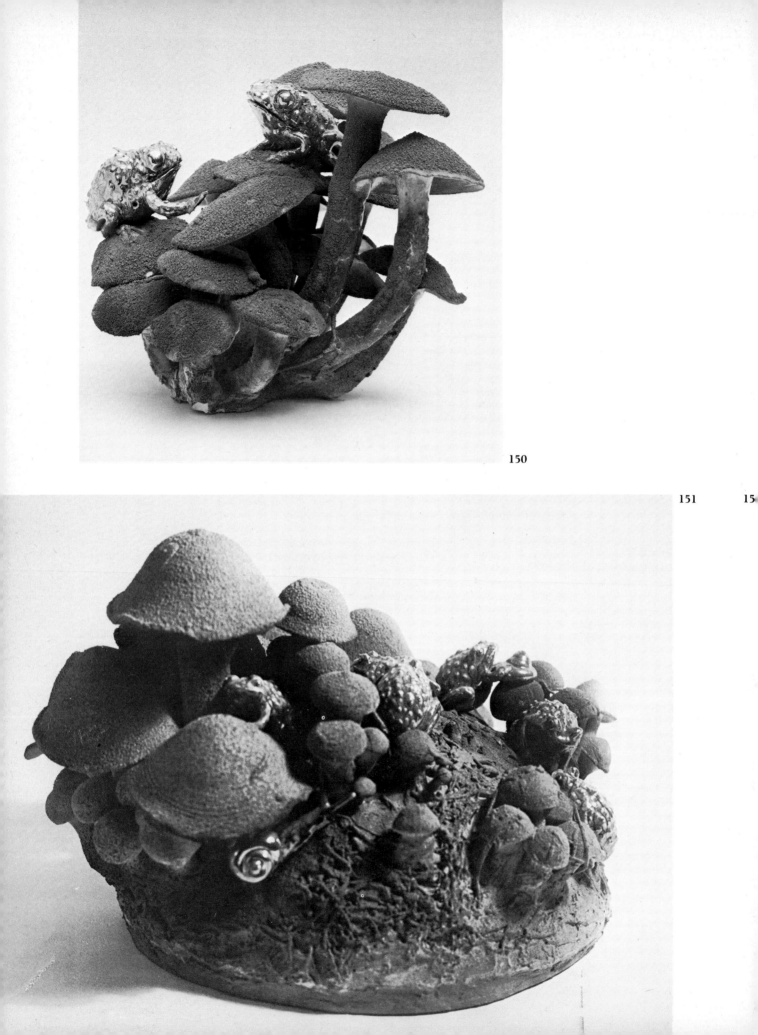

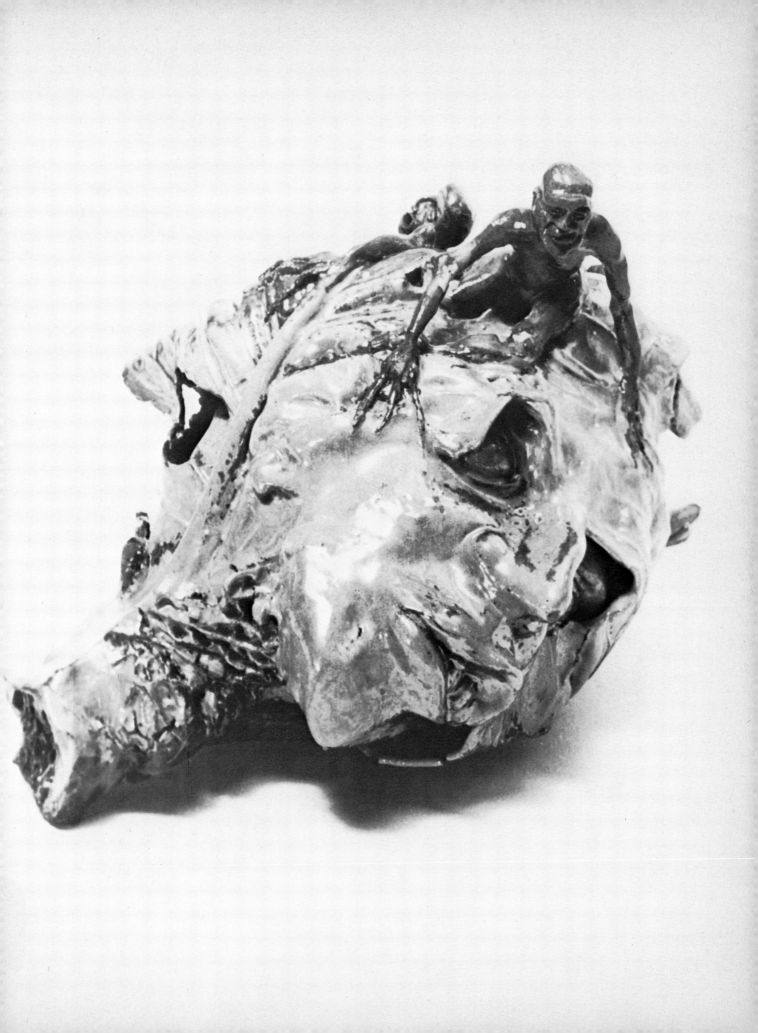

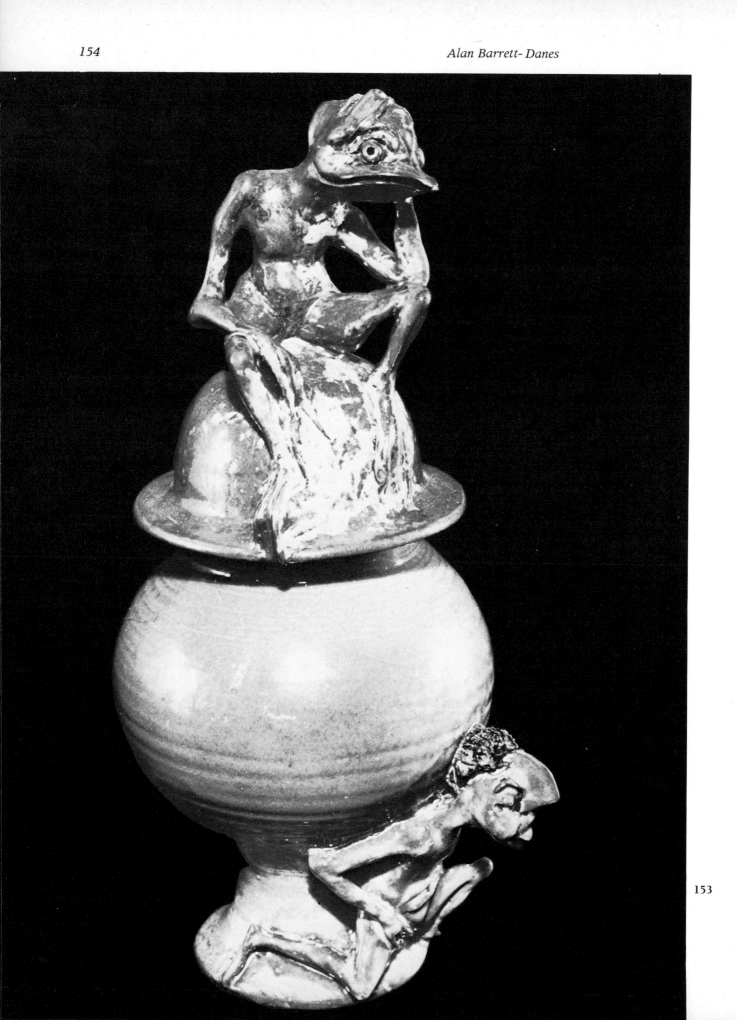

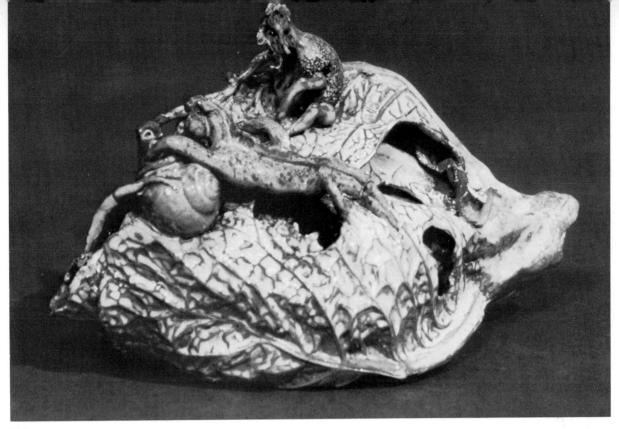

154

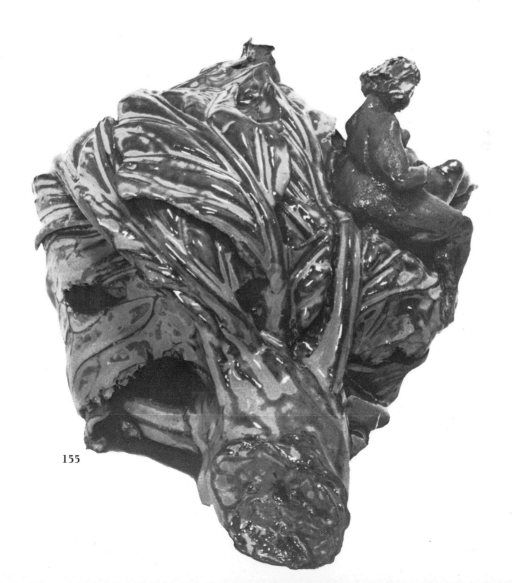

155

Dan Arbeid

Dan Arbeid's work is adventurous. It speaks the language of pottery in a loud voice, and the luscious organic forms seem to invite or to challenge comment. While some people are antagonistic towards his pottery, prejudiced perhaps by its coarseness, to others his work is an extreme pole in the art of ceramics.

Every piece from his limited production is coaxed and urged restlessly on to completion. He has a deep emotional involvement with each form he begins, and he often finds the pot is transformed in shape and mood several times during the making. He has no rigid conception of the end product when he begins a project: *'Each new piece I make is a journey with an unknown destination.'* Those fellow potters who watch him work sometimes see him carry a pot beyond its optimum form and, dissatisfied, he will often destroy finished work if it does not excite him.

For a potter who relies so much on instinct, and whose best work comes from inspiration rather than from preconceived ideas, his early training and the rigid dogma of his teaching come as a surprise. Instead of progressing, like Bryan Newman, from art school experiment to an organized large-scale production of hand-designed tableware, he reversed this more normal procedure, and from early experience in mass production and factory methods he has moved to a very limited production of individual pieces. This is the result of his personal convictions about the place of a craftsman potter in modern society, and the decision that as far as he is concerned pottery-making must be removed from the constant necessity to sell work to earn a living.

Born of a Jewish family in London in 1928, he left school when he was fourteen, in the middle of the war, to work in a clothing factory. He continued to work as a cutter in tailoring until 1955 when his dissatisfaction reached a peak, and the future appeared to offer no possibility of variety or change. In April 1955, he went to work in Israel on a kibbutz, partly to help to resolve for himself the problems of identification with Jewry, and partly to allow himself the breathing space to find a new direction in life. A year later, in 1956, he went to Beersheba in southern Israel, where he had heard about a new ceramics factory sited on the edge of the Negev desert. Here he met Nechamia Azaz, the Israeli sculptor and potter, who had been given charge of developing studio ware using the factory's facilities. Dan Arbeid's interest in pottery had been awakened before he left England, and the job he was offered in the workshops of the ceramics factory was to provide the new direction he had been seeking. During the next twelve months he energetically absorbed all the techniques and processes which were undertaken in the studio, learning about clays,

mould-making, slip decoration and pouring, jolleying and hand decoration. He helped to increase production in that year by 200 per cent. *'It is very hot in Israel; we could make three or four casts from the same mould in a day.'*

The experience of working at Beersheba left him, however, with a strong desire to explore more fully the aesthetics of pottery-making, and he returned to London to attend the Central School of Art. Late in 1957 he became the technical assistant at the Central School, and he was able to explore the other aspects of ceramics and learn more about the techniques of firing, for in Israel firing had been supervised by another department, with studio pottery packed around sanitary ware in tunnel kilns. In 1958 he began to concentrate on hand built stoneware, encouraged at the Central School by Gilbert Harding-Green, and he produced a series of large pots which combined bold form with an appropriate richness of surface texture and glaze.

Soon afterwards he held his first one-man Exhibition in London, at Primavera in 1959, and his work quickly came to be regarded as a major development in the expressive use of stoneware. Succeeding exhibitions have placed the emphasis, theme-wise, on the different techniques of hand-made individual pottery – wheel-made pots, coiled, beaten and folded, thrown and turned – but always his work has been unified by a sensuous, ripe vegetable quality which no other potter achieves. He does not draw inspiration directly from organic forms, and insists that if natural forms excite him, he makes pots to express his excitement with nature, not to project a particular sensual experience.

Much of his early work was made at New Barnet, Hertfordshire, where he occupied the potter's studio at the Abbey Art Centre. He has since established a workshop at Wendens Ambo in Essex in a converted Victorian village school where he lives with his wife and two children. Dan Arbeid has taught at the Central School since 1959, and also at Farnham School of Art and Camberwell Art School. In 1966 he was appointed lecturer in ceramics at the Central School, and in 1970 he became senior lecturer in the department.

With increasing emphasis placed on his teaching function, and less time available for making pots, he has to tackle the problem of how to present pottery as a discipline to a full-time art student. He is emphatic that he does not want to train craftsmen-potters who are mindless anachronistic automata. He likes his students to appreciate that whatever they make entirely by hand will be made less efficiently than the equivalent article made in a factory. In such a situation a craftsman's greatest potential is his aesthetic sensibility.

Perpetuating hand-made methods for the sake of the sentimental market for rustic articles annoys him, especially when the demand insists on no standards other than a 'hand-made' look, which in itself often encourages bad workmanship. He is equally critical of the low visual standards which still apply in much of the pottery industry, and feels that all designers for industry should have the breadth of training which only an art school can provide. He believes that the function of a pottery depart-ment in an art college is to help individuals to find their own direction and relationship with clay, not to try to fit each student to a precise preconceived set of standards. Perhaps in a self-conscious attempt to maintain a liberal view, he may overwhelm students by plaiting contradictory arguments, and stating positive views from conflicting standpoints. When talking about pottery he often gets carried on a wave of zeal for his subject. When alone with his work he is more tentative and often stressed by uncertainty.

He is frequently confronted with the problem of the relevance of his own marginally functional stoneware shapes: *'I cannot justify or explain my own work in terms of the demands of modern society, and I can offer no public excuse for the things I make.'* He is not making them for a public, but it pleases him when they delight other people. *'. . . but there is a private involvement which is important to me.'* His pottery is bound up with the search for self-awareness, and he seeks to use pottery as the key to an understanding of all creativity. Like Hans Coper, Dan Arbeid is drawn to pottery because many of its values are constants.

Although his work has affinities with pots from other places and times, Dan Arbeid feels that he belongs to no particular tradition, and continually states that the greatest mistake a student can make is to be a slave to an alien tradition. He regrets the blind adherence to Eastern values by many Western potters. *'What is the point here in Europe of making a pot and trying to embody in it a Japanese prayer?'* One can sense in this *cri de coeur* not a call to functionalism so much as an anxious determination to be rid of inappropriate concepts in forming his own precepts. He acknowledges his indebtedness to Gilbert Harding-Green as a teacher and critic of his work, whose sensibility has been a constant guide.

As his teaching duties have increased, the erratic flow of pots from his hands has become even more irregular, but he finds a creative fulfilment in his teaching, which he loves, replacing to some extent the need to make his own work. As a potter of considerable importance, any news of new work coming from his studio in Wendens Ambo is eagerly awaited and welcomed.

He has exhibited many times at Henry Rothschild's galleries in London and Cambridge, and also at the British Crafts Centre, London, and the School of Applied Art, Bristol. Over the past decade he has also exhibited in Rotterdam (Boymans Museum), Cardiff, Prague, Tokyo and Oslo, and his work is represented in private and public collections in many countries, including the travelling collections of the Victoria and Albert Museum and the Inner London Education Authority, and the collection of the West of England School of Art, Bristol.

157 Standing form It is the magnificent silky white glaze, in perfect harmony with the shape, which makes this pot so pleasant to handle. It was coiled from a grey firing body, and scraped down to its present bone-like form. The cool glaze is made from felspar (48 per cent), whiting (20 per cent), china clay (22 per cent) and flint (10 per cent), and is hard, not maturing below 1,300°C. 17 in. high, 1,300°C reduced. 1964.
Victoria and Albert Museum

158 Fruit bowl This bowl is thrown from a highly grogged buff body. The rim and strong handles recall vigorous medieval ware. The ash glaze has an oily texture, burning red where it is thin, and dark again where it lies thickly on the inside. 17 in. diameter, 1,280°C oxidized.
Used in the home of the artist

159 Folded pot 'It could have been made by a Bizen potter', said Gillian Lowndes about this pot. It is made from dark clay, beaten out on sand and china clay and bent into two nearly equal rings, joined at the slight waist. The top is folded out, split and beaten flat. The thick icy glaze varies in depth and texture, and clings to the pot like sea spray to a rocky coast. 13 in. high, 1,250°C oxidized.
Collection of the artist

160 Coiled pot It is difficult to be indifferent to this unusual form, mushrooming up from its wide base, menacing or comic like a vast sea urchin or a budding hydra. The pot was coiled from a mixture of St Thomas's Body and red Staffordshire clay. The boil-like protuberances, regularly placed around the pot, were pressed out from inside with a rubber ball. The unusual surface quality results from a combination of slip and glaze in two glost firings. Black slip was first painted on top of the bumps. A crawling felspathic glaze was then poured over the pot, but rubbed off the bumps. After the first glost firing, the whole surface of the pot was rubbed over with thin black slip containing cobalt oxide. This slip, vitrified into the glaze in the second firing, gives the pot its unusual blue colouring. 15 in. high, 1,250°C; 1,100°C oxidized.
Collection of the artist

161 Standing form Another bone-like shape, this bold form was coiled from a mixture of Crank Mixture and fireclay, and scraped down into a crisp series of organic curves. The glaze inside is felspathic, pearly like the inside of a shell. Outside, a thin coat of simple ash glaze – 50 per cent ash, 50 per cent china clay – gives an engobe with a rough texture. *'I remember it looked beautiful with cornflowers in it, but I wish I*

had it back now, in a plastic state, to alter that terrible rim.' 10 in. high, 1,300°C reduced.
Victoria and Albert Museum

162 Raku teapot Coiled from Crank Mixture and made elephantine with its trunk-like spout and handle, this pot was fired in a raku kiln with an alkaline lead antimony glaze, reduced in sawdust after removal from the fire. 10 in. high.
Collection of the artist

163 Three standing forms Each of these pots is a 'folded' pot, made by rolling out a slab of clay and bending it round, joining the ends together in a clay seam (not visible on the photograph). The clay used contains manganese oxide, and was rolled out on a loose mixture of ash, china clay and sand. Each pot was formed around a rolling pin, and was later given a slab base. The top of the pot in the foreground was quickly made; the other two tops underwent many changes before arriving at their present form. The same glaze is used on all three pots, a lime-silica-felspar glaze which is transparent where it is thin, revealing the frosty texture of the clay. Where it is thicker (towards the top of the tall pot on the left) it is golden, like honey. 8 in., 14 in. and 15½ in. high, 1,250°C oxidized.
left and centre: Collection of the artist
right: Collection of Miss Pamela Morton

164 Slab and pinched forms Both pots were made from pigmented bodies containing 6 per cent manganese, 2 per cent iron and 2 per cent chrome. The form on the left with pinched flanges and top is thickly glazed with a dark blue glaze containing cobalt and iron. It has a uniform colour and oily texture. The 'candlestick' pot, right, made in part from a bent slab, has a hollow base. The soft felspathic glaze is dark brown where it is thinly applied, and creamy white where it is thick. 9 in. and 10 in. high, 1,250°C oxidized.
Collection of the artist

165 Rosebowl Partly coiled, partly slab built, this earthy pot is made from pigmented clay, purple brown in colour, and is unglazed on the outside. The coiling lines show where the pot swells from its firm foot. The top half of the pot is made from a single slab, bent and joined. 6 in. high, 1,250°C oxidized.
Collection of C. Davis

166 Slab pot This two-part slab pot with coil decoration was made from Crank Mixture glazed with an alkaline chrome glaze. It was fired in a raku kiln and reduced in sawdust after removal from the kiln. 9 in. high.
Collection of the artist

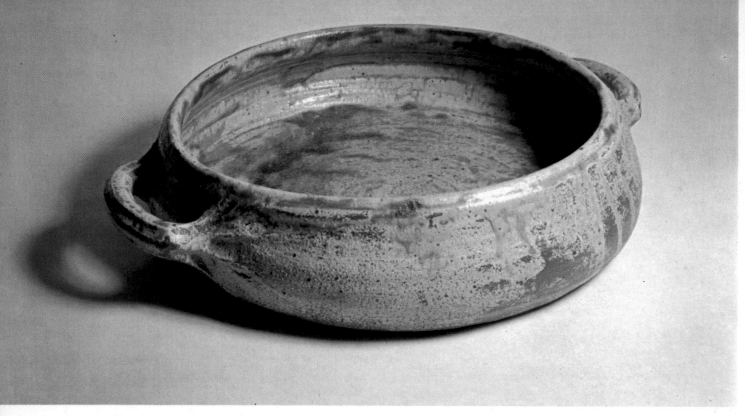

158

159

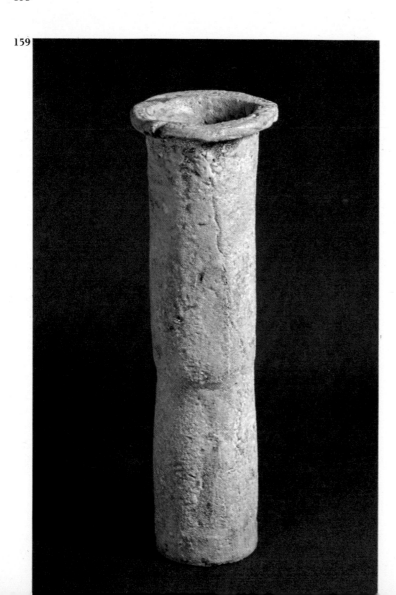

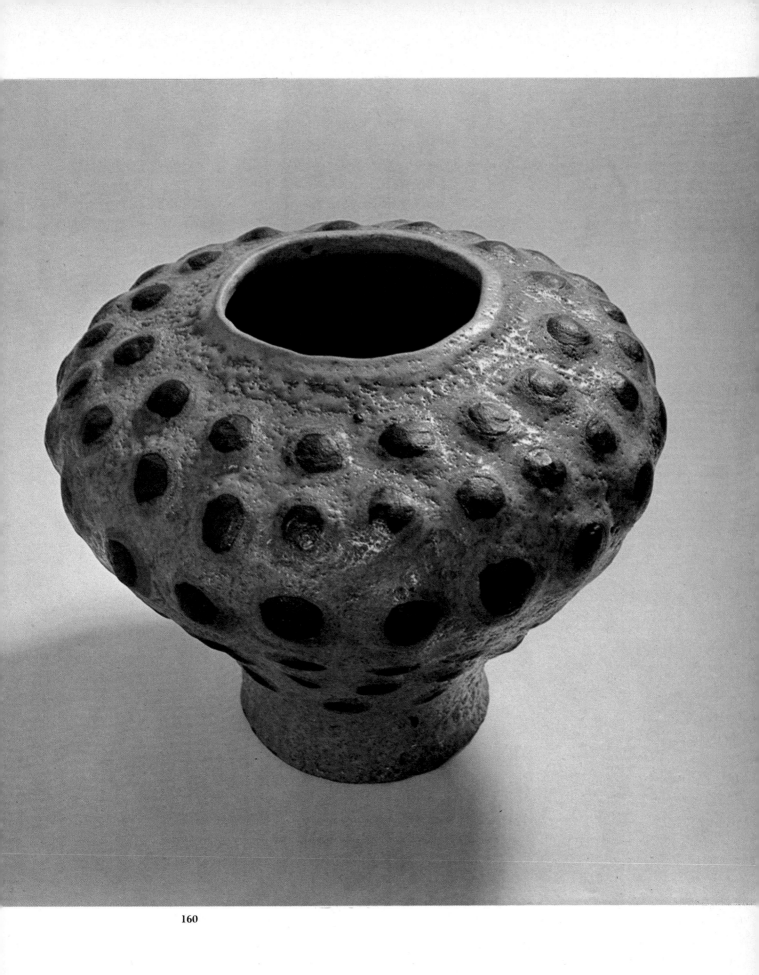

160

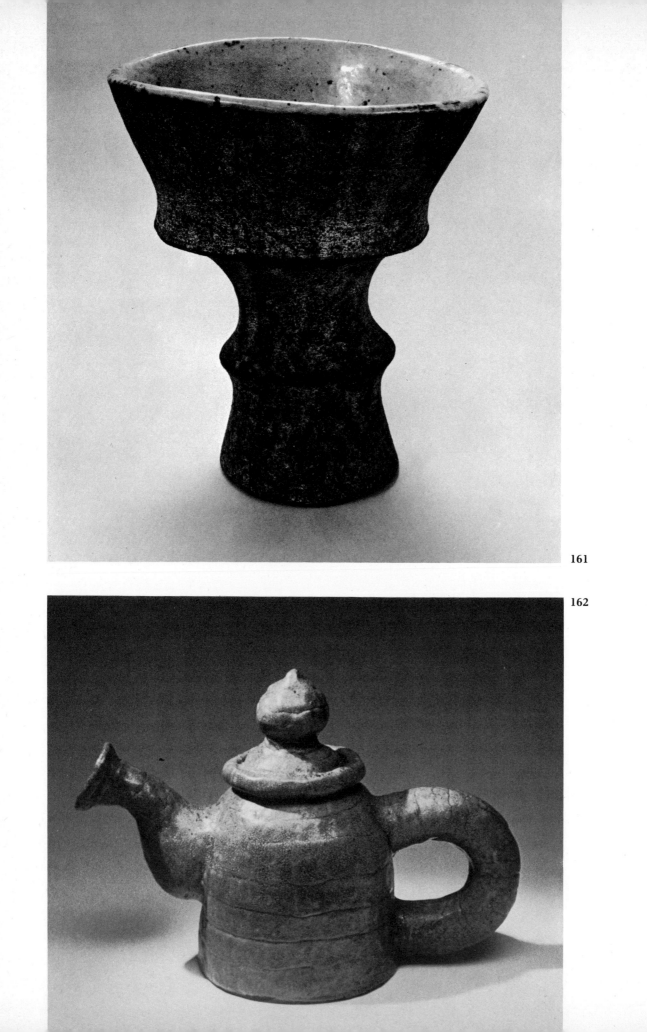

161

162

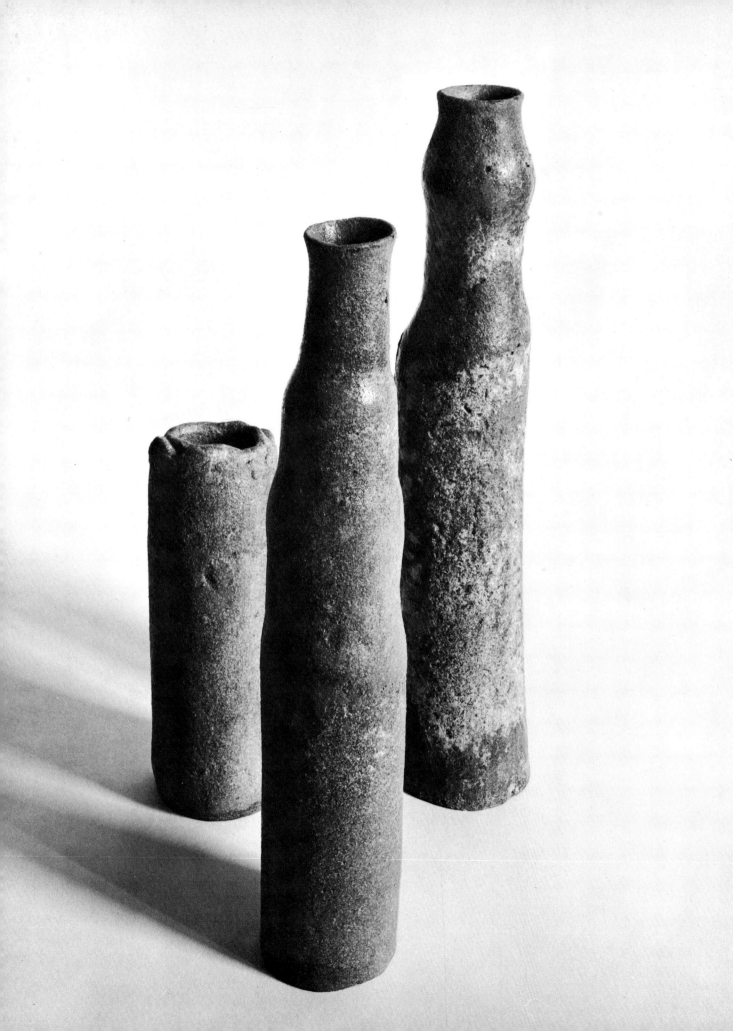

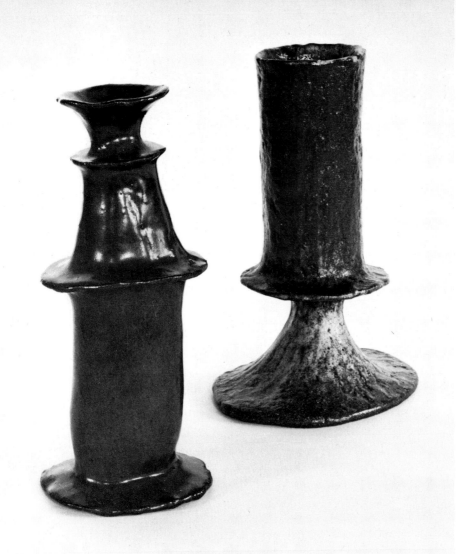

164

165

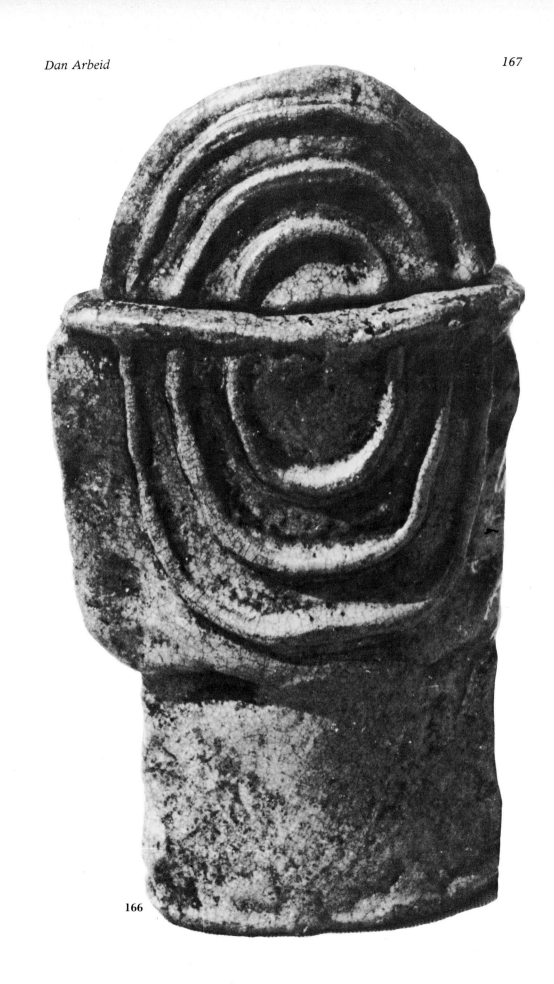

Ian Auld

Ian Auld has long been recognized as a fine craftsman and a creative artist. His pots are beautifully finished and show careful attention to detail. Although rarely working on the wheel and particularly associated with slab-building techniques he has employed and developed since the 1950s, he is in many ways a very traditional potter, drawing inspiration from pottery and applied crafts of the past. Japanese, Korean and Persian pots are his particular touchstones, and thus in this book his work shares with that of Lucie Rie the distinction of being both personal and in the four thousand year old tradition of carefully considered ceramic form. The slab-sided containers which constitute his best-known pottery stay calm and serene in spite of roughness of surfaces and angularity of the forms.

Ian Auld was born in Brighton in 1926, and left school during the war. Before being demobilized from the Navy he spent a lot of time painting, and joined the Brighton Art School for a year before going to the Slade in 1946. Here he became interested in decorative techniques, particularly print-making. His first important encounter with pottery came in 1951 at the Institute of Education where he was preparing himself without much enthusiasm to be a general art teacher. Bill Newland was the head of the pottery department. *'For the first time I found a teacher who was friendly and wanted to help.'* Bill Newland's impressive skill in every aspect of thrown and decorated pottery made a considerable impact on him, and large press-moulded earthenware dishes, popular at the time, gave Ian Auld the opportunity of exercising his decorative abilities with a new material. Clay very quickly became a satisfactory creative medium for him, and anxious to learn more about its application he left the teachers' course to work in a small commercial pottery in Cookham, Berkshire. In the six months he spent there he gained technical experience in all aspects of pottery-making, from preparing clays to packing for transport. He was next appointed technical assistant at the Central School of Arts and Crafts in London, a post which is designed to give artists the opportunity to work and experiment, and has been the starting point in the careers of several leading British potters. At this time Ian Auld was interested in bright earthenware glazes and decoration of all kinds, and he began to experiment with plaster of Paris stamps as a means of decorating the surface of clay.

In 1954 he was asked to start a pottery department in the Art School in Baghdad, and he stayed in the Middle East for three years, making the most of the opportunities this gave him for travel and study. He went to India, Turkey and Persia, looking for traditional work not only in clay but also in metal and glass. His pots at this time were

few in number, and he denies being influenced directly by Persian and Arabian art, but the slab pottery he began to make on his return to England had a simple architectural quality which seems to belong more to a Middle Eastern townscape than to any European tradition (see Plate 179).

The building of an oil-fired kiln in Essex in 1957 marked the beginning of his work in stoneware. At this time he was making slab pots because of a desire to have a flat surface to decorate, using seals, impressed and incised patterns. He later simplified this decoration and used drier and coarser glazes (Plate 168) to the point where surface and form virtually became inseparable (Plate 176). In 1964 he started to make solid forms in clay (Plate 169) – ceramics which were not clay containers – and some kind of definition and justification of his pottery became inevitable. He is very much aware that his work has moved away from utilitarian objects, while the shapes which inspire them are often humble domestic vessels. He is wary of the studied uselessness of an unstable bottle form which is unsuitable for flowers but which will never hold wine, yet the narrow-necked bottle is still one of his favourite forms. His enthusiasm for Roman glass leads him to translate aspects of its shapes successfully into clay (Plate 177), yet the exquisite result is useless as a pot and clearly not sculpture.

The pressure of tradition has led him to give some of his work traditional features, such as coiled or thrown necks, and caused him to use functional details such as lugs for purely decorative purposes. He sometimes makes a conscious effort to overcome traditional tendencies – to widen the tops of slab forms (Plates 170 and 175) – and aims to give his vessels a clarity of purpose to match their crisp and well-defined outlines.

The basic desire to make and decorate a hollow form in clay, to refine a persistent image without regard to use or to economic considerations, has distinguished precedent, and this is well expressed in some of his more sensitive work. Often his pots consist of a single simple form, a rectangle, cube or ellipsoid, with a carefully developed relationship between the shape and its termination. The development of Ian Auld's pottery often parallels a change or extension in his field of interests. His early slab pots were based on Japanese models. Crenellated and indented slab forms (Plate 178) led him to an interest in castles, medieval iron work, locks and keys. A compulsive collector of artifacts, mainly ancient, but also from primitive cultures in Africa and Oceania, he has also acquired pottery ranging from early Mediterranean and Persian pots to seventeenth-century English ware, and there are links between his collections and travels and his own work.

In the early days of his teaching at the Central School and Camberwell School of Art he concentrated on the simple techniques of hand-building and the aesthetics of three-dimensional design in clay. He left London in 1965 to succeed James Tower as senior lecturer at Bath Academy of Art, and later moved to Bristol Polytechnic as lecturer. Always fascinated by African art and in particular Yoruba carving, he took the opportunity in 1970 of a research fellowship at Ife University to spend nearly two years in Nigeria, together with Gillian Lowndes. Here he tried local clays and bonfire firings, and also visited the Michael Cardew / Michael O'Brien pottery at Abuja, but the African experience was for the gathering of information and material rather than for practical pottery. His most recent work shows signs of influence from Africa, being less hard and with hints of the patterned, fretted forms and anthropomorphism of African folk art.

On his return to England he has become increasingly involved with the higher administrative levels of art school teaching, being appointed to succeed the late Dick

Kendall as head of ceramics at Camberwell in London in 1974, and as ceramics assessor for various degrees and diploma courses. Thus the flow of his work has slowed down and the studio he shared in Wiltshire with Gillian Lowndes from 1966 to 1974 has had to give way as creative opportunities have become more sporadic.

He admires several of his contemporaries in Britain, such as Hans Coper, Anthony Hepburn and Glenys Barton, and many American potters such as John Mason. He has always admired the search for perfection in minimal form which is found in some modern ceramics and many of the antiquities which he cherishes.

His first of many exhibitions at Primavera, London, was in 1959 and he shared an exhibition there with Gillian Lowndes in 1965. His work toured the United States in 1960 and he shared a two-man show with Colin Pearson at the London Crafts Centre in 1961. He exhibited at the Craft Centre Copenhagen in 1964 and in the same year held a one-man show at the London Crafts Centre. A second joint exhibition with Gillian Lowndes is scheduled for the British Crafts Centre in 1976. He has also exhibited in Holland (Boymans Museum, Rotterdam), Switzerland (Exposition Internationale, Geneva), Finland, Japan, Australia, Spain, Italy, France and Germany. His work is in many private and public collections in many countries including the Victoria and Albert Museum, London, the Princes Grat Museum and the Stedelijk Museum in Holland.

168 Bottle This large bottle is slab-built, with a coiled top. The texture on the sides is made by applying thick sanded slip with a palette knife to the walls as the pot dries. The rectilinear decoration is incised with a knife, and the small circular marks are made by impressing the surface with plaster of Paris seals. The dry stoneware glaze breaks to orange where it is thin. 18 in. high, 1,280°C reduced.
Collection of the artist

169 Two standing forms A white grogged body was used to make the small solid wedges, which were pared and combed to shape, and assembled on their central axis. The pot in the foreground is unglazed, with a combed surface. The pot behind has a matt ochre glaze, golden where it is thick, burning to fiery-red where it is thin. Each 12 in. high, 1,280°C reduced.
front: Collection of L. Shurz
rear: Collection of Gillian Lowndes

170 Two slab pots A coil added to the top of each pot makes the simple and effective rim. The striking surface quality of the pot on the left is the result of very heavy grogging in the slip applied to the pot as it dries. The pot is deeply incised with a knife, and glazed with a matt ochre glaze, deep red-brown in colour. The wavy decoration on the more oriental pot on the right is made with a wooden comb. The pot has a white semi-matt dolomite glaze which breaks to brown on the edge of the decoration. 11 in. and 12 in. high, 1,280°C reduced.
Private collections

171 Pot A regular square slab pot, decorated with applied soft sheets of clay, worn like a tabard. Made after the potter's visit to Nigeria, the pot shows signs of anthropomorphism and the influence of Yoruba sculpture. It has a dry greenish-brown whiting glaze. 12 in. high, 1,280°C reduced.
Private collection

172 Rectangular dish This dish is not press-moulded but built from slabs of coarsely grogged stoneware body, with a wave-motif decoration incised with a wooden comb. The light coloured glaze contains dolomite and titanium. 12 in. by 10 in., 1,280°C reduced.
Collection of J. Pritchard

173 Slab bottle This slab-built bottle has a tall coiled top. Plaster of Paris stamps which are so characteristic of Ian Auld's early work are often used for multiple decoration on the sides of his pots. Here a single seal, impressed into a rectangle of clay, dominates the whole side. The green-blue glaze breaks to dark brown against the sharp angles of the body. 7 in. high, 1,280°C reduced.
Private collection

174 Coiled pot Recalling Egyptian Gerzean ware, this ellipsoidal pot is covered with whorl decoration, incised with a wooden comb. Iron oxide rubbed into the recesses before glazing has turned chocolate coloured. The pale blue felspathic glaze is semi-matt, thick in the grooves, thin on the ridges, where the buff body shows through. 14 in. high, 1,280°C reduced.
Collection of the artist

175 Rectangular form This slab pot has a coiled top. The decoration is combed, with clay strips applied as ridges. The ochre glaze is very dry and the top part of the pot was double-dipped. Ian Auld's personal seal, IA in a square, is often used on the side of his pots rather than the base, and can be seen here near the bottom right. This pot was exhibited at the Exposition Internationale at Geneva in 1965, but later disappeared from exhibition in London, presumed stolen. 16 in. high, 1,280°C reduced.

176 Slab form This is one of the largest of a series of standing forms made from single slabs of clay. These ceramics can be related to the artist's interests in crenellations, castles, keys and Chinese coins. While the silhouette is this form's most striking feature, the shape is enhanced by a beautiful rough-textured ash glaze. Basically grey in colour, the faces are streaked with pink and orange where the glaze is thick and bubbly. 11 in. high, 1,280°C reduced.
Collection the artist

177 Five vases Made from coarsely grogged body, these vases have slab bases. The long necks with their swelling tops are inspired by the artist's collection of first-century Roman glass. All the pots have a combination of three glazes; ash glaze used over and under a bubbling felspathic glaze gives variety of texture and an icy pale grey colour, while the dark splashes towards the top of the pots come from a blue glaze, poured on. 12 in. to 15 in. high, 1,280°C reduced.
far left: Collection of Mrs Guthrie
second left: Collection of Robert Fournier
rest: Collection of the artist

178 Castle forms These slab-made indented forms are enormously heavy – each pot containing twenty-one large slabs. The pot on the left has a thin ochre glaze, dark brown in colour, near the base, and a thick ochre glaze, ochre coloured, near the top. The central pot has a single dry glaze in various thicknesses, poured from above. It varies from light grey to ginger coloured. The pot on the right has a thick ash glaze at the top only. 11 in. to 17 in. high, 1,280°C reduced.
Private collections

179 Derricks These tapering forms were made in an attempt to produce a stable form for tall slim slab pots. Each pot is made from four slabs with applied ridges, seals and knobs. The unglazed pot in the foreground has incised lines made with a palette knife, and stained with iron oxide. The brown pots have an ash glaze over an ochre glaze from Bernard Leach. The green pot has a single ash glaze, applied thickly. Average height 14 in., 1,280°C reduced.
pot in foreground: Collection of Gillian Lowndes
right: Collection of Michael Holford
rest: Collection of the artist

180 Lock A solid form made from slabs of clay with decoration incised and applied. Dolomite glaze. 9 in. high, 1,280°C reduced.
Collection of the artist

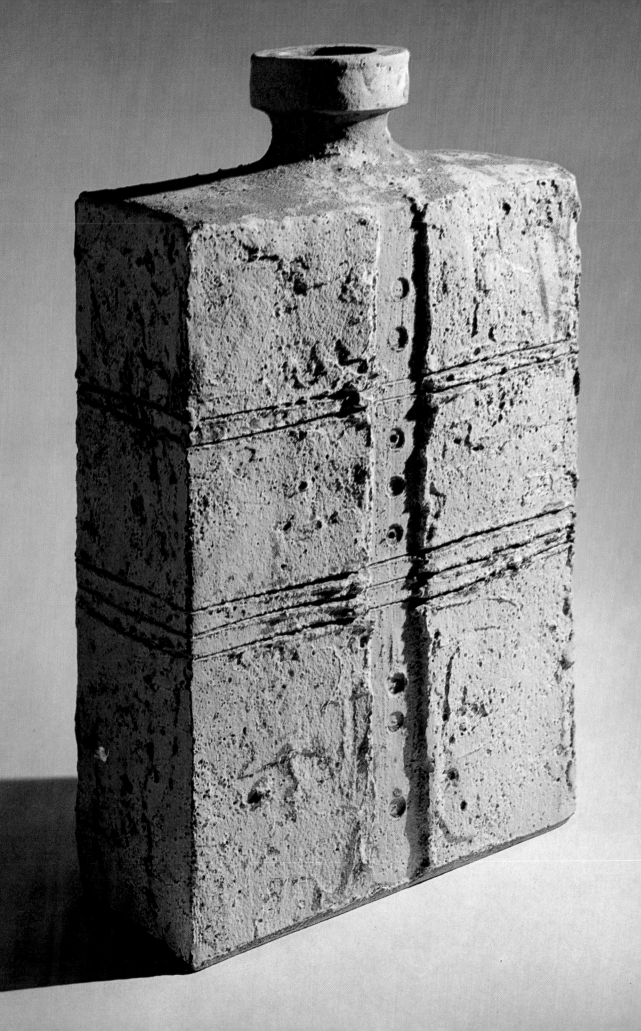

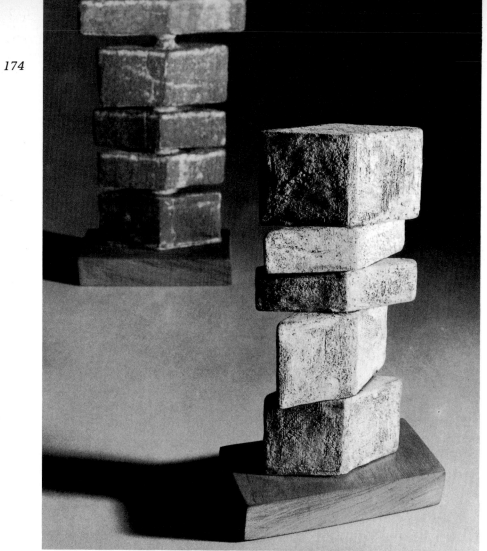

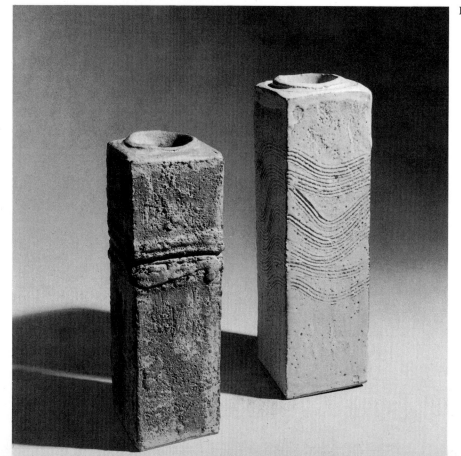

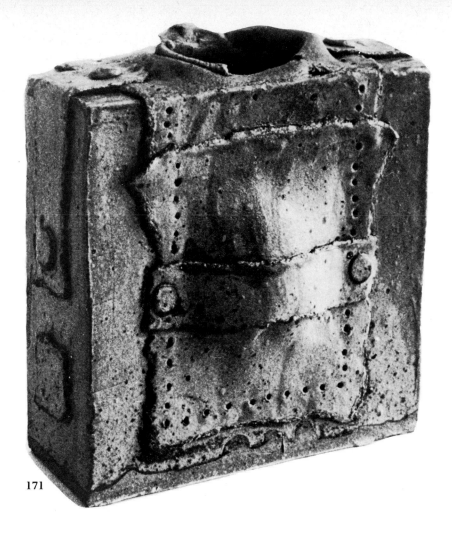

171

172

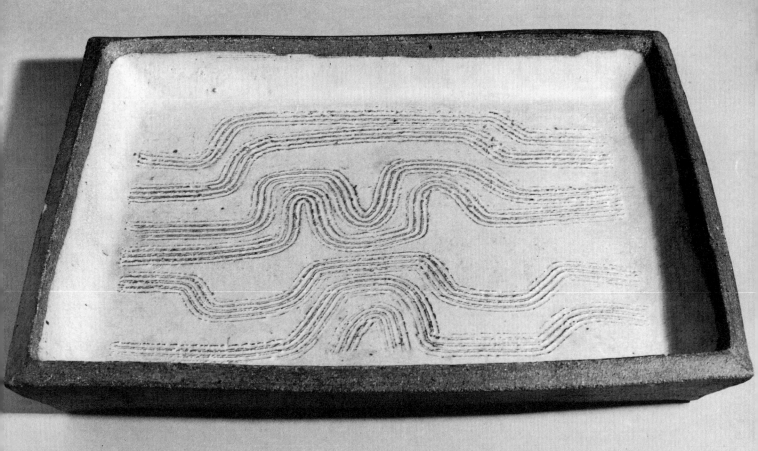

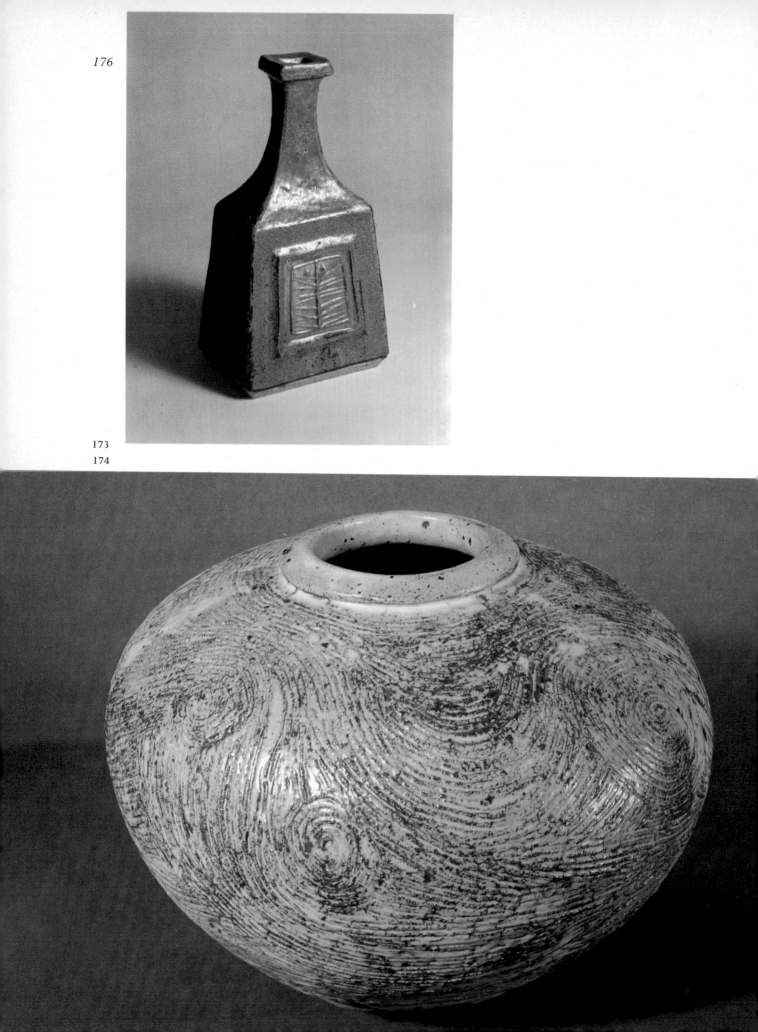

176

173
174

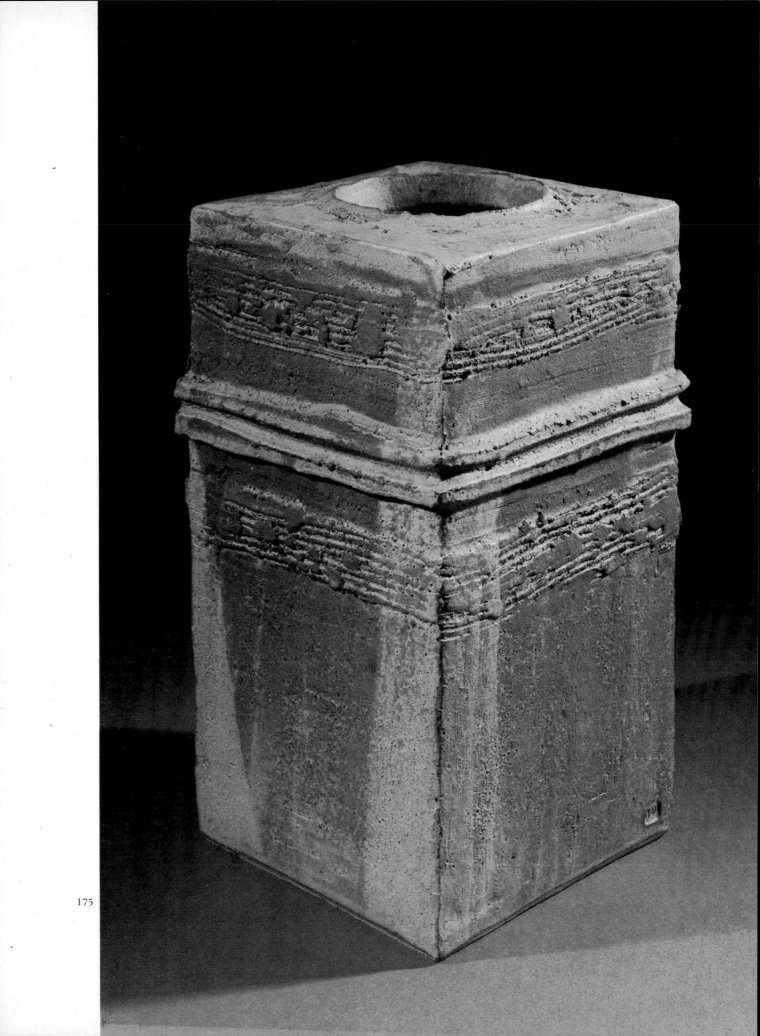

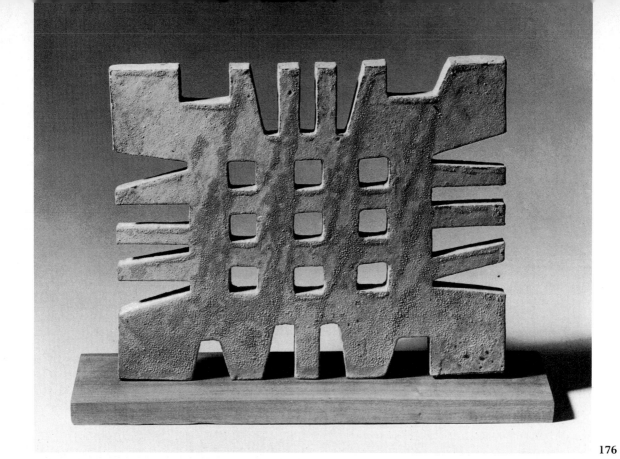

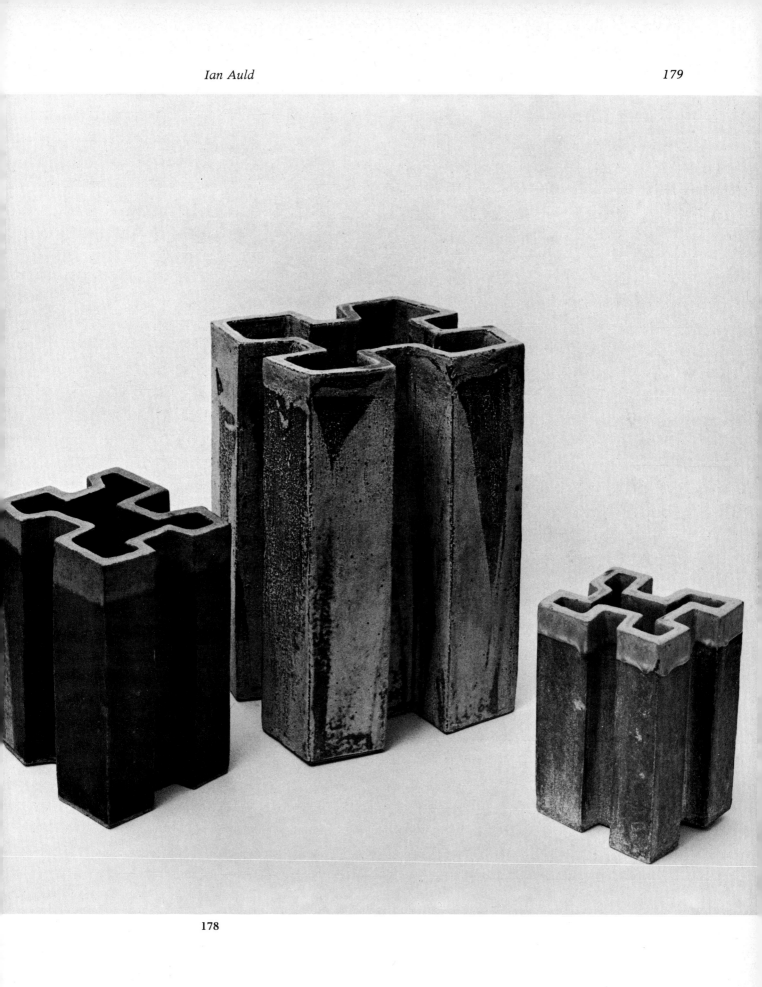

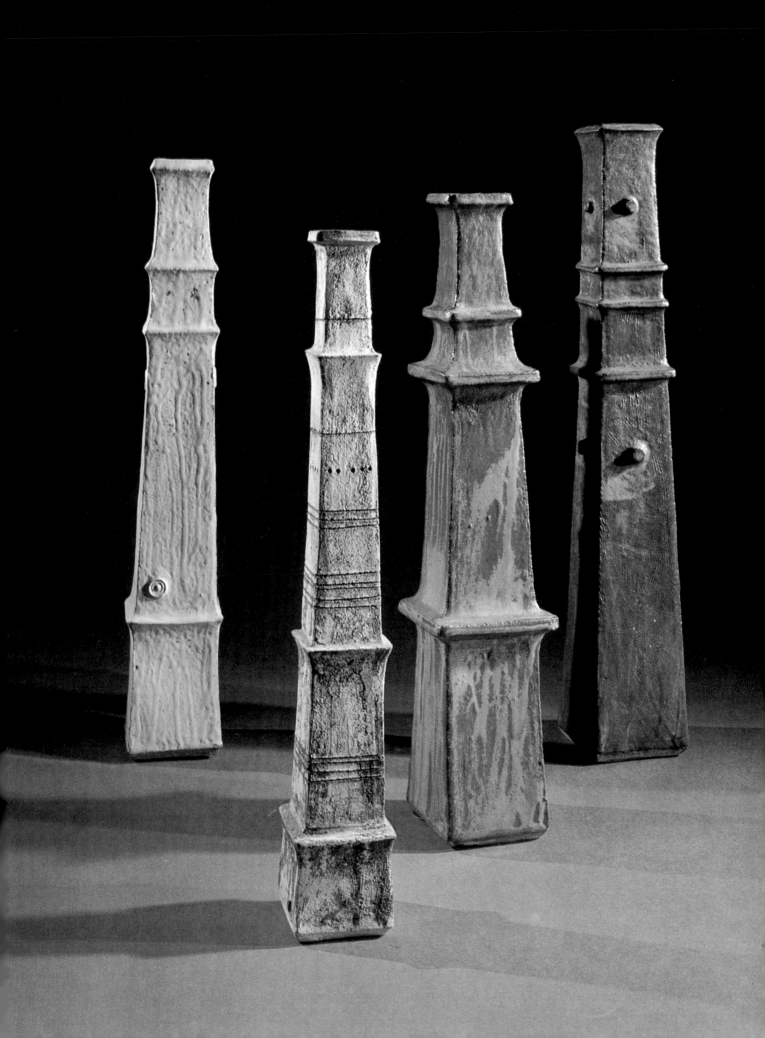

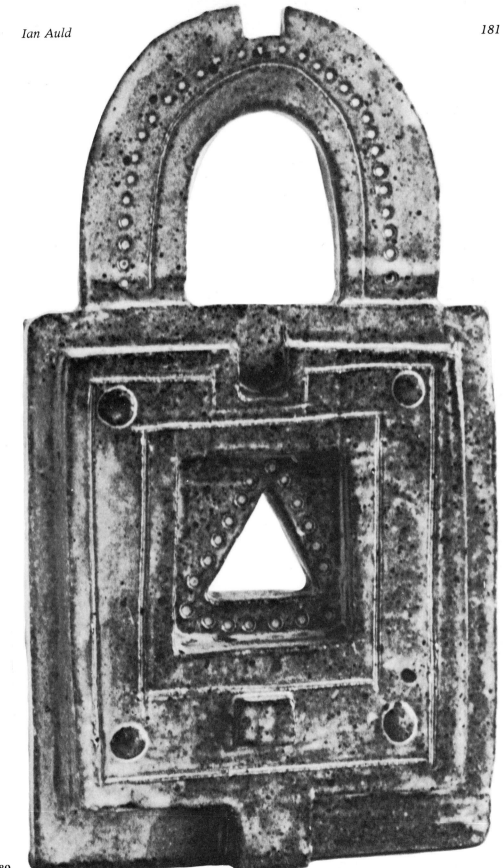

Robin Welch

Robin Welch, born in 1936, runs an efficient workshop producing mainly jolleyed domestic stoneware of distinctive design based on simple solids. His attitude to pottery, though practical, is far from traditional. He feels, like Dan Arbeid, that studio potters producing domestic ware are working against many of the concepts of the present age, yet he is sure that there will always be people who like and admire domestic pottery, and he enjoys the challenge of designing and marketing his own range. Robin Welch does not want his pottery to be part of a backcloth of rural crafts, for he is interested in contemporary living. His own work looks modern, crisp, well finished and strong. He considers one of his functions as a potter to be that of designer, ready to co-operate with interior designers and architects in an attempt to create an interest in the use of ceramics as a form of decoration in the living environment.

Like most potters, he has a love for his basic material. On the one hand he appreciates clay for its practical qualities and variety, for its emotional earthy appeal, and above all for the vast range of work it makes possible. On the other hand he is impatient with the material for its slowness. Unlike many people who are sympathetic to the long gestation process of pottery making, Robin Welch finds the suspense of waiting for results from a slowly cooling kiln very frustrating, and often turns to painting where the creative act is not so far removed from the end product.

Robin Welch was born in Nuneaton, in Warwickshire, but he moved to live in Cornwall when he was seventeen. He went to Penzance School of Art and studied pottery under Michael Leach. Living close to St Ives, he worked for short periods as a student at the Leach Pottery, learning a great deal about clays and firing. He was drawn close to the methods employed at the Leach Pottery, and he thinks that the influence of Bernard Leach in this important phase of his development still shows in some of his work. *'All my handles, rims and lips come from Leach.'* His experience at the St Ives Pottery has also affected his approach to running his own workshop.

A second critical period in his development was a short term as a student at the Central School in London. Here the liberal attitude to pottery, with the emphasis deliberately taken off oriental values, caused him to reassess his own work. Two years spent as technical assistant at the School were full of experiment – the evolution of new glazes and a new technique for composite pot building. Hard-edged, high-fired pottery in black and white, using the beautiful white clay, 'T' Material, became his particular trade mark.

Within a few years he opened up workshops first in London, then in Australia and

later in Suffolk, England. The challenge of starting a country workshop near Melbourne with a student colleague came in 1962, and the work he did there was very successful. He found Australian people ready to accept ceramic art beyond purely functional pottery, and was able to develop, with enthusiastic patronage, his ideas for ceramic wall panels (see Plates 183 and 185).

He returned to England in 1965, and his present pottery workshop at Stradbroke in Suffolk was started in 1966. The studio created out of old farm buildings was designed to accommodate two or three assistants, and a single-burner oil-fired kiln made to plans modified from Homer was installed (see page 182). It soon became obvious, however, that his aim of producing repeat ware to a high degree of precision by throwing could only be done by the expenditure of a great deal of time, and from 1968 a gradual change of emphasis took place, so that currently nearly all the ware produced uses the industrial techniques of jolleying and press-moulding, and the production is carried out by a small team. Firing is now in a Midland Monolithic 100 cwt trolley hearth kiln which was built in 1973.

Whilst continuing to produce his own personal work, as illustrated in the following pages, he spent much time in the early 1970s designing shapes which suited his production methods, learning the technology from visits to Stoke-on-Trent. His catalogue states, *'The use of these semi-industrial techniques has enabled us to devote more time to the creation of more individual pots and sculpture, which we feel should be a basic concern of the studio potter.'* His individual pots were very much influenced by a visit to America in 1972, when he spent some time glass blowing and studying raku firing. His pots have always been very strong and uncompromising, decorated – if at all – with broad bands of colour, and such shapes are unexpected in a raku kiln. The work of the kiln in modifying and adding richness to his glazes by reduction, however, has always featured in Robin Welch's stoneware pots, and the creative nature of the raku kiln is both attractive to him and a useful contrast to the uniform character of his repeat ware.

The standard of craftsmanship of Robin Welch's work is high. Knobs and handles are robust rather than delicate. Rims, often with an inward facing chamfer (Plate 187), are firmly treated and sturdy, never fine. His strong tableware is in many ways the antithesis of the light, springing feminine work of Lucie Rie. Many of his composite pots have been monumental in scale, assertive and big enough to stand naturally on the floor. They often have hard uncompromising edges, emphasized by crisp decoration in bands and stripes. While appreciating the relaxed and sensual pots made by his contemporaries – he admires the work of Gillian Lowndes and Dan Arbeid – his own pots always tend towards straight lines and constant radius curves. Instead of the emotional expressiveness of the work of a potter like Ruth Duckworth, Robin Welch's pots have an abstract austerity which is self-conscious and precise. For a potter who finds symmetry and cylindrical forms fundamental to his work, his most usual method of making tall heavy pots is to combine several thrown pieces. *'I would like to make an asymmetrical shape, but even if I start out with the definite intention of doing this I find I have to scrape the surfaces down and make them perfect.'* He is fascinated by geometry and mathematics. It may have been the rhythmical geometry of half-finished pots on the workshop shelves which led him to make the wall panel of repeating shapes in low relief (Plate 183), but more often an experiment with a series of geometric relationships will be carried across into another medium such as paint, on canvas, or metal sculpture, simultaneously with his work in clay.

Work in other media can sometimes help him to answer aesthetic problems which he unearths while making abstract forms in clay.

With the experience of two English art schools behind him, he does not have great faith in the advantages of an art school training for students wishing to become studio potters. He feels that repetitive throwing and industrial and mass-production techniques should have more emphasis, and also that important subjects lacking in British art school teaching for the potter are business management, book-keeping and product costing. '*A little more knowledge of these can make the difference between success and failure in a small workshop.*'

While most potters depend on part-time teaching for a steady income, Robin Welch prefers to press ahead with production and marketing which keep him largely independent of teaching, although he has done teaching blocks at several art schools and is on examining boards for diplomas. Teaching carries such heavy responsibilities – how can one justify encouraging a large number of students to become potters in an age which will support only a few? He has little respect for those teachers who ignore this responsibility and he feels that the concentrated effort which is necessary to get a workshop on its feet is more worthwhile and creative.

Robin Welch regrets the general lack of co-operation between industry and artist potters in Britain, compared to the situation in Scandinavia and Finland. He would like to have more opportunity to study techniques for mass production as an industrial designer in ceramics. Awarded a CAC bursary in 1976, he is using this opportunity for further study of industrial ceramics at Stoke-on-Trent Technical College, with a project for co-operation with large-scale industry in view, and to concentrate on his own individual work, with research into low fired lustres on high fired glazes.

He feels the need to make contact, not necessarily with other artists but with their work by visiting exhibitions of all the visual arts. He is more affected than many other potters by contemporary movements and less by historical influences. He emphasizes the need to be within easy reach of London – the advantages of a country workshop would be outweighed by disadvantages if London were not accessible.

Robin Welch has held three one-man exhibitions in London at the British Crafts Centre and six in Australia. He has also exhibited in Sweden, Finland, Italy and Japan, and his work is represented in private collections in many countries as well as in the Victoria and Albert Museum in London, Exeter Museum, Reading Museum, the Fitzwilliam Museum, Cambridge, Bradford City Art Gallery and the National Gallery of Victoria and the Art Gallery of New South Wales.

182 Cylindrical forms All four thrown forms are made from dark brick clay – red saggar marl – which fires in an oxidizing atmosphere to a rich brown, and is given a smoky purple bloom in reduction. A metal kidney used in throwing pulls the coarse sharp grog in the body into long horizontal streaks. All the pots are partially glazed, and the oxide content of the clay has produced a green colour through the ash glaze, blotched with dark brown and black from iron. The pot on the left has an ash glaze inside and a band of felspathic glaze outside, brushed on, and bluish white where it is thick. The tallest pot, scored with a turning tool near its top, has brushed bands of the same felspathic glaze, the lower band darkened with cobalt and iron. The pot on the right was dipped in iron-rich ash glaze, dark green-brown in colour. 4 in. to 12 in. high, 1,300°C reduced.
right: Collection of Ripon College
rest: Collection of the artist

183 Ceramic wall panel This wall panel is made by tooling thrown shapes on to hand-made 4 inch square tiles. The clay used is Crank Mixture. A single white matt glaze is used, though some of the tiles are unglazed. Considerable variety of colour results from different thicknesses of glaze, and the use of copper, cobalt, iron and manganese oxides under the glaze and rubbed into the surface of the unglazed tiles. Some of the recesses in the thrown disks contain deep turquoise pools of melted soda glass. 6 ft by 2 ft 4 in., 1,300°C, some tiles reduced, some oxidized.
Collection of Kym Bonython

184 Thrown bowl This heavy thrown bowl has the horizontal flange which is characteristic of much of Robin Welch's work. The bowl was glost-fired with a white matt glaze over the Crank Mixture body, and then refired with copper oxide rubbed over the outer rim. In reduction the copper has turned wine-red on the outside. Inside the bowl, the painted rectangle is purple and blue, from a mixture of soda glass and copper on top of a blue glaze. 13 in. diameter, 1,300°C reduced.
West of England College of Art

185 Ceramic wall panel Made from slabs and thrown pieces, mounted on matt-black painted wood, this panel uses thrown disks taken from the wheel on large-size bases, later to be cut to square or rectangular shapes, juxtaposed with simple undecorated slabs. Some of the circular shapes were thrown as knobs and applied to bases when leather hard. The yellow and fiery-red pieces have a white matt glaze containing different strengths of iron oxide; the grey-green and blue pieces have the same matt white glaze, thick and thin, over a cobalt and iron mixture.

The panel projects in relief less than two inches from its baseboard. 24 in. by 20 in., 1,300°C reduced.
Collection of the artist

186 Cylindrical pot This tiny thrown shape is made from white 'T' Material, thinly glazed with a light ash glaze. Characteristically, the clay burns orange-brown where the glaze is very thin. The bands are dark Antwerp blue from a mixture of cobalt and iron oxide, which is also painted on to the flat scored rim. The swelling in the pot is given point by the fine light line between dark stripes. 4 in. high, 1,300°C reduced.
Collection of Kenneth Clark

187 Stoneware bowl The body used is a mixture of white refractory fireclay and red earthenware, and the pot is heavy, with a hemispherical inside profile. The ash glaze is a rich green colour, dark blue near the rim from cobalt and iron oxides. The dark blotches are iron, breaking through from the body. $6\frac{1}{2}$ in. diameter, 1,300°C reduced.
Collection of the artist

188 Three cylinders Unlike many of Robin Welch's pots, these cylinders are light – thinly thrown from 'T' Material and turned. The glazed is a white felspathic glaze fired to 1,280°C and the bands are gold and copper lustre and copper oxide, fired to 1,000°C. 6 in. to 10 in. high, 1,280° and 1,000°C.
tall pot: Collection of Mr and Mrs Knowland
other two pots: Collection of the artist

189 Raku bowl Making precise thrown and turned shapes is out of keeping with raku ware, but this is how Robin Welch approaches the raku kiln. The bowl is turned to shape with a metal tool. The body is 'T' Material and it is glazed all over with a white barium glaze. The small patches of design are bright red from Podmore's red glaze and blue from cobalt carbonate, painted on with a brush. 12 in. diameter, 1,000°C.
Collection of the artist

190 Thrown shape This pot was thrown in two pieces from 'T' Material, and joined above the central disk. The disk itself was made by adding a coil of clay to the pot's waist when leather hard and throwing it out. The dark bands top and centre are cobalt and iron oxide, and the rest of the pot is thickly covered with a matt white glaze. After glost firing to 1,280°C, copper oxide was rubbed into the craze and on to the unglazed parts, turning wine-red in reduction at 1,100°C. 23 in. high, 1,280° and 1,100°C reduced.
School Art Loans

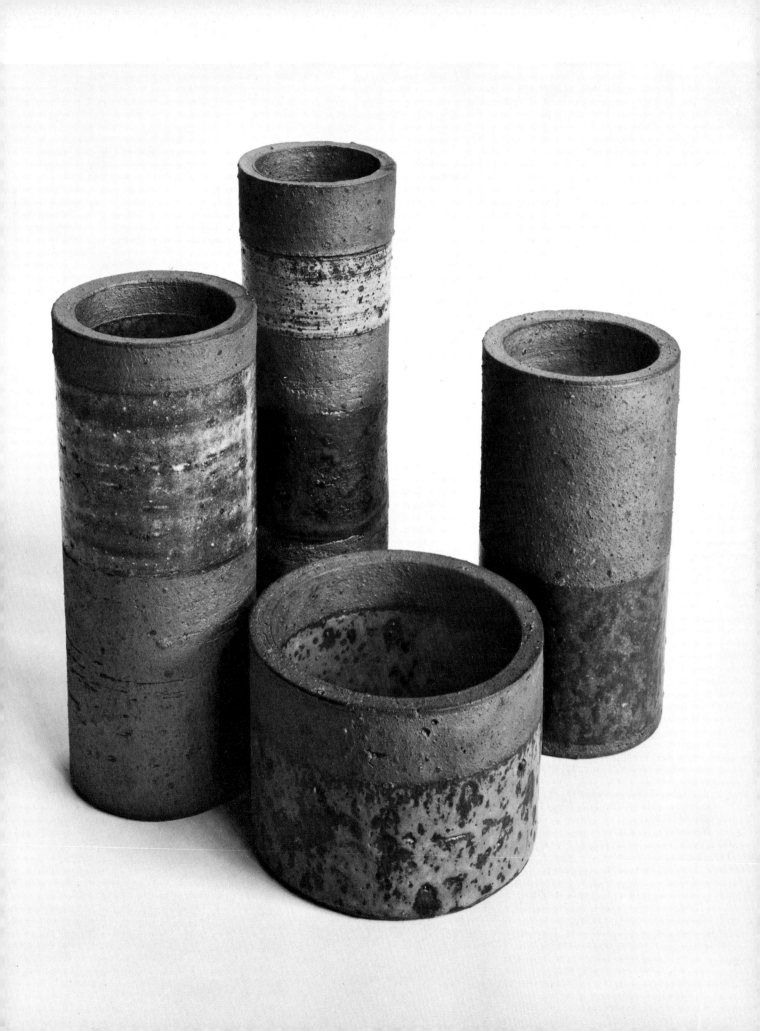

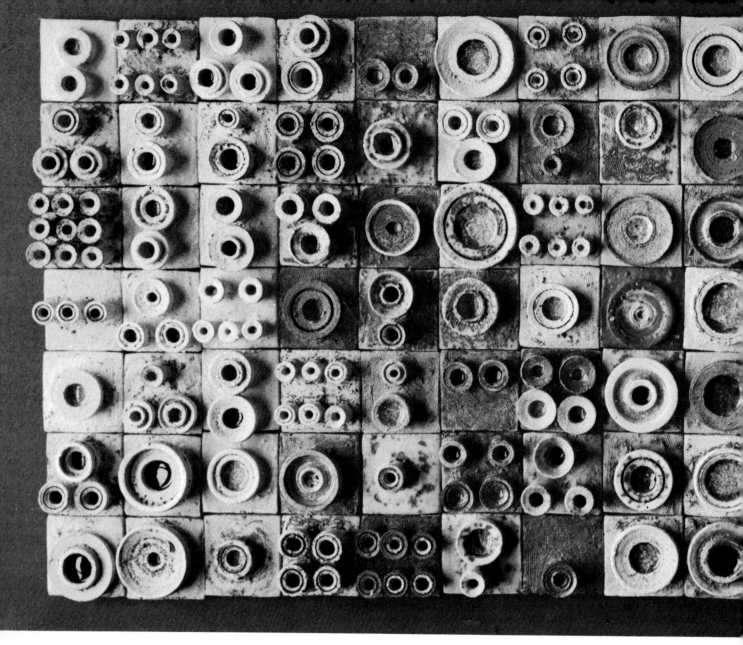

183

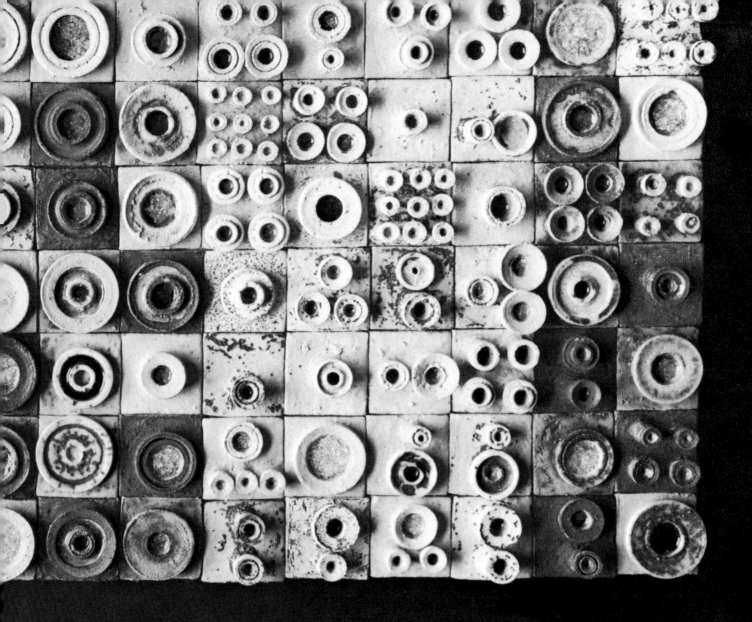

184

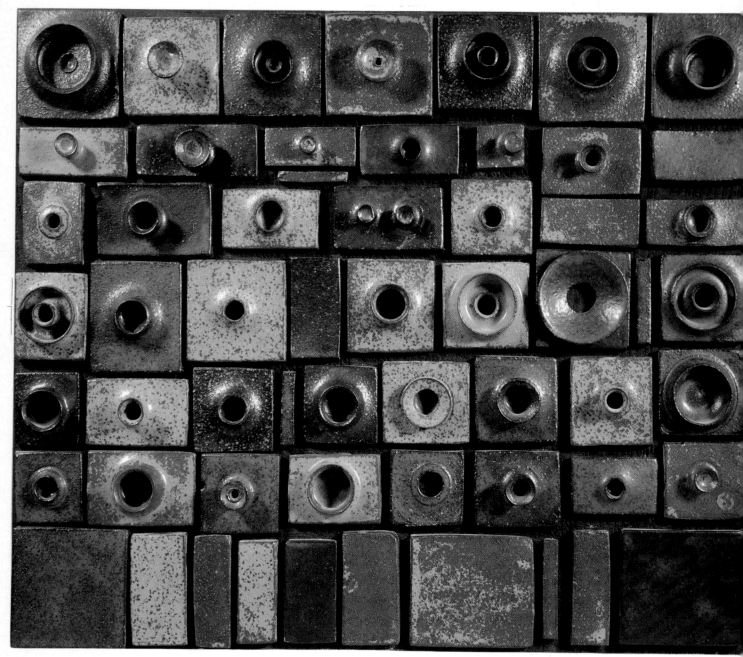

185

Robin Welch

186

187

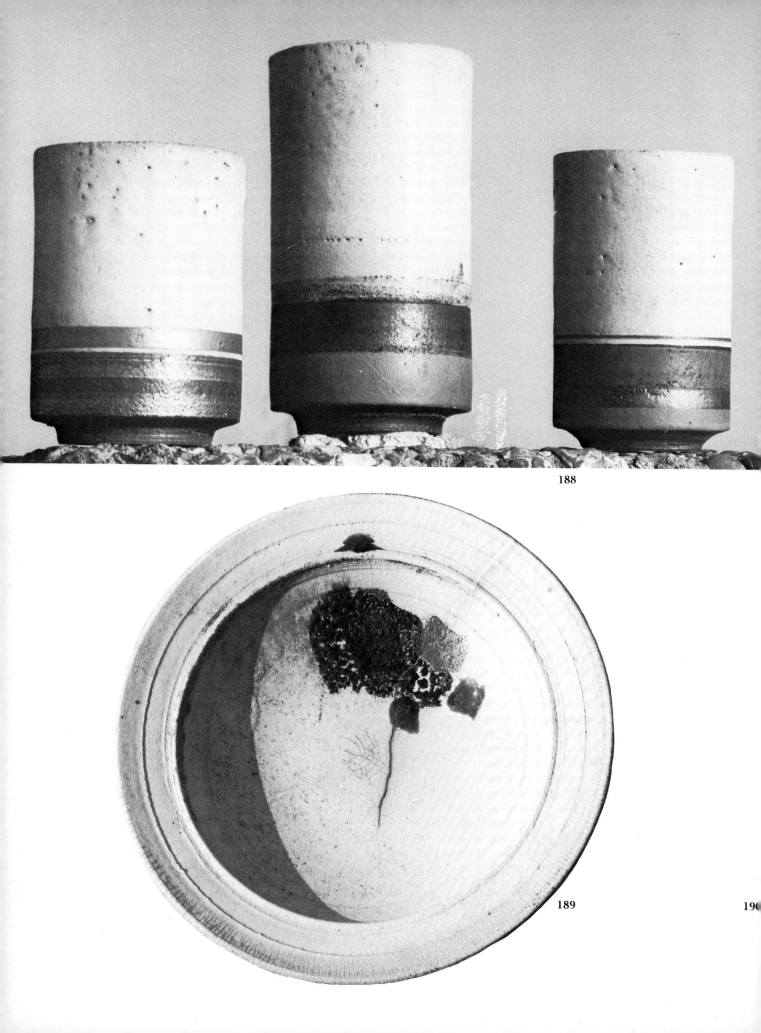

188

189

190

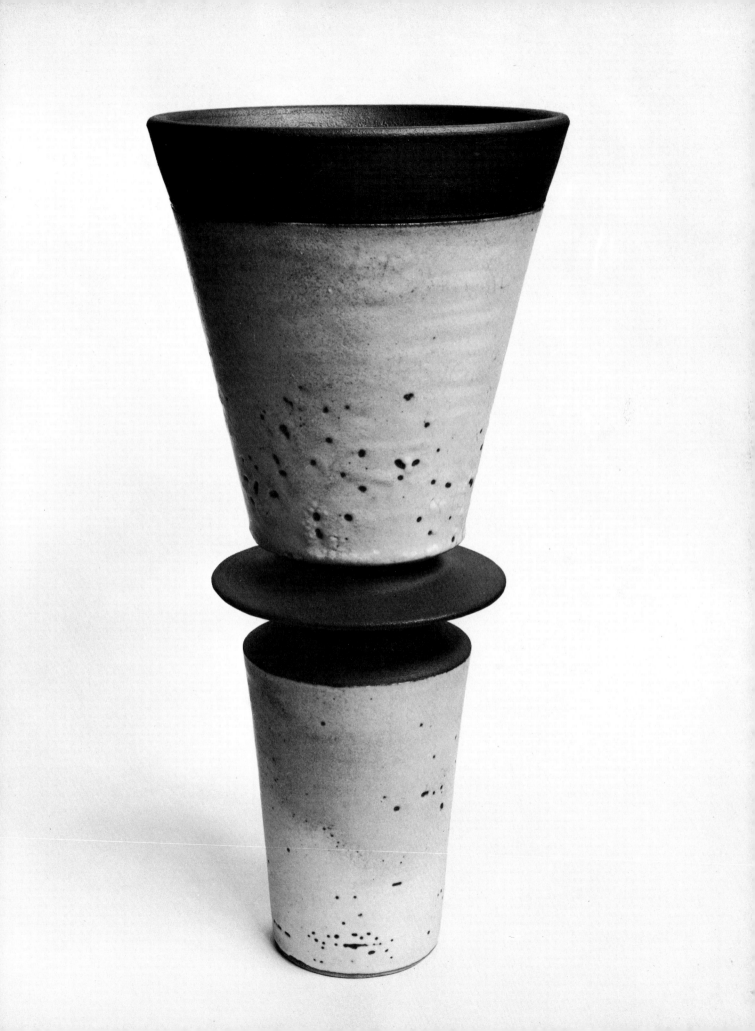

Gordon Baldwin

Gordon Baldwin makes sculptural objects in clay. His terms of reference lie mainly outside the ceramic tradition, and like Anthony Hepburn, with whose work his own has many affinities, he is orientated as an artist towards painting and sculpture rather than towards pottery. Unlike Anthony Hepburn, however, who loves clay for what it is, he uses clay because it is obedient. Always inventive as a three-dimensional artist, his technical expertise has improved enormously over the last decade and he now produces ceramics with a very high degree of finish. He progresses with confidence from one phase of work to another, each piece overlapping the next in time so that although he works quickly a single piece may be in work for a long period – up to a year or even more. He, like Hepburn, looks to America and modern American creative work for his touchstones but is more eclectic in his interests, and music and poetry influence and infiltrate his ceramics in a rather disconcerting way.

Gordon Baldwin was born in Lincoln in 1932, and was trained initially at the Lincoln School of Art where he learned pottery as part of the intermediate course under a pupil of Bernard Leach. After two years he went to the Central School of Arts and Crafts in London to concentrate on pottery. The pottery department at the Central School at this time combined a high standard of craftsmanship with a traditional and conservative approach, and seemed to him isolated from the other limbs of the Art School. A major turning point in Gordon Baldwin's career was when he took part in a short basic design course given in the School by William Turnbull. This and subsequent teaching by Eduardo Paolozzi made it clear to him that potters, sculptors and painters were not necessarily different kinds of artists with different values. He began to make big pots and, inspired by medieval shapes, made a series of large coil pots – too large even to fit in the kiln.

As a student he experimented widely with an unconventional hybridization of methods such as using glaze from a slip-trailer, and at the same time produced a range of tableware. In the process of taking diploma courses at the Central School he became acquainted with industrial techniques when he went as part of his course to work in Stoke-on-Trent.

He took a part-time teaching post at Goldsmith's College of Art in 1955 and then became first the technical assistant and shortly afterwards a teacher in the pottery department at the Central School. He was appointed to Eton College to teach pottery and sculpture in 1957, and has continued to teach at Eton and the Central School up to the present time, with an additional teaching commitment at Camberwell.

It would be difficult to over-emphasize the effect that Gordon Baldwin has had

upon those students who have responded to his ideas. A combination of enthusiasm, iconoclasm and a restless searching for new applications for well-known techniques makes him a most dynamic teacher. He makes very few concessions to convention and often teaches as an exercise the deliberate violation of accepted principles of decoration and design. Unlike many potters, he is able to teach and work at the same time, and tends to teach through his own work and to extend his enthusiasm for a particular personal project across into his teaching programme. Taking his teaching duties very seriously he has also served on education committees and councils and acted as a diploma assessor, but he intends to shed these responsibilities, preferring, as he himself says, *'to stay at the sharp end of teaching'*.

Gordon Baldwin still on occasions makes thrown tableware and has also produced functional ceramics beyond the normal range of tableware – a convector heater and a free-standing ceramic fireplace – which shows the special qualities that glazed clay can bring to objects normally associated with other materials. The sculpture in other media has encompassed stone, wood, concrete, zinc-aluminium alloy and lead, but it is for abstract and surrealist ceramic sculpture, as shown here, that he is best known.

He has pursued a theme of experimental abstract pottery for many years and though he dislikes being associated with a particular style of work, and consciously tries to avoid stylization and repetition, certain phases of his work have had characteristic common features – standing forms, often bisymmetrical or with perching shapes on their tops; shiny black basalt-like objects, squat and sinister-looking; white boxes with allusive decoration and figurative excrescences; and fragile white bowls and crumpled concave sheets of clay polarizing more and more towards painting.

Although each piece is unique and complete, his pots are usually made in series as if each unit is a fragment of a larger whole – a decorated pavement, a jigsaw, a flag or even a token in some cool, sophisticated game. Two conflicting elements – the precise, deliberate man-designed contour and the ragged, random, torn surface – appear together in practically all his work. These are the two sides of an ambivalent nature: chance and choice. They are the essentials in a philosophy in which detached fractions are entities and all isolated units are interrelated.

Somewhere between the appreciation of man-designed form with its milled surfaces and micrometer precision and the recognition of the effects of natural forces – erosion, flexion, tearing and stress – lies Gordon Baldwin's creative concept. He brings the two together in a single object which is clearly defined yet bears the clues of fragmentation: parallel lines like postmarks which disappear where the object is torn or continue in another plane like a vein of quartz in a metamorphosed rock. It would be misleading to pursue such a geological metaphor in describing Gordon Baldwin's work in clay, for although it is of the earth, it is not at all earthy or reminiscent of nature. The clue to his most recent work lies in surrealism, and artists like Jean Arp, Max Ernst and Magritte, and the magical ability of clay to represent the notion that things are not what they seem.

Gordon Baldwin prepared, as part of his teaching work, a surrealist exhibition in 1970 and found a close correspondence between his views and the views of the artists in the exhibition. His work since has been much influenced by surrealism and has included figurative elements such as cast human features and fruit and an upturning of normal spatial and conceptual relationships in the classic Magritte fashion.

A second influence has been his interest in modern music and in particular the ideas, lectures and teaching of the American composer John Cage.

An interest in poetry and words has had, to my mind, a less happy effect on his ceramics. The complex concepts embodied by an association of letters in a written word are at odds with the more straightforward graphic effect of a string of letter forms. Both ceramic object and enigmatic phrase (see Plate 202) are invested with a ponderous solemnity which seems unnecessarily to devalue both. I prefer the sculpture to communicate directly without the need for the viewer to understand the language in which the words are couched. Chinese inscriptions have been admired by non-Chinese speaking occidentals for centuries, but for grace, not for wisdom.

Thus I prefer the decoration which depends on colour and line and texture, and most recently Gordon Baldwin's work has been evenly glazed in white and then painted, much as an easel painter might paint on canvas, using underglaze and body stains in bright or 'pastel' colours. The patterns, themselves often fragmentary, often show brush marks, or at least the marks of whatever applicator has been used, and the Baldwin tension between precise and random forms is epitomized by the coloured band, uneven on one side and straight and controlled on the other by a piece of masking tape, like the glue marks left on a pasting table when the wallpaper has been lifted off. Similarly, precise mathematical shapes, like upturned ziggurats, may be incised with a wandering design or sprayed with dark-coloured shadows from atomizers, like a landscape shone at by as many light sources.

For an artist who uses such random effects the important thing is not to know what you are doing but to know when to stop. Gordon Baldwin is a very confident artist, with the sculptural sense to control these effects. He also has very considerable technical skill. Most of his work is stoneware glazed with the semi-matt blue-white glaze comprising felspar 83, dolomite 14, whiting 46, clay 39, flint 18 and tin or zircon 18, fired to exactly $1,240°C$, although he still occasionally uses the simple lead earthenware glaze which featured on his early shiny pots.

The decoration, whether painted or sprayed on, or rubbed into the surface, is body or underglaze colour put on top of the fired stoneware glaze and fired in a third low temperature firing, possibly then fired again for extra additions.

Gordon Baldwin uses a combination of all pottery-making techniques including press-moulding and throwing, though slab-building (as for his boxes, Plates 197 and 200) and coiling (as for the beautiful bowl in Plate 201) predominate. A fertile and energetic artist, he usually has several projects on the go at one time, and rarely nowadays suffers technical failures, though he rejects about half his production on aesthetic grounds. He works best under pressure, such as that of an imminent exhibition, and often works up to eighteen hours at a stretch in his studio at Eton College, whilst his wife, a painter, works in her own studio nearby. Gordon and Nancy Baldwin work in no sense as a team, as do the Barrett-Danes, but his wife's talented work undoubtedly influences his own. They exhibited together in the Oxford Gallery in 1975, the same year as Gordon Baldwin's ceramics were chosen for the British Council's Polish and Scandinavian touring exhibition. His previous exhibitions have included a one-man show and a two-man show with Peter Simpson at the Crafts Centre, London, four mixed exhibitions in London and Oxford since 1969, and foreign exhibitions in Tokyo, Munchengladbach, Frechen, West Germany, the International Ceramics exhibition in Faenza, Italy, in 1972 and Pennsylvania State University, United States in 1976. His work can be seen in the collections of the Victoria and Albert Museum, the Crafts Advisory Committee, Contemporary Arts Society, London, Museum Bellerive, Zurich and Boymans Museum, Rotterdam.

192 Standing form This symmetrical and rather sinister-looking black pot is coiled and stands on slab legs. The shiny top surface is made by a mixture of three glazes, dark green, dark blue and black, applied in fine stripes through a slip trailer. 14 in. high, 1,100°C.
Private collection

193 Sea form This rocking form is slab built and sits on a cast Ciment Fondu base. It is decorated with a variety of dark shiny glazes, designed to create moving shadows and reflections like a distorting mirror. These were applied by pouring and slip-trailing along the length of the top. 28 in. long, 1,100°C.
Collection of H. and R. Hyne

194 Salad bowl This bowl has three thrown conical legs which raise its curved underside about one inch above table level. The shiny inside has a greyish-white tin glaze. After one glost firing this surface was painted with wax, red clay, manganese, cobalt, copper and iron oxides, and refired. The texture in both the waxed and unwaxed areas is the combined result of a stiff-bristled brush for painting and rather obtrusive throwing lines. 14 in. diameter, 1,100°C.
Collection of Mrs Frank Evans

195 Standing form This form was coiled from grogged clay; the circular disk is made from a solid slab. The dull surface on the left side is painted with copper oxide, manganese oxide and lead bisilicate, contrasting with a shiny black glaze. At the vertical junction between the two surfaces, and on the circular disk, are fine lines of glaze, painted on. 28 in. high, 1,100°C.
Collection of P. Rees

196 Vessels for Jean Arp These slab-built forms – two segments of the same slab-built cheese – have contrasting lids which lift off and are unified by a suave white glaze containing dolomite and tin oxide. The apple-like lid in the form on the right is thrown and the linear decoration is Podmore's glaze/body stain ground with a little flux and painted on between pieces of masking tape before it is refired. 7 in. and 12 in. high, 1,240°C oxidized and 1,100°C.
Collection of the artist

197 Abstract expressionist A large folded slab of clay, born in a shallow mould and with a partly torn, partly cut rim. Podmore's glaze/body stains in blue, red and two tones of yellow are used for the design. 15 in. diameter, 1,240°C oxidized, 1,100°C.
Private collection

198 Composition on spike The box with its mirror-like top surface and its rock-like sides is spiked on a separate thrown cone. The top and bottom are slabs, the sides of the box coiled. The shiny black earthenware glaze is darkened with copper and manganese. The spike is matt black with copper oxide. 10 in. high, 16 in. wide, 1,100°C.
Collection of the artist

199 Vessel with a painting as a lid Both parts were thrown, the lid thrown upside down on a wide bat and turned to a flat disk, thinning towards the edges. The designs are painted on top of the white dolomite glaze in blue, green, yellow and pink Podmore glaze/body stains between pre-cut curves of masking tape. The metallic line which runs counter to the trend of the painting is made of aluminium powder and resin, rolled on and burnished after firing. 15 in. wide, 1,240°C oxidized, 1,100°C.
Collection of the artist

200 Recorded activity 3 (left) **and Diary box** (right) The hollow slab pot on the left has a flat top with random worms of clay added. After the stoneware glaze firing each was sprayed with dark green pigment from a fine atomizer at a low angle so that the lee side stays white. The grid lines are scored and inlaid with copper, and the pot refired.

The Diary box is slab built with impressed lettering, and on one side is a 'cloud', cast from a plaster mould made from a weathered stone. The lid can be removed to reveal a recessed platform. White dolomite glaze. Left: 15 in. wide; Right: 11 in. high; 1,240°C oxidized and ('*Recorded activity* 3') 1,100°C.
Collection of the artist

201 Bowl One of a series, thin and white like vast eggshells, this bowl has raised ridges inside like tendons, and fine lines defining an area green with copper carbonate underglaze. 16½ in. diameter, 1,240°C oxidized and 1,100°C.
Collection of Nancy Baldwin

202 In the wrong rain . . . An upturned ziggurat shape built of slabs. On the top a thick layer of clay peels upwards and is painted in yellow, blue, brown and black, partly from additions to the barium-based stoneware glaze and partly from glaze stains in a second earthenware firing. The flag design on the side is black, and the enigmatic message painted on in copper carbonate with a fountain pen. 10 in. square. 1,240°C oxidized and 1,100°C.
Collection of Ann and Guy Shepherd

203 Offerings The dull white parts are coated with white slip, and rubbed with copper carbonate. The dull black areas are manganese and copper oxides with lead bisilicate. 30 in. high, 1,100°C.
Collection of Mrs Audrie Sachers

204 Two coiled bowls Slab buttresses are an ingenious way of achieving stability without a foot-ring. The glassy turquoise glaze is boracic, over a coloured slip. 15 in. diameter, 1,100°C.
left: Collection of Anthony and Veronica Ray
right: Collection of Walter Birins

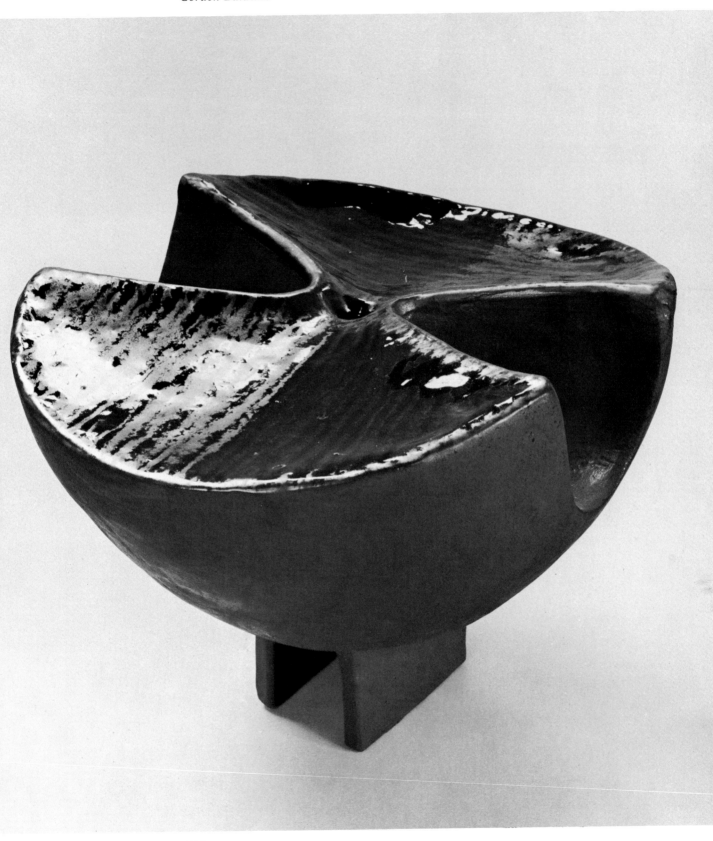

192

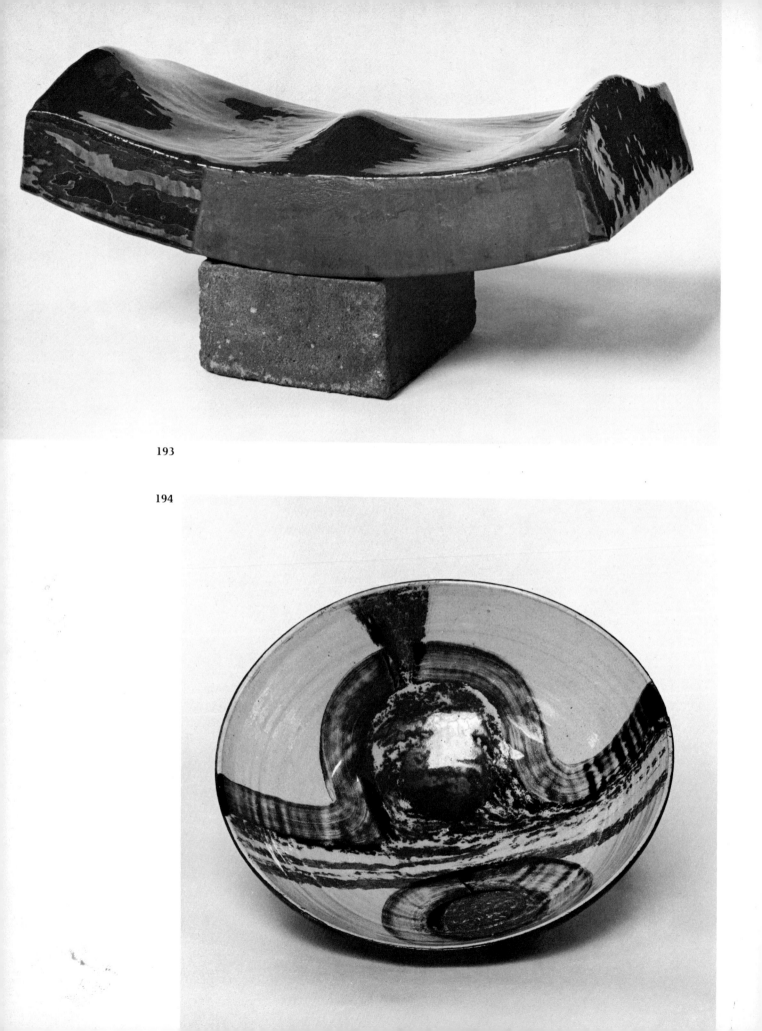

193

194

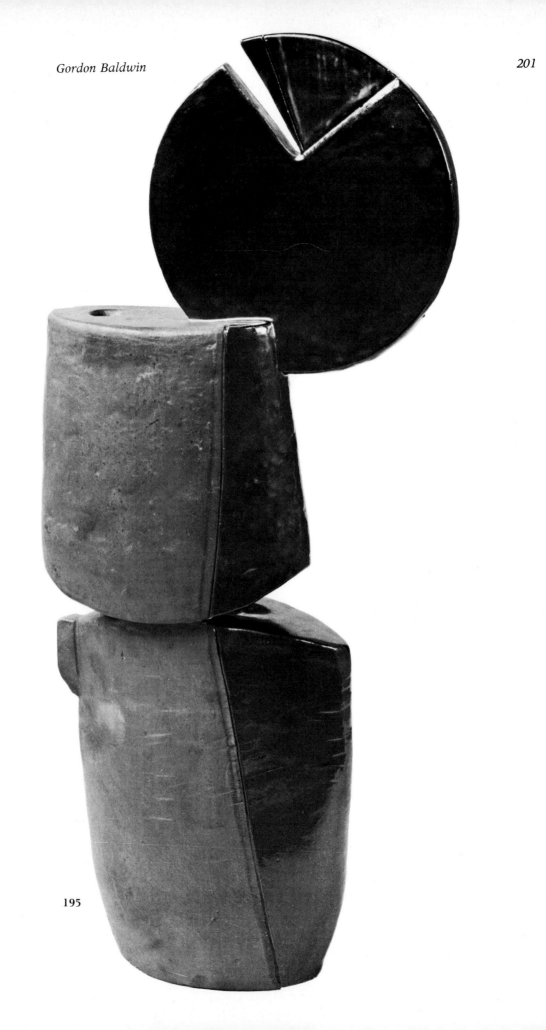

195

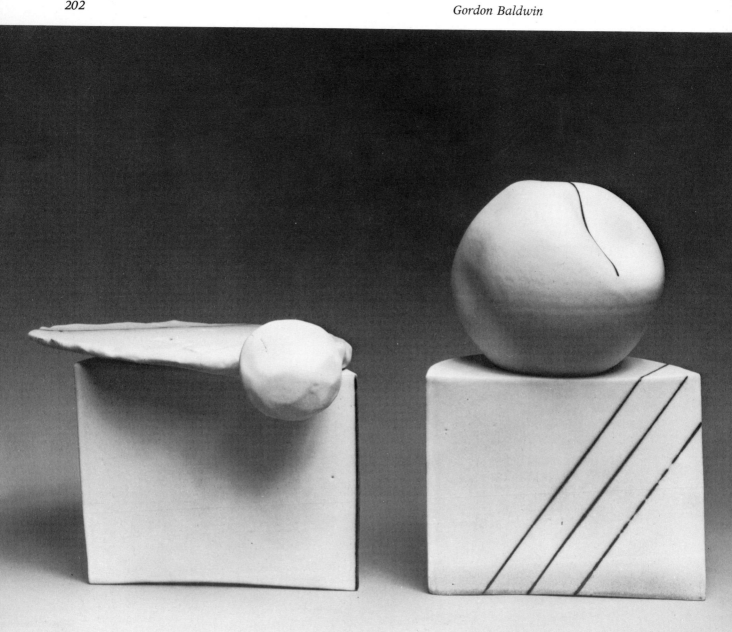

196

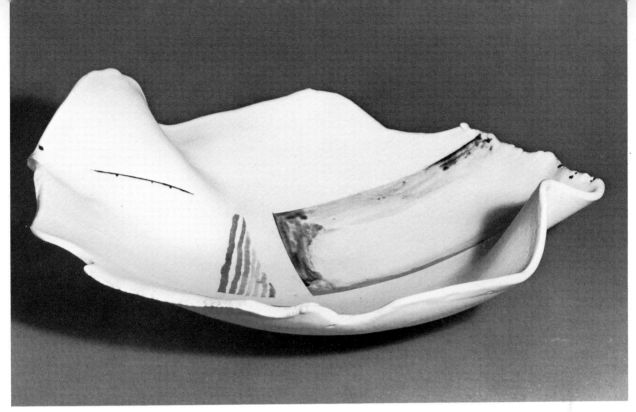

197

198

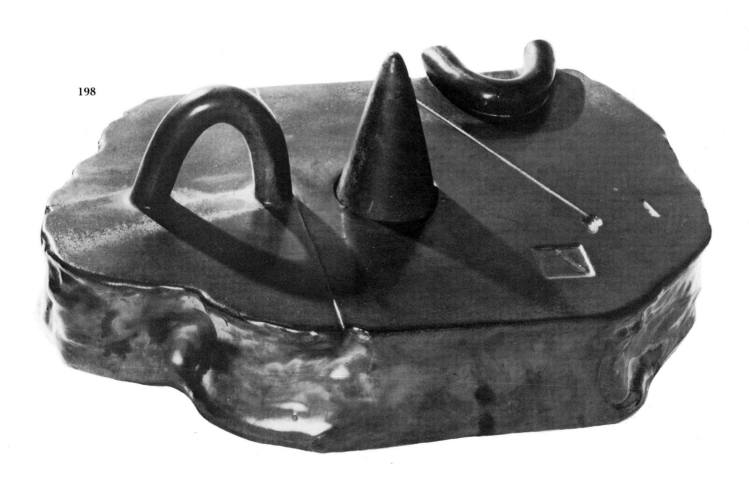

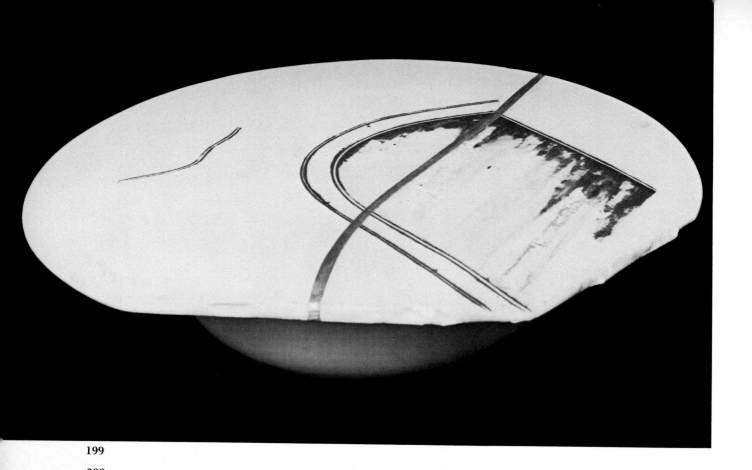

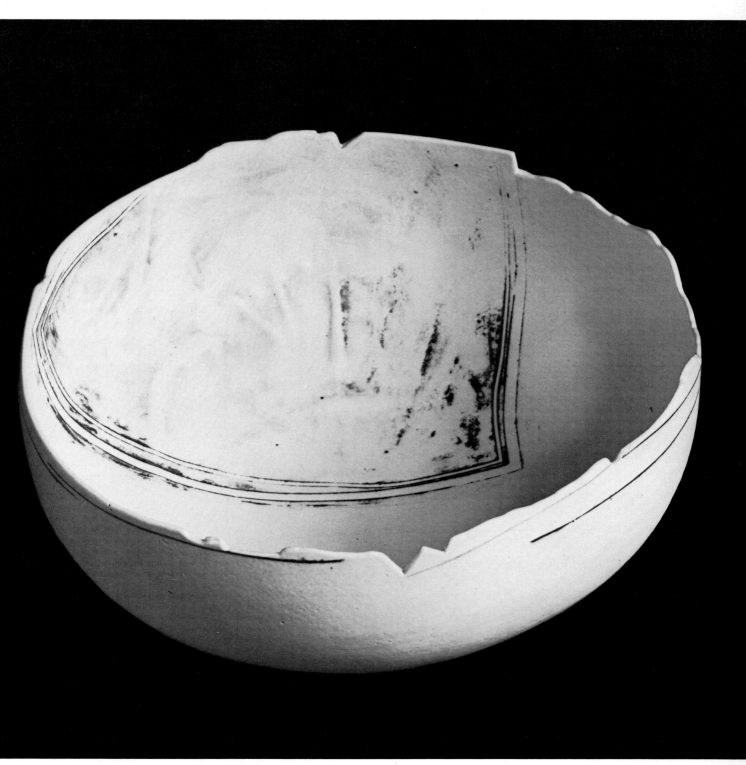

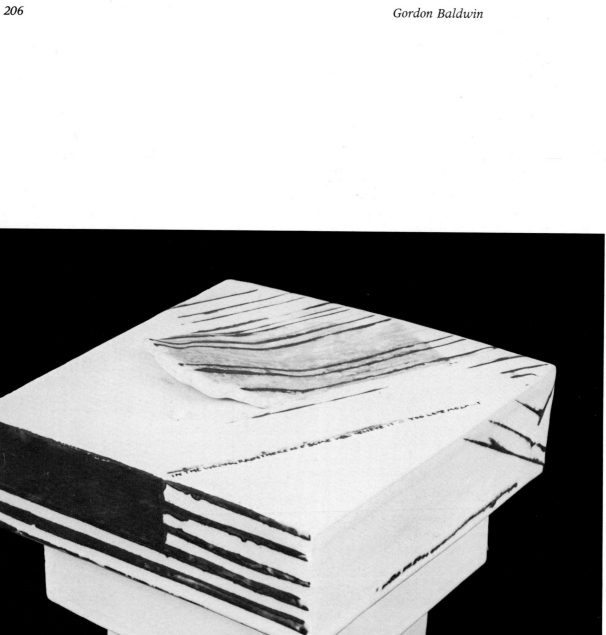

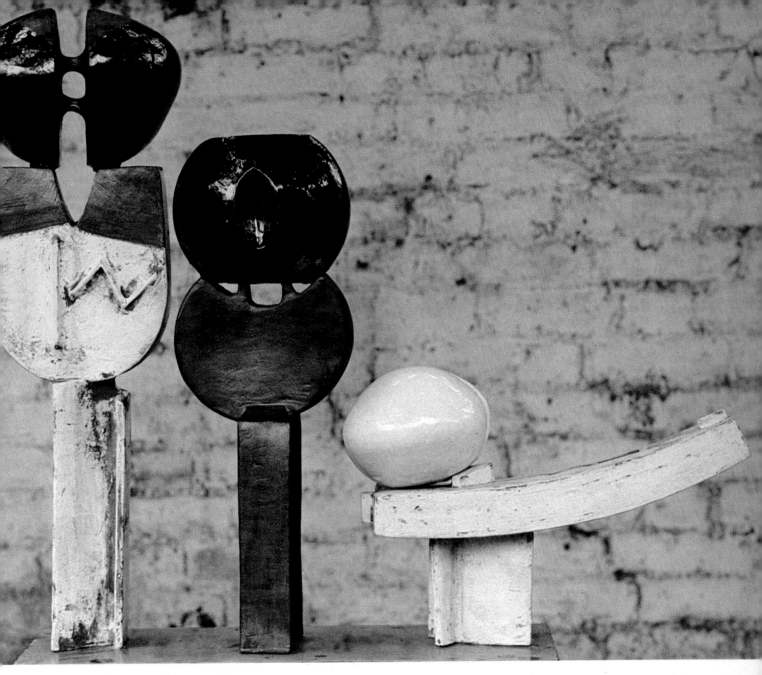

203

204

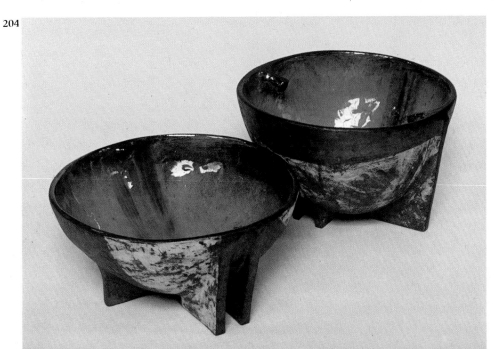

Acknowledgments

Illustrating pottery with photographs and presenting these photographs intelligibly in a book is not as easy as it might seem. Colours, textures, sizes and three-dimensional forms can be misleading when conveyed in pictures. In trying hard to show the objects as they are, I would like to thank Michael Holford, who has provided all the colour photographs as well as many of the black and whites, and Peter Kinnear and John Mennell for their skills and personal help, and all the other photographers whose work is credited below. I would also like to thank Alfred Gumn for taking so much care in the preparation of the screened half-tones used for the printed result.

Photographic credits
Alphabet and Image: Plate Nos 31, 32, 35, 39, 40, 59, 63–65, 70–72, 75, 79, 88–91, 93–95, 97–104, 121, 125, 126, 130, 134, 135, 151; Derek Balmer: 53; Alison Britton: 44, 45, 47, 48; Geremy Butler: 87, 150; Ceramic Review: 2; Euan Duff: 84; Krys Grenon: 3; Michael Holford: 1, 4, 6, 16, 20, 22, 23, 26–28, 30, 33, 34, 41–43, 54–57, 60–62, 66–69, 73, 76–78, 80–83, 85, 86, 92, 96, 111, 115, 116, 119, 120, 122–124, 127–129, 131–133, 136–143, 156–161, 163–165, 167–170, 172–179, 181–187, 190–196, 200, 201, 203, 204; Peter Kinnear: 105–110, 112–114, 117, 118; Nic Knowland: 188, 189; Paul Koster: 21, 24, 25, 29, 36; John Mennell: 58, 74; Oxford Gallery (photo Prudence Cuming Associates): 197, 199; Eric Webster: 5, 7–14, 15, 17–19.

Selected glossary

Agate Ware in which clays of different colours are left unmixed, showing a striated pattern like agate stone.

Biscuit Pottery which has been fired once, and remains porous, like a plant pot. Alternatively, the first, unglazed, firing of the ware.

Body The clay from which a pot is made, as distinct from glazes or slips covering the surface.

Bizen Traditional Japanese ware with a vitrified body, often lightly ash glazed from burnt rice straw. Bizen ware embodies an approach to pottery which gives full value to natural and accidental happenings during making.

China clay (or 'Kaolin') A pure primary clay resulting from the decomposition of granite. It is an essential ingredient in porcelain bodies, and is added to most prepared earthenware and stoneware clays. As a glaze ingredient in high temperature glazes its characteristics are opacity, lightness of colour, and low fusibility.

Composite pottery Forms composed of more than one piece, joined before or after firing.

Continental wheel A foot-operated throwing wheel, distinguished by a very large wooden flywheel which is kicked round by the potter to provide the wheel with its power.

Crank Mixture A proprietary clay of very coarse and open texture prepared by Potclays Ltd, Stoke-on-Trent, Staffs, England.

Dolomite Magnesian limestone, used as a flux in stoneware glazes. It produces a characteristic semi-matt texture, and is off-white in colour.

Earthenware Low temperature glazed pottery, in which the body remains porous. In studio pottery, the normal range of temperature for earthenware is 1,050°C to 1,150°C.

Engobe Originally an alternative word for slip, engobe is sometimes used to describe glazed surfaces which are so dry and open as to exhibit the characteristics of clay rather than glaze.

Felspar An abundant mineral containing silica and alumina. It is the commonest ingredient in stoneware and porcelain glazes, and is used in porcelain bodies. Although its mineral content varies according to source, it will often vitrify as a glaze on its own.

Fireclays Refractory clays with a low silica content.

Glost firing A glaze firing. A kiln packed with glazed pots to be fired is often called a 'glost kiln'. The same kiln packed with unfired pots is called a 'biscuit kiln'. It is unusual for a kiln in a studio pottery to be reserved for a single function, although low-temperature kilns cannot be used for stoneware, and kilns used once to produce salt-glazed pots will always put a film of salt-glaze on pots fired thereafter.

Grog Ground-up unglazed pottery. When added to clay it changes the handling qualities of the clay and in addition reduces shrinkage and warpage, and promotes drying. It is often used by potters for its textural effect which varies according to its degree of coarseness.

Jolleying The industrial process of making repeat-ware by using a profiled arm or 'jigger' to press and shape clay into or over a plaster mould on a revolving spindle or 'jolley'.

Kidney A kidney-shaped tool made of flexible steel for finishing pots thrown on the wheel, or made of stiff rubber for pressing and smoothing clay in a mould.

Leather-hard A stage in the drying of pottery when turning, finishing and assembling of parts can be carried out without damaging the form by handling.

'Once fired' Pottery which goes into the kiln only once. See *raw glazing*.

Oxides Among the many oxides used in clays and glazes as colorants are: *cobalt* (blue), *copper* (blue green, pink to wine-red in reduction), *iron* (yellow, through rust brown to black), *manganese* (brown to purple), *nickel* (green and grey), *titanium* (cream and white), *tin* (white) and *uranium* (yellow).

Oxidized firing A stoneware glaze firing with an adequate supply of oxygen for combustion, allowing oxides to develop their full colours.

Porcelain White-firing pottery, usually translucent, made from clay prepared from felspar, china clay, flint and whiting, and fired to the point of vitrification, from 1,250°C to 1,400°C.

Press mould A two- (or more) piece plaster mould which, when assembled, squeezes an intervening layer of clay into a precise profile.

Raw glazing The application of glaze to pottery which has not been biscuit fired (and is therefore fragile), in preparation for 'once firing'.

Reduction firing A stoneware glaze-firing in which the oxygen supply is limited so that combustion is incomplete. Clays in reduction firing turn darker and grey; glazes turn colder and often bluish or green. The process of limiting the oxygen supply in the kiln is normally begun when the glazes in the kiln are about to reach the temperature of fluxing. Reduction is not possible in electric kilns without causing damage to the elements.

St Thomas's Body A proprietary clay prepared by Potclays Ltd, Stoke-on-Trent, Staffs, England.

Sgraffito A decorative technique in which a sharp tool is used to scratch through a slip or glaze to reveal a different colour of clay or glaze below.

Slip Clay in a very liquid state.

Slip-casting The technique of making pottery by pouring slip into plaster moulds, which absorb the moisture, leaving a solid cast.

Soft and hard glaze When applied to stoneware, the term 'soft' refers to glazes which mature at temperatures between 1,200°C and 1,250°C. The word 'hard' refers to glazes which mature at temperatures above 1,280°C.

Stoneware Pottery fired to temperatures above 1,200°C. Stoneware is usually impermeable when unglazed, because the clay has vitrified.

'T' Material A proprietary clay, white and coarse in texture, prepared by Morgan Refractories, Neston, Cheshire, England.

Throwing lines Near-horizontal ridges on the walls of a wheel-made pot, made involuntarily by the fingers of the potter as the pot is thrown.

Turning The trimming of shapes with a tool when the clay has become leather hard.

Vitrification point The temperature at which a glaze ceases to be granular, and achieves a glassy surface by melting. Also, the temperature at which clay becomes impermeable.